Caught by History

Holocaust Effects in Contemporary Art, Literature, and Theory

CAUGHT BY HISTORY

Holocaust Effects

in Contemporary

Art, Literature,

and Theory

Ernst van Alphen

STANFORD UNIVERSITY PRESS
Stanford, California 1997

Stanford University Press, Stanford, California

© 1997 by the Board of Trustees of the Leland
Stanford Junior University

Printed in the United States of America

CIP data appear at the end of the book

For Rob Lopes Cardozo

Acknowledgments

I wish to thank a number of friends and colleagues for reading and commenting on drafts of various chapters of this book, and for discussing the issues with which it is concerned. Their comments and responses have contributed to this book in important ways. I would especially like to mention Frank Ankersmit, Armando, Stephen Bann, Cynthia Chase, Sabine Cohn, Jane Colling, Maarten van Delden, Geoffrey Hartman, Marianne Hirsch, Frans-Willem Korsten, Janneke Lam, Anneke van Luxemburg, Tony de Meyere, Ursula Neubauer, Nanette Salomon, Leo Spitzer, Susan Suleiman, James Young, and Carol Zemel. Jane Colling also provided valuable help in correcting my English.

Special thanks are due to various institutions for their precious support. First of all, I wish to thank the J. Paul Getty Foundation for the fellowship awarded to me in the academic year 1994–95. I am also deeply grateful to the Rockefeller Foundation for the exceptional hospitality I enjoyed during my stay in July 1994 at the Bellagio Study and Conference Center. An invitation for the Humanities Institute "Cultural

Memory and the Present" at Dartmouth College was of crucial impor-
tance in helping me to formulate my final arguments; I am grateful to
Jonathan Crew and Leo Spitzer for their invitation, and to them and the
other participants for helpful discussions. Access to the Fortunoff Video
Archive for Holocaust Testimonies at Yale University, facilitated by a wel-
coming and helpful staff, was of great significance to my work. I could
not have written this book without the stimulating environment of my de-
partment and the Faculty of Letters of the University of Leiden, as well
as of the Amsterdam School of Cultural Analysis (ASCA), which provided
me with the indispensable framework within which the questions I was
interested in could actually be asked. Receptive and responsive discussions
with students made a crucial difference in my approach. My colleagues
went out of their way to enable me to accept grants and take leaves of ab-
sence, sometimes at personal expense. The Faculty of Letters contributed
funding for the improvement of my English prose. I am also grateful to
Helen Tartar, Ellen Smith, Xavier Callahan, and my copyeditor Anne Can-
right of Stanford University Press. It has been a great pleasure to work
with them.

I also thank the following journals and publications for allowing me
to reprint revised versions of published articles: *Annals of Scholarship*
(chapter 1); *Inside the Visible*, edited by Catherine de Zegher, and its pub-
lisher, MIT Press (chapter 3); *Death and Representation*, edited by Sarah
Webster Goodwin and Elisabeth Bronfen, and its publisher, the Johns
Hopkins University Press (chapter 5); and *Poetics Today* (chapter 7).

I want to end these acknowledgments by expressing my intense grati-
tude to two persons who have been in different ways a constant source
of inspiration. Mieke Bal was always there to encourage me, to listen to
me, and to respond to what I had written. To her I owe my greatest debt
of thanks and much more. Rob Lopes Cardozo made me aware of what
it can mean to be "caught by history." I dedicate this book to him.

EvA

Contents

Introduction Caught by History
How This Book Came About 1

1 History's Other
Oppositional Thought and Its Discontents 16

Part I The Seduction of Directness

2 Testimonies and the Limits of
Representation 41

3 Autobiography as Resistance to History
Charlotte Salomon's 'Life or Theater?' 65

Part II The Historical Approach to Memory,
with a Difference

4 Deadly Historians
*Christian Boltanski's Intervention in
Holocaust Historiography* 93

5 Touching Death
Armando's Quest for an Indexical Language 123

Part III The Imaginative Approach to Memory

6 The Revivifying Artist
Christian Boltanski's Efforts to Close the Gap 149

7 A Master of Amazement
Armando's Self-Chosen Exile 176

Part IV Giving Memory a Place

8 Sublimity in the Home
Overcoming Uncanniness 193

Notes 209
Works Cited 225
Index 235

Illustrations

1. Anselm Kiefer, *Piet Mondrian—Hermannsschlacht* (1976) 5
2. Anselm Kiefer, *Shulamite* (1983) 9
3. Charlotte Salomon, *Life or Theater?* no. 4685 73
4. Charlotte Salomon, *Life or Theater?* no. 4698 76
5. Charlotte Salomon, *Life or Theater?* no. 4179 77
6. Charlotte Salomon, *Life or Theater?* no. 5025 81
7. Charlotte Salomon, *Life or Theater?* no. 4870 85
8. Charlotte Salomon, *Life or Theater?* no. 4905 86
9. Charlotte Salomon, *Life or Theater?* no. 4936 88
10. Christian Boltanski, *Chases High School* (1988), detail 97
11. Christian Boltanski, *Monument: The Purim Holiday* (1989) 98
12. Christian Boltanski, *The 62 Members of the Mickey Mouse Club in 1955* (1972) 104
13. Christian Boltanski, *174 Dead Swiss* (1990) 105
14. Christian Boltanski, *Monument* (1987) 107
15. Christian Boltanski, *Reserve: Détective III* (1987) 109
16. Christian Boltanski, page from *Sans-Souci* (1991) 110
17. Christian Boltanski, *Canada* (1988) 113
18. Christian Boltanski, *Inventory of Objects That Belonged to a Woman of Bois-Colombes* (1974) 114
19. Christian Boltanski, *The Clothes of François C.* (1972) 116
20. Christian Boltanski, *Storage Area of the Children's Museum* (1989) 117
21. Christian Boltanski, *Reference Vitrines* (1969–70) 118
22. Armando, *The Tree* (23.xi.1984) 129
23. Armando, *The Tree* (9.xii.1985) 130
24. Armando, *Forest Outskirts* (19.iv.1984) 131
25. Armando, *The Unknown Soldier* (1974) 133
26. Armando, *Waldsee* (Forest lake) (1982) 134
27. Armando, *Drawing* (1982) 141
28. Armando, *Drawing* (1983) 142
29. Armando, *Flags* (1984) 143

30. Christian Boltanski, *Il faut que vous m'aidiez . . .*
 (You have to help me . . .) (1970) 155
31. Christian Boltanski, *Tout ce dont je me souviens*
 (All I remember) (1969) 161
32. Christian Boltanski, *L'homme qui tousse*
 (The man who coughs) (1969) 162
33. Christian Boltanski, *Theatrical Composition* (1981) 168
34. Christian Boltanski, *Shadows* (1984) 169
35. Christian Boltanski, *Candles* (1987) 170
36. Christian Boltanski, *Candles* (1986) 172
37. Christian Boltanski, *L'ange d'alliance*
 (Angel of accord) (1986) 174
38. Harry Elte, Town House, Amsterdam, built 1928 194

Caught by History

Holocaust Effects in Contemporary
Art, Literature, and Theory

Caught by History
How This Book Came About

If we do not know our history, we are doomed to live it out as if it were our own private fate.
—Hannah Arendt

As someone born in the Netherlands in 1958 into a non-Jewish family, who passed through primary and high school in the 1960's and early 1970's in the same country, I had the memory of the Second World War and the Holocaust drummed into my mind. Or rather, the Dutch school system and representations in the media tried to do so. But they failed to have the required effect. I was bored to death by all the stories and images of that war, which were held out to me "officially" as moral warnings. At school we were shown documentaries of the war. Our teachers encouraged us to read books that informed us in great detail of what had happened not so very long ago. But I avoided my society's official war narratives. Until recently, for instance, I refused to read Anne Frank's *Diary of a Young Girl*. This refusal impelled me to write the book you are about to read.

My resistance to teachings about the war and the Holocaust requires explanation. To which aspects did I overreact so vehemently? Why was I bored instead of feeling morally addressed? Of course, at the time I was not aware of the im-

propriety of my boredom. I simply did not want to be bothered by "their" war stories, a response that implied also a refusal to reflect on my own resistance to those stories. Now I can only reconstruct my motivations, which I did not then articulate and of which I was hardly aware; in retrospect, however, they seem entirely plausible. First of all, war and Holocaust narratives were dull to me, almost dulled me, as a young child because they were told in such a way that I was not allowed to have my own response to them. My response, in other words, was already culturally prescribed or narratively programmed. Fleeting, idiosyncratic identifications I might have with perpetrators instead of with victims were prohibited by the official framings, hence were impossible. The narration of this past had no ambiguities; moral positions were fixed.

Second, the framework in which documentaries were shown and historical narratives were told seemed to me almost hypocritical. Stories about death and unimaginable destruction were framed by proud heroism. The fact that "we" had "won" the war and put an end to the worst possible inhumanity seemed to involve much more than the closure of the historical sequence of war events. The telling and retelling of the events was not so much part of a mourning ritual or of an education in moral sensibility; it was in fact a ritual reconfirmation of a nation's proud self-image as heroic victor. The subjectivity of the victorious narrators of the story of the war and the Holocaust overruled the awe one might feel in the face of the story being told. As the person who was being told these stories I was not interpellated, to use Althusser's term, as a human being with moral responsibility, but as a young boy who had to construct his masculinity in the image of heroic fathers. That is why I felt bored: intuitively, I did not want to get involved with this cultural construction of a national, masculine identity.

Third, in my perception, the Holocaust did not really "fit" the story of the Second World War. In the overall narrative the Holocaust was presented as the most sinister practice of Nazi Germany, which of course it was. Its meaning depended on the narrative framework of the Second World War, in which it was embedded. But somehow, for me the place the Holocaust occupied in that story did not make sense, or not enough sense: there was much more to say about the Holocaust than was possible in terms of the meanings provided by the framework of war on which it depended to be "explained." So for me, in my refusal of this framework, the images and stories of the Holocaust remained isolated fragments. They did not join with other war episodes to form a continuous story-

line, but represented discrete events foreign to a constructed world that seemed too coherent and understandable. Whereas the Holocaust was explained as being part of a more or less consistent, reconstructible history, to me it seemed like an intrusion of another world, one that did not relate to the war story of heroic masculinity. Unable to express my discomfort with the way the Holocaust was embedded in the war narrative, I could only store the Holocaust images away. These images became "haunting" because they were meaningless within the repertoire of masterplots provided by the culture of which I was a part.

As I write, it is 1995, and all over the world the defeat of Nazi Germany, the liberation, and the end of the Holocaust are being commemorated. Given my long-standing aversion to everything related to this war, it is perhaps surprising that a few years ago I became involved in working on Holocaust art and literature. To me, though, the occasion for this change is clear. Whereas the education I received failed to make the Holocaust a meaningful event for me, Holocaust art and literature finally succeeded in calling my attention to this apocalyptic moment in human history. The reasons for this capture by art and literature are not so clear, however. And so I decided to get to the bottom of the matter.

It is remarkable that it was imaginative representations of the Holocaust that hooked me. For it is an unassailable axiom in Holocaust studies that historical discourse such as documentary is much more effective in teaching about the Holocaust than imaginative discourse. This distinction between historical and imaginative discourse has had a fundamental impact on Holocaust studies. In Chapter 1 below, this distinction and its far-reaching consequences for the study of the Holocaust today—its power to *stay* for generations that can no longer count on lived experience—will be analyzed in some detail. I will discuss the ramifications of this distinction and the suspicion with which art and literature about the Holocaust are met.

Perhaps art itself can have a say in this matter. One artist, a German, who has challenged the distinction between historical and imaginative treatments of Nazi Germany and the Holocaust is Anselm Kiefer. His work has given rise to much controversy, especially in Germany. And because Kiefer's work has played a major role in my own reconsideration of the resistance I felt to narratives of the war and the Holocaust, his "case" seems an effective means for introducing the problematic broached in this study. In many respects his work is exemplary of the

kinds of art and literature that changed my attitude toward the memory of this past, and of the issues that are at stake in Holocaust studies.

Holocaust art and literature that are not modeled on documentary realist genres like testimony or memoir but that are nevertheless appreciated as "good" evoke this past as unrepresentable. This explains, for instance, why Holocaust poetry such as that of Paul Celan is so highly respected, even though it belongs to the realm of the imaginative. The canonical status of this poetry would seem to be at odds with the general aloofness with which scholars approach literary representations of the Holocaust. In contrast with narrative imaginative genres, however, poetry as a genre is somewhat distanced from what are seen as factual events. Holocaust poetry, that is, usually represents metaphysical despair or personal sentiment. The representation of these issues is somehow not in conflict with the privileging of historical discourse with regard to the Holocaust. But as soon as Holocaust art or literature introduces narrative elements that relate to historical "reality," post-Holocaust culture has its guard up. Narrative imaginative images or texts are considered to be in violation of a strict taboo.

One of the many reasons Kiefer's work has been so much discussed during the last two decades is that it does not show respect for the usual distinction between historical and imaginative representation. His work is provocatively historical and imaginative at once, and remarkably, it does not place these modes in opposition. The historical aspects of his work are infused with mythical elements, a combination that makes it extremely difficult, perhaps even senseless, to distinguish the historical from the imaginative.

Kiefer's work is not formalist abstract, as are, for instance, the artworks that were commissioned for the Holocaust Museum in Washington, D.C. The works by the American artists Sol Lewitt (*Memorial*), Ellsworth Kelly (*Consequence*), and Richard Serra (*Gravity*) present themselves unproblematically as imaginative.[1] There, formalist abstraction evokes the sublime unrepresentability of the Holocaust. Kiefer's works are, on the contrary, figurative. Nonetheless, as his painting *Piet Mondrian—Hermannsschlacht* (1976; Fig. 1) makes clear, the figurativeness of his works is not just a continuation of the figurative tradition, but a polemical response to abstraction. Like his teacher Joseph Beuys, Kiefer reacted against the kind of modernist art that, coming out of New York, was much in vogue internationally in the 1970's and 1980's. Abstract Expressionism and Pop Art were dead ends for him because they were both

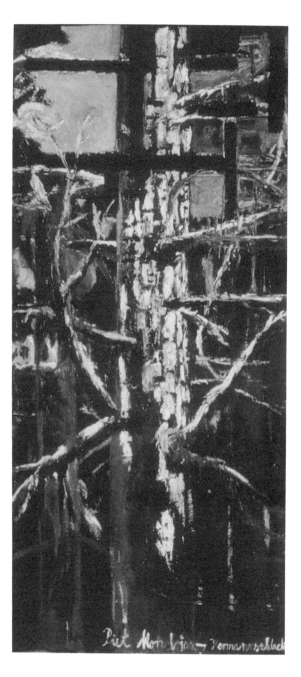

Figure 1. Anselm Kiefer,
*Piet Mondrian—
Hermannsschlacht,* 1976;
oil on canvas, 245×112
cm. Collection Geertjoos
Visser, Belgium

narcissistically focused on art itself as the most important subject matter of art. Kiefer expressed his conquest of a subject matter for art outside itself not only by means of a different art practice, but also thematically in his paintings as a struggle within art, a *Bilderstreit*. Some of his paintings of the late 1970's represent this battle literally. The artist's palette is shown in places where battles were fought or where they are commemorated. The palette allows a reading of itself as a weapon, a soldier, or a trophy.

Kiefer's painting *Piet Mondrian—Hermannsschlacht* does not represent the *Bilderstreit* as battle, but it makes it clear who the enemy is. The *Bilderstreit* is here directed against the artist who exemplified modernism: Piet Mondrian. Kiefer targeted this canonical modernist oeuvre in part because it emblematizes a pictorial tradition that he wanted to leave behind. But he was also interested in the fact that Mondrian's development into abstraction has as its starting point the motif of the tree. Kiefer reverses the transformation that took place in Mondrian's oeuvre along the tree's trunk and branches. In *Piet Mondrian—Hermannsschlacht*, that is, he does not transform a tree into abstraction; rather, he transforms a Mondrian grid back into a tree. Of course, Kiefer did not choose this motif merely for formal reasons, but because, as Simon Schama has pointed out, the tree and the forest play such an important role in German and Nazi mythology.[2] He wanted to return the compositional lines of the tree back to the narrative function the tree serves in the national culture of Germany.

The battle, or *Schlacht*, in the title is doubly significant. Historically, it refers to a battle that took place in the Teutoburger Forest in 9 A.D. between Arminius, also called Hermann, and the Roman army. Hermann was the son of the chief of a German tribe, who had made a military career in the Roman army. When he returned to his tribal identity, however, he raised a rebellion against the Roman empire, which culminated in the slaughter of an entire Roman army. This event, which reclaimed German soil for people with German blood, has become a key element in several episodes of German cultural history, functioning as the primary symbol of the origin of German cultural identity.

After the defeat of Nazism, Germany no longer had a place for this founding story of Germany's *Blut und Boden* (blood and soil) ideology. The mythical narrative episode of the *Hermannsschlacht* was consequently "forgotten." Kiefer, however, revives the motif of the tree and the forest in which the myth is condensed, though his return to narrative fig-

urativity does not take place within the conventions or genres of documentary realism. He does not intend to convey a coherent, continuous German history, but rather the opposite, that is, the ruins of history. For the tree has been burned.

Kiefer, apparently, is not merely re-presenting or illustrating Germany's myths and history. He is not nostalgically longing for a forgotten past. His works can be read as, in the words of Andreas Huyssen, "a sustained reflection on how mythic images function in history, how myth can never escape history, and how history in turn has to rely on mythic images."[3] Kiefer's trees, forests, and landscapes have been burned because these mythic places of the German imagination were violated and contaminated by history.

Kiefer does not represent German history realistically in his work. He does not isolate single events or episodes from the chronological telling of the past. Such an approach would leave intact the traditional notion of history, with the depiction of a single event standing as a synecdoche for the rest of the historical narrative. Instead he shows the effects of history, its ravages. What we see are fragments from "a memory that itself lies in ruins."[4] The *grand récit* of Germany's proud history is evoked only as a forever-elusive absence. But Kiefer does more. Indeed, if he did not, his achievement could be regarded simply as a sentimental fixation on the ruins of history. No, in his work he also offers a critical analysis of how history came to be ruined and how history could become so destructive. Kiefer emphasizes the mythic imagination that empowered Germany's history. Thus, not only does he make the havoc of history into the subject matter of his art, but he also dissects the mythic vision as a cause of this havoc.

His *Bilderstreit*, especially as it is fought in *Piet Mondrian—Hermannsschlacht*, seems to argue not only that mythic imagination is active in history, but that it can also be active in art. Underlying modernist art, such as that of Mondrian, are transcendental views that are thoroughly mythic. If German history is one of the possible effects of mythic imagination, by inference we must also look askance at the modernist practice of art. As Huyssen comments, "It is history, German history, that stunts the painterly flight toward transcendence. Painting crashes, redemption through painting is no longer possible, mythic vision itself is fundamentally contaminated, polluted, violated by history."[5]

One could argue that Nazi Germany's contamination of history and mythic imagination legitimizes, even necessitates, the maintenance of the

clear-cut division between historical and imaginative discourse that currently informs Holocaust studies. Such a claim suggests that the disruption of that distinction is necessarily and inherently harmful, that a safeguarding of the distinction in fact counters the origins of Nazism. This is, indeed, one of the major thrusts of the opposition to Holocaust art.

Kiefer's work certainly does not imply such a need—no more than do any of the works I will be discussing in this book. For although he addresses constantly the contamination of history and mythic imagination by Nazi Germany, he does so through a provocative disruption of that very distinction between historical and imaginative. Let me explain by means of his painting *Shulamite* (1983; Fig. 2), from his series about the Holocaust, how this strategy works and how it offers a model for Holocaust art in our time.

Significantly, this series of paintings is based on the famous poem "Todesfuge" (Death Fugue) by the Jewish poet Paul Celan, who survived the Nazi concentration camps. The poem consists of a sequence of highly mythic images. The fame of the poem might seem to contradict the general reluctance to embrace the imaginative representation of the Holocaust, but as I explained above, poetry is generally excepted from this rule because as a genre it is traditionally not involved in plotting, whether factually or fictionally. Kiefer, however, highlights Celan's mythic handling of the Holocaust by grounding his painting in this poem.

In *Shulamite* Kiefer has transformed Wilhelm Kreis's fascist design for the Funeral Hall for the Great German Soldiers in the Berlin Hall of Soldiers (1939) into a memorial to the victims of the Holocaust. The funeral hall is blackened as if by the fires of cremation. The space looks like an enormous brick oven, the gigantic proportions of which come to symbolize the incredible scale of the Nazi genocide. The threatening space does not reveal, however, any realistic reference to cremation or gassing. It does not actually document the Holocaust. The tiny glimmers of light that we see in the utter depths of the blackened, empty space are the seven flames of a menorah, the Jewish seven-branched candelabra. Thus the celebratory memorial space of Nazism is transformed into a memorial to its victims.

Several attitudes toward Nazi Germany's past, and toward the Holocaust specifically, are condensed in this image. The work *documents* that past much as the traditional historian might: the image represents an architectural creation of the Nazis, one of the many actual products of Nazism. The image also *analyzes* the Nazi past by foregrounding the

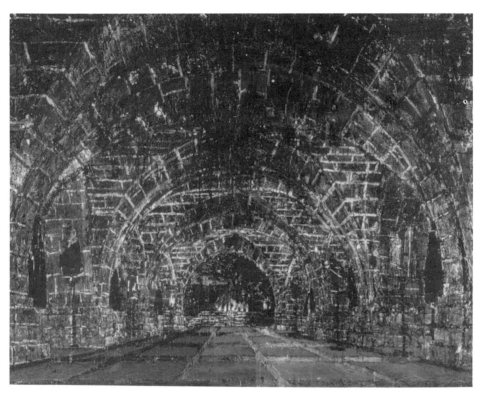

Figure 2. Anselm Kiefer, *Shulamite*, 1983; oil, acrylic, emulsion, shellac, straw, and woodcut fragments on canvas, 290×370 cm. Saatchi Collection, London

mythic fascinations that determined, even produced, that past: the image represents an existing architectural creation as a place that reveals the death cult of the Nazis. The image also opens up the possibility of *working through* Germany's fascist past. The space is no longer celebratory: it has been transformed into a space for mourning the victims of the Holocaust. This working through does not take place as a repression or forgetting of the past; rather, it *reenacts* the past. Looking at this painting we are directly confronted with how Nazi culture exploited visual aesthetics for its own deadly ends. The painting is structured according to the aesthetic principles of the Nazis: it is a monumental painting of a monumental architectural space; we enter this space along an extreme central-point and low perspective.

It is this function of reenactment that has made Kiefer such a controversial artist, for his approach can be seen as a nostalgic or melancholic

strategy of reanimating German fascism. German critics in particular have read his work in this way. Chapters 2 and 3 are thus devoted to this strategy of reenacting the Holocaust. There I argue that reenactment as an artistic project can also function as a critical strategy that does not seek to tell, via a mediating narrator, but rather shows, directly. In Chapter 4, "Deadly Historians," I argue this point using the works of the French artist Christian Boltanski. His consistent use of historical resources such as the archive reveals the Janus face of the historical approach to the Holocaust. This strategy of mimicking archival research is confusing because it does not provide objective information about the Holocaust. Instead we are lured into the event itself, experiencing directly a certain aspect of Nazism or of the Holocaust as we view an image. We are no longer listening to the factual account of a witness, to the story of an objectified past. Rather, we are placed in the position of being the subject of that history. We are subjectively living it.

It is in this framework of reenactment that I will propose the term *Holocaust effect*. This term can evoke misunderstanding because the term *effect* is easily associated with the seductions of popular culture, which thrives on easy "effects" instead of truth or essence. Another association not meant here is that posited within the theoretical framework of reader response criticism. There the term *effect* has mainly psychological resonances; one is interested in the effects of a work of art or a literary text on the viewer or reader. In this book I will not activate either of these connotations. Instead I use *effect* exclusively in the sense it is given in the interconnected theoretical frameworks of semiotics and speech-act theory. When I use the term *Holocaust effect*, therefore, I do so to emphasize a contrast with the term *Holocaust representation*. A representation is by definition mediated. It is an objectified account. The Holocaust is made present in the representation of it by means of *reference* to it. When I call something a Holocaust effect, I mean to say that we are not confronted with a representation of the Holocaust, but that we, as viewers or readers, experience directly a certain aspect of the Holocaust or of Nazism, of that which led to the Holocaust. In such moments the Holocaust is not re-presented, but rather presented or reenacted. In terms of speech-act theory I might explain it differently. The Holocaust is not made present by means of a constative speech act—that is, as a mediated account, as the truthful or untruthful content of the speech act; rather, it is made present as performative effect. Those performative acts "do" the Holocaust, or rather, they "do" a specific aspect of it.

We are there; history is present—but not quite. The indispensable distance that decisively distinguished nostalgia, or even neo-Nazism, from this "good" present-ation is what matters to me; it is what I wanted to come to understand in the writing of this book. A confrontation with Nazism or with the Holocaust by means of a reenactment here takes place within the representational realm of art. Our access to this past is no longer mediated by the account of a witness or a narrator, or by the eye of a photographer. We will not respond to a re-presentation of the historical event, but to a presentation or performance of it. Our response, therefore, will be direct or firsthand in a different way. That different way to "keep in touch" is the subject of inquiry that propels this study.

This book is not structured according to artists, but according to issues, all of which challenge the dichotomy between historical and imaginative discourse. In Chapter 1 I discuss the presuppositions and modes of thinking that underlie the dichotomy, as well as recent critical efforts to deconstruct it. Thus, the chapter outlines the theoretical framework that I consider to be relevant for understanding the artistic creations of Charlotte Salomon, Christian Boltanski, and Armando. Their works will not, however, be subjected as "objects of study" to a theoretical discourse that would be "applied" to them. Rather, I will make these artworks speak "theoretically" in their own right. I will consider their contribution to the debate by focusing on how they challenge, how they work up or work on, the categories that have determined Holocaust representations so far. All three artists have developed alternatives for conceptions that have often been confining instead of empowering or illuminating. After considering the strategies of each, I read those artistic solutions for their theoretical implications.

Further, in Part One I devote two chapters to the issue of directness. The genres of testimony, autobiography, and the diary are all highly valued in Holocaust studies because of their presumed directness. And of course, these genres are more direct than others in several ways. They distinguish themselves by providing historical accounts of individuals who witnessed, or even partook in, the recorded events. The diary is direct in yet another way, for there accounts are recorded more or less immediately after the events in question. The act of writing almost coincides with the events and experiences described.

This relative directness has led to the conviction that these genres provide transparent views of history. History is alleged to be unmediated be-

cause the narrating subject was also a subject in the history being told. In Chapter 2 I will argue against this conviction: not only does mediation by language not block a transparent view of history, I suggest, but the symbolic order of language and representation is a necessary precondition without which history or reality cannot be experienced at all. In this chapter I analyze testimonies of Holocaust survivors rhetorically in order to determine where the so-called unrepresentability of the Holocaust originates. Does the impossibility or difficulty of relating their stories originate in the extremity of the events? I will argue that the problems with which representations of the Holocaust struggle must be located in the process and mechanisms of representation itself. In so doing I do not want to diminish the extremity of the Holocaust as a historical event in any way. Rather, I presume that in principle, precisely because of its indirectness, representation offers the possibility to give expression to extreme experiences. But how?

Chapter 3 deals with Charlotte Salomon's painted life-history *Life or Theater?*, a work that provides a negotiated answer to this question. This famous autobiography, a painterly counterpart to Anne Frank's diary, is usually seen as a moving account by a young Jewish victim of the Holocaust that derives its strength from its direct expression. I argue the opposite. I contend that Salomon tells her story indirectly, "between the lines." She can represent herself only in the ironic distance she maintains from the stories of others that she is telling, stories which circulate in her culture and which are also told to her by Daberlohn. Salomon's life history is structured around two motifs: male creativity and female suicide. This structure leads to a paradoxical situation for Salomon as the narrator of this autobiography, for her life history seems to tell the story of the impossibility of the female artist. Gender, then, leads necessarily to narrational indirectness. This indirectness will raise the question of the difference between the conventional autobiography and *Life or Theater?* as autobiography, a difference generated by the artist's gender.

The next issue I address, in Part Two, concerns art that endorses the historical approach to the memory of the Holocaust, but with a difference. Chapter 4 discusses installations by Christian Boltanski, in which modes of representation formulated by many Holocaust commentators, modes that are supposed to provide an objective, truthful account of past reality, are adopted and explored. Boltanski's installations consist of vitrines, collections of photographic portraits, and inventories. All these genres are privileged within the historical paradigm; they embody the

promise of the presence of the past. However, Boltanski's consistent return to these historical genres reveals something else. His acts of reconstruction and making present hit us with the awareness that what is being reconstructed is also lost. And that is not all. Collections, archives, inventories also embody the perfection of the disciplinizing of history as a scholarly field. Boltanski, however, does not make Holocaust art by documenting, thus disciplinizing, it. His archival and historical modes of representation reenact the Holocaust in unexpected and uncanny ways. Moreover, he forces us to realize that the disciplinizing of history was exactly what the Nazis did as they made history and practiced genocide.

Chapter 5 discusses visual as well as literary works by the Dutch artist Armando. All his works are thoroughly historical in their fight against the passing of time. For him there is a moral and existential need to keep in touch with the past of the war and the Holocaust, which, in his view, was not fully understood or experienced while it was happening. Surprisingly, though, his representation of this history of destruction constitutes a history without narrative plot, without beginning, end, or development, without a clear distinction of roles. Indeed, Armando's work challenges the meaningful continuity produced by emplotment. Narrativity is met with suspicion because the coherence and meaningfulness it creates was alien to the lived experience of the Holocaust. Instead Armando develops an indexical language that allows him to maintain contact with that past, literally and concretely. As consistent in his obsession as Boltanski, he represents only objects, creatures, and situations that were actually present at the scenes of action. Through this strategic maneuver of indexicality he is able to encircle the spot where "things happened." He never describes the event itself: that would be impossible. But he gets close to it by articulating that which touched it, that which was present.

In Part Three I leave the historical approach to memory behind and turn to its complement, the imaginative approach to memory. Chapter 6 again looks at installations by Boltanski, but this time the focus is on those that explore alternatives to the historical process, with all its shortcomings and side effects. Here, too, testimony is the background against which these alternatives can be understood. Yet in this case I consider another important function of testimony, one that bridges the gap of time that commences when the bearers of testimony are no longer there. Testimony not only provides a product, historical information; it is itself a process, a transactive process between a listener and a testifier that reintegrates the Holocaust witness in the present. Thus the testifier is no

longer isolated within a past event. The voice and subjectivity of that individual are reestablished by the process of offering testimony and in the dialogical relationship with a listener. I will argue that Boltanski's mail art, which he sent to people in the early 1970's, can be understood as a phatic attempt to relate to other people in the present. He creates a dialogical situation in the present as a way of foregrounding the need for (re)constituting subjectivity.

Boltanski goes still further in his installations *Shadows* and *Candles*. As a rule, his historical installations do not rely on the presence of objects to make their point; on the contrary, we are generally hit by their confrontational absence. In *Shadows* and *Candles*, however, the projections of the figures that stand for death represent a total correspondence between projected figure and model. When we watch the projected shadows on the wall we do not relate to a dead, fixed subject, as in the historical installations, but to a moving subject living in the present. The dance of death on the walls of these installations is no longer a reenactment of the Holocaust, but a countering of it. The dead are brought back in their full, living presence.

Chapter 7 discusses another facet of Armando's art practice. Not content with reaching back to the past, Armando also powerfully, in a way that pushed to the outer limits, put himself in a situation wherein he could literally reenact the past in the present. In the 1970's he exiled himself to Berlin, where he lives today, "surrounded," as he puts it, "by the enemy." This elective condition of self-banishment determines the content of his works in a fundamental way. Why is the situation of exile so productive for Armando's particular practice of art? His exile, after all, is not at all motivated by the pursuit of a historical knowledge that might be traced to Berlin, "the lion's den." Rather, Armando displaced himself in space so as to keep alive his bewilderment about the past, to give it a place in the present in a very literal way.

This attempt to "give the past a place" prompts me to end where I began: in my personal situation, which finally motivated me to reconsider my resistance to everything related to the Second World War. A few years ago I moved to a house that was, in Armando's words, "a guilty house." Things happened there during the war. The house itself does not testify to what happened—and that makes it guilty. It is as silent as normal houses with no Holocaust history. What took place there is the following. The architect who built the house for himself and his wife lived there until 1943. In that year the Nazis took him and his wife away from the

house because they were Jewish. They were killed in Theresienstadt. In my neighborhood there are thousands of houses like that, with the same history. They are all indexes of the Holocaust. The words spoken by Jean-Baptiste Clemence in Albert Camus's novel *The Fall* apply in an almost literal way to the area I inhabit: "I live in the Jewish quarter or what was so called until our Hitlerian brethren made room. What a cleanup! Seventy-five thousand Jews deported or assassinated; that's real vacuum cleaning. . . . I am living on the site of one of the greatest crimes in history."[6]

The dilemma for me was whether I could feel at home in this house. Was it haunted because of its history? In order to feel at home, would it be necessary to repress or ignore its history, or would such a repression make it even more *unheimlich* (uncanny)? In a short final chapter, I try to make myself at home by giving the memory of the Holocaust a place. Specifically, I assign it a place within this house, by rethinking the concepts of the uncanny and the sublime, characteristics that, in the history of the arts and literature, are usually invested in the spatial dimension. I will not, however, discuss the spatial dimension of my house, the architectural features that might trigger uncanniness or sublimity, although such an analysis is possible. For my goal, however, it is not relevant; for I am interested in understanding those concepts in terms of memory and the history of this house, not in terms of space.

This study, then, explores art and issues, with each informing the other. Ultimately, its goal lies beyond the objects of analysis, beyond the subjects of reflection. In these chapters I want to document and analyze, reenact and so work through, my own position and that of my generation. My resistance to, and then fascination with, a past that no longer exists but keeps haunting the present is part of what the art and theory under discussion contend with. That contention, this book urges, is necessary if we want to give memory a place, now.

History's Other

Oppositional Thought and
Its Discontents

What underlies determinism as a principle of representation is the rigid adherence to a mythical structure of memory which does not really admit any life beyond.

—Sidra DeKoven Ezrahi,
"Representing Auschwitz"

Imaginative discourses such as art and literature are highly esteemed in Western culture, except when their topic is the Holocaust. Then, suddenly, those discourses are met with suspicion. The suspicion is caused by an opposition that seems to enforce itself automatically in the face of the memory of the Holocaust. That is, imaginative discourse is immediately opposed to historical discourse and the historical reality to which this discourse is subordinated. This opposition between historical and imaginative discourse has determined in a fundamental way not only the discussions in Holocaust studies, but also the kind of art, literature, and historiography that has been produced "about" the Holocaust.[1]

The opposition has all the features of a dichotomy. First, it reduces all expressions to two contrary classes, simplifying both categories to their polemically defined "essence." Second, it is not neutral, but produces a hierarchy: one element is positive, the other negative. Third, the

positive term of the dichotomy can only be defined by contrasting it to the negative term. Hence, the dichotomy is legitimized not by explaining the positive features of historical discourse, but rather by pointing out the negative features and effects of imaginative discourse and then saying that historical discourse is or does not do "that." Hayden White has termed this negative rhetorical strategy in defining self-identity "ostensive self-definition by negation."[2] More fascinated by what one is afraid of being than by what one is or hopes to be, one can define the positive term only negatively as what it is not—its opposite. In Holocaust studies, historical discourse has usually been the positive term, which consequently needs little explanation; by contrast, the dubious, even nefarious, features of fictional, imaginative discourse—the negative term—have been spelled out endlessly.

This cultural aloofness to Holocaust art and literature needs clarification. The opposition that is usually created between the historical and the literary or artistic approach to the Holocaust is not based only on the practical norm of effectivity. It is also heavily invested with morality. In the case of the memory of the Holocaust, imaginative representations are considered not only less effective, but even objectionable. Literature or art, after all, may yield aesthetic pleasure. And pleasure is supposed to be a barbarous response when we are confronted with this particular past, which is itself barbarous. Instead we should focus and meditate on the hard facts of the Holocaust. The historian presents these facts straightforwardly, soberly, and sparingly, using apparently transparent discourse without rhetorical ornamentation, while artists and writers reconstruct an indirect and skewed image of the Holocaust, using flights of fancy and trivializing imaginative techniques. Iron-hard history is contrasted to the concoctions of the imagination.

Improper Pleasure

The dichotomy between the historical and the imaginative approach to the Holocaust is legitimized first of all by moral considerations. These considerations always have the same point of reference. It has become unavoidable to begin reflections on Holocaust representations with a discussion of Adorno's famous dictum that "after Auschwitz it is barbaric to continue writing poetry."[3] This statement appears to condemn poetry, or artistic, imaginative representations in general, as barbaric. By this statement Adorno has set the tone for an overwhelming suspicion of literary or artistic representations of the Holocaust. Whereas up to World

War II the creation of art and literature possessed a serious, almost religious aura, after Auschwitz it suddenly seemed a shockingly frivolous occupation. This explains why literary representations of the Holocaust are especially valued if they make people think of literature as little as possible. The writing must be bare and realistic. Fictionalizing is taboo, while ego-documents, personal testimonies modeled on journalistic or documentary accounts, are considered to be the most appropriate genre for representing the Holocaust.

Yet when Adorno's statement was repeatedly used with reference to the Holocaust only, and not to the impropriety of literature generally, Adorno readdressed it. In an essay of 1962 on commitment and literature he specifies that a *particular kind* of literature has become inappropriate after Auschwitz:

I do not want to soften my statement that it is barbaric to continue to write poetry after Auschwitz; it expresses, negatively, the impulse that animates committed literature. . . . It is the situation of literature itself and not simply one's relation to it that is paradoxical. The abundance of real suffering permits no forgetting. . . . But that suffering—what Hegel called the awareness of affliction—also demands the continued existence of the very art it forbids.[4]

The Holocaust entails a paradoxical problem. From one perspective, the necessity to remember and to represent has never been as acute as it is today. If we are to avoid another systematic attempt to exterminate an entire people, the commemoration of this apocalyptic event in Western history is more than a moral obligation to the victims of it. At the same time, many Holocaust representations are based on the premise of forgetting instead of maintaining contact. How is this possible? How can representation encourage forgetting?

Adorno's judgment condemns the aesthetic, stylistic principle that underlies the production of images or poetry out of experiences:

When it [the Holocaust] is turned into an image . . . , for all its harshness and discordance it is as though the embarrassment one feels before the victims were being violated. The victims are turned into works of art, tossed out to be gobbled up by the world that did them in. The so-called artistic rendering of the naked physical pain of those who were beaten down with butts contains, however distantly, the possibility that pleasure can be squeezed from it. The morality that forbids art to forget this for a second slides off into the abyss of its opposite. The aesthetic stylistic principle, and even the chorus' solemn prayer, make the unthinkable appear to have has some meaning; it becomes transfigured, something of its horror removed.[5]

In short, Adorno objects not to representation as such, but to *transfiguration*. Events and experiences like those of the Holocaust ought not to be transformed into images or artworks, so as to be read with aesthetic pleasure. Nevertheless, *art* is utterly indispensable. Indeed, according to Adorno, we *need* an art form that keeps Holocaust experiences from being forgotten.

Objections to literary imaginings of the Holocaust based on Adorno's earlier statement in fact rely on a rather limited conception of literature and art, one restricted to sheer aesthetics in the sense of enjoyment or distraction. The most important function that Sir Walter Scott attributed to the historical novel, the transmission of historical knowledge by fictional means, has disappeared. When Adorno sharpens his statement later, this function returns: we must, he says, keep the world informed of the suffering of the victims, and it is the task of literature to provide that knowledge. Aesthetic experience cannot be reduced to "pleasure" in the sense of (distracting) amusement.

It is striking that in many discussions about Holocaust representations, aesthetic experience and the transmission of (historical) knowledge are conceptualized as polar opposites instead of as mutually supportive processes. The hierarchical opposition between history and imagination, it seems, has collapsed into another hierarchy: objective cognitive remembrance versus aesthetic pleasure and distraction. However, Adorno's work neither justifies nor legitimizes this new opposition.

The moral reasoning behind the dichotomy between the historical and the imaginative realm is not limited to the impropriety of "aesthetic pleasure." A second rationalization—and one to which Adorno also objects—is found in the so-called redemptive function of art. According to a generally accepted conception, art and literature redeem us from our singularity and mortality. This redemptive function thus provides a religious dimension to the human manufacture of art. The artist or poet is, like God, able to create eternal objects; in the case of human creativity, the raw material is passing experience. From this perspective, the artist is a redeemer—a redeemer as Christ was.

Leo Bersani argues in *The Culture of Redemption* (1990), however, that this exalted conception of art and literature rests on a highly problematic conception of life and history. On the one hand, art redeems us from experiences of reality and history, which are apparently unbearable. On the other hand, this unbearableness is then presented as extremely frivolous. The horror of individual human experiences functions as ma-

terial for eternal artifacts. Thus that horror is ultimately subordinated to that which is of real importance: art.

This lofty conception of art and literature becomes controversial when art seeks to redeem us not from ordinary historical experiences, but from the horror of the Holocaust. The implication might, for instance, be that the Holocaust was meaningful because it gave rise to monumental works of art such as the poems of Paul Celan or Charlotte Salomon's autobiographical *Life or Theater?* Although the Holocaust is over, its monuments have eternal value. The Holocaust was not only apocalyptic, but it also yielded fruits, namely, works of art. Holocaust experiences have ennobled life. The so-called redemptive function of art, in other words, is improper in the case of the Holocaust precisely because it leads us not beyond, but away from the historical reality that must be imprinted on the memory in all its horror.

Here, though, two problems collide. Just as it is impossible to limit the function of literature or art to the production of aesthetic pleasure, it is equally impossible to define literature by its redemptive function alone. Adorno's statement about aesthetically (in the sense of pleasure) motivated transformations of reality is relevant in that it serves as a moral warning, an unassailable axiom in Holocaust studies—and rightly so. But sadly, the authority of this statement has hindered serious interest in Adorno's aesthetic theory, within which context his statement should be read. It is ironic that Adorno's aesthetic theory, which is devoted to opening up a reflexive and critical function for art and literature, receives no attention where it is most needed. Instead his statement on aesthetic transformation, which is but one aspect of his theory, has been used to reinforce a dichotomy that was already in place.

The Rhetoric of Fact

The high valuation of the practices and craft of the historian above those of the artist or literary writer has enormous ramifications for those whose creative work deals with the Holocaust. Documentary realism has become the mode of representation that novelists and artists must adopt if they are to persuade their audience of their moral integrity—that is, of their reliance on cognitive intentions and their rejection of aesthetic considerations. This prescript is so strong that it has paradoxically led to rhetorical uses of testimony in Holocaust art and literature. I want to consider in some depth this use of testimony as a trope. For what at first

sight seems to represent a prostration of art and literature before the historical treatment of the Holocaust, which in turn apparently bolsters the hierarchical opposition between the two kinds of discourse, might as easily suggest the reverse case: the rhetorical use of testimony or other historical modes *within* the realm of the imaginative can, in fact, imply an undermining or hollowing out *of the opposition.*

Within imaginative texts, testimony is often adopted rhetorically as a narrative strategy to convince the reader or viewer of the testimonial and factual authority of the fiction. This "rhetoric of fact," as Young has called it in *Writing and Rewriting the Holocaust*, can be found in D. M. Thomas's *The White Hotel* (1981), which is based in part on Kuznetsov's *Babi Yar: A Documentary Novel* (1967). As the subtitle of the source indicates, the "documentary" status of Kuznetsov's text is ambiguous: although a work of fiction, this novel relies on a testimonial source, namely, the memories of Dina Pronicheva, a survivor of Babi Yar.

Thomas's use of Kuznetsov's "documentary novel" for his own book caused a heated discussion in the pages of the *Times Literary Supplement*.[6] At first it seemed he was being blamed for plagiarism. Yet such a charge makes little sense, since Thomas acknowledged his source both in the text and in interviews. Nevertheless, Thomas sinned against another fundamental rule, one that applies only to those whose subject matter is the Holocaust. One indicts D. M. Thomas, in fact, for using historical material for aesthetic and imaginative ends. The scandalous event was the confusion, then the reversal, of the hierarchy between historical and imaginative discourse. A fictional narrative had been "stuffed" with the words of an actual witness, which were, therefore, abused. Thomas had thus created "a texture of fact, suffusing the surrounding text with the privilege and authority of witness."[7] The outcome of this hybrid narrative, partly historical and partly fictional, is what Roland Barthes has called a "reality effect." The text as a whole does not claim that what it represents was real; rather, it creates a *sense* that what it represents was real. It is precisely this difference between the real and the effect of the real that motivated James Young to distinguish between "fact" and the "rhetoric of fact."

This distinction provides an explanation for the indignant responses to Thomas's *The White Hotel.* The problem is not that he plagiarized another source; no, it is that as a novelist he is a maker of illusions, and in this capacity he has disrupted or disrespected the divide between discourses that give access to historical factuality and those that inspire the

imagination. That is an extremely delicate problem in the debates that to-
day shape Holocaust studies.

One could argue that Thomas was naive in his use of the rhetoric of
fact. He employs it, it seems, to convince the reader of the factual au-
thority of his fiction. Yet he has not thereby challenged the hierarchical
opposition of historical and imaginative discourse. Indeed, he seems to
deny any awareness that the dichotomy even exists. In contrast, the
rhetoric of fact is activated in an openly challenging way by Art Spiegel-
man in his two-volume comic strip series about the Holocaust, *Maus*
(1991). The cartoon medium is of course heavily invested with the
marker of fictionality and imaginativeness. Yet *Maus* is autobiographical.
It tells the dual story of the son (Spiegelman himself) and of the father's
survival of Auschwitz. The connotations of the medium are in tension
with the genre of the work, that is, autobiography or life history. Spiegel-
man himself indicates an awareness of this tension; whereas he intended,
he said, to write the "great American Comic Book Novel," recently he
has insisted that *Maus* be classified as "nonfiction."

The nonfictionality of *Maus* is affirmed by the way his father's memo-
ries are transmitted to us. In the narrative portion of the work, Art tapes
his father's story on a tape recorder. Spiegelman's images and texts suggest
that he has transcribed the testimony verbatim. Even his father's broken
English and Polish accent are reproduced. Spiegelman appears to have re-
spected the compulsion to use documentary realism, with the tape recorder
serving as a symbol of that style. However, his yielding to the reticence of
documentary realism is provocatively countered on the visual level, for he
has drawn the Jews as mice, the Germans as cats, and the Poles as pigs.
His imagination, in short, has gone wild. As Marianne Hirsch remarks, it
seems that in the aural realm Spiegelman seeks absolute unmediated au-
thenticity, while in the visual he chooses multiple mediations.[8]

The tension between medium and genre, and between visual and au-
ral, is intensified by the insertion of three photographs in *Maus*. There is
a photograph of Art and his mother in volume 1 of this cartoon creation,
and one of his deceased brother Richieu on the first page of volume 2.
The last page has a third photograph, of his father, Vladek Spiegelman,
in a starched camp uniform. A lot can be said about these family pictures
and the story they tell in the margins of the comic book narrative.
Rhetorically, the photograph operates at the same level as autobiography.
It is a "trope of witness," it persuades the viewer of its testimonial and
factual authority in ways that are unavailable to narrative.[9] In *Maus*, the

photographs tell the following: Art Spiegelman has not made up these characters; they really existed. The photograph of his father in camp uniform tells even more: he was in Auschwitz.

Maus, however, is the brilliant work it is not only because it makes use of this rhetoric of fact, but also because it foregrounds this rhetoric as an *effect*. According to the narrative, the photograph of Art's father was not taken in Auschwitz, but in a souvenir shop after Vladek was released from the death camp. Thus, as Marianne Hirsch argues in an article about the family pictures in *Maus* (1992–93), the photograph is documentary evidence (Vladek was in Auschwitz), but at the same time it isn't (the picture was taken in a souvenir shop). It may look like an authentic documentary photograph of the inmate, taken by the Nazis to satisfy their archival compulsions, but in fact it is merely and admittedly a simulation, the result of a dressing-up game.

This simulation does not reinforce the rhetoric of fact, but exposes it explicitly as a rhetorical effect. And it is precisely this self-conscious use of the rhetoric of fact that allows Spiegelman to open up new meanings, or possibilities, for the photographic genre, which traditionally is appropriated exclusively for documentary realist goals. According to Hirsch, the power of the photographs Spiegelman includes in *Maus* lies not in their ability to evoke memory, in the connection they establish between the present and the past, but in their status as fragments of a history we cannot take in. *Maus* thus represents what Hirsch calls "the aesthetic of the trauma fragment."

This term can be understood as follows. The two separate chronological levels that structure the narrative of *Maus*, the past and the present, are connected to each other in the act of testimony. Spiegelman's father testifies in the represented present to his past experience. "But," notes Hirsch, "once in a while, something breaks out of the rows of frames, or out of the frames themselves, upsetting and disturbing the structure of the entire work. The fragments that break out of the frames are details that function like Barthes's *punctum*; they have the power of the 'fetish' to signal and to disavow an essential loss."[10] This implies that the photographs are not functioning as connections to, or as proof of, the historical reality, but the other way around. A fragment of historical reality imposes itself but cannot be inserted in the narrative frames of the family history. Hence, the photographs do not establish a historical framework of factuality; rather, as isolated moments they signify the very impossibility of such a frame.

The photo taken in a souvenir shop is a master stroke. The incident testifies to a poignant contradiction on which I will dwell at more length in Chapter 2: both the need to remember and the impossibility of remembering events whose traumatic nature precludes the normal mnemotechnic process from taking place. Spiegelman's decision to include this particular photograph demonstrates his theoretical mastery as much as his artistic accomplishment. By this means the work undermines the distinction between historical and imaginative discourse so tenaciously held in place by many Holocaust specialists.

Framing Mimesis

The works of Art Spiegelman and D. M. Thomas both display evidence of the compulsion to employ documentary realism for representations of the Holocaust. This compulsion is paradoxical when seen from the perspective of art and literary history, because in the second half of the twentieth century realism has long been stripped of its nineteenth-century promise. In the words of Robert Scholes, "It is because reality itself cannot be recorded that realism is dead. All writing, all composition, is construction. We do not imitate the world, we construct versions of it. There is no mimesis, only poeisis. No recording, only construction."[11] Despite the "death of realism" generally, however, artists and writers dealing with the Holocaust have reactivated this old mode of representation, with all its "guarantees" of objectivity and transparency. In brief, documentary realism and testimony have become the favored genres because they are associated not with subjective interpretation, but with objective, distant presentation.

James Young has shown the paradoxical effects of neglecting or refusing the constructedness of realism for literary writers whose subject matter is the Holocaust:

Instead of highlighting this critical insight [of the constructedness of mimesis], the Holocaust has compelled writers to assume the role of witness to criminal events, actually rehabilitating the mimetic impulse in these writers rather than burying it altogether. Holocaust writers and critics have assumed that the more realistic a representation, the more adequate it becomes as testimonial evidence of outrageous events. And as witness became the aim of this writing, "documentary realism" has become the style by which to persuade readers of a work's testamentary character. For the survivor's witness to be credible, it must seem natural and unconstructed.[12]

The reinstatement of the mimetic impulse is connected to the tendency to distinguish between testimony and interpretation—a distinction that, as we have seen, is questionable at best. This separation leads in turn to a hierarchy of genres in which the Holocaust can be represented.

Not surprisingly, those genres that seem intrinsically based on the act of testimony are most highly valued. Best of all is the diary, because the writing of the diary all but coincides with the events of which testimony is given. The memoir ranks a good second in the hierarchy of genres. Although it was not written at the time of the event, and has therefore lost some of the diary's temporal connectedness, it is nevertheless direct in that it is told by someone who witnessed the events "in person." The fact that witness and narrator are identical provides trustworthiness and authenticity to the testimony.

Young, however, has argued that the distinction between the testimony of factual events and the constructedness of interpretation is highly problematic. Those who partook in or witnessed the events of the Holocaust did not at some later date suddenly come to a stage of interpretation of those events. The experience of the events is not "naked" or factual at all; it cannot, in fact, be separated from the act of interpretation.[13] In other words, the experience of history depends on cultural and narrative frames.

Such frames do not distort history; instead, they allow history to be experienced or witnessed. To illustrate the intricate dependency of history and interpretation, Young compares the themes, the language, the preoccupations, and the conclusions of the two most famous Holocaust diaries written by young people: Anne Frank's *Diary of a Young Girl* and Moshe Flinker's *Young Moshe's Diary*. Both diarists were Dutch and teenaged while in hiding; both eventually perished in the camps. But whereas Moshe Flinker was brought up in a religious and Zionist home, and wrote his diary in Hebrew, Anne Frank came from an assimilated family that was non-Zionist, and wrote in Dutch. This difference in cultural background apparently had a radical effect on how they experienced the history that they lived.

Anne Frank's diary reflects both the dark world around her and "her own compulsion to be—and therefore, it seems, to *see*—good: 'It's really a wonder that I haven't dropped all my ideals,' Anne writes two weeks before her capture, 'because they seem so absurd and impossible to carry out. Yet I keep them, because in spite of everything I still believe that people are really good at heart.'"[14] In the context of her assimilated world-

view, she does not seem to identify herself as part of a collective Jewish tragedy, but as a member of a human community. In contrast, from the start of his diary onward Moshe Flinker identifies as a self-conscious Zionist with all of Jewish history and politics. The fact that he writes in Hebrew reinforces his linguistic and ideological connectedness to the Jewish people. Young shows how Flinker sees the history of which he has become a part from the perspective of Jewish history, determined as it is by pogroms, exile, and persecution.

Although both young people wrote their diaries while hiding from Nazi persecution and both met the same end, they grasped the history in which they were victimized in radically different ways. In Young's words, "Where Anne might have seen beauty and hope in a fiery sunset, Moshe 'saw' only apocalypse. The 'vision' of events in these diaries depended on the languages, figures, and even religious training that ultimately framed these testimonies."[15] Young's point is that these frames were not imparted afterward, but were in place even while the events in question were happening. Not only are event and interpretation hard to disentangle, but, Young implies, the interpretive frames were themselves part of the course these events ultimately took. So the act of writing a diary, and the interpretive acts thereby implied, do not result so much in a layer of words (transparent or not) on top of the events, but rather, they become events themselves in the history to which they testify. As Young puts it, "The diarists' figures and narrative mythoi functioned as agents in their daily lives."[16]

This insight has radical consequences for the status we usually attribute to testimonial genres like the diary or the memoir. It is difficult to maintain that those narratives are plain documents of events, or that they constitute perfect *factuality*. Indeed, testimonial discourse documents not factuality, but the *actuality of writer and text*. From this perspective testimonial genres represent not just a mediation of history, but an active force in the history they relate.

The Figurativeness of Art and Literature

The argument presented in the previous section is mainly directed against the conviction that historical representations are somehow situated outside the realm of the imaginative. Such a conviction implies the possibility of a discourse that is transparent and that can transmit history in all its factuality. And this very specific assumption about the nature of historical discourse gives rise, in turn, to the dichotomy between historical and

imaginative discourse. Young argues the untenability of these related assumptions by showing imaginative aspects in the production and representation of history.

Those who have defended the split between documentary realism and imaginative discourse, however, have not focused on the "unimpeachable" qualities of documentary realism, but only on the precariously situated imaginative discourses of art and literature. As we have seen, this is usually done by means of a warning against the aesthetic pleasure to which the realm of the imaginative can give rise. I will now elaborate on several arguments that throw an unfavorable light on art and literature. This is necessary for my project because the works of contemporary art that I discuss in subsequent chapters challenge the split between historical and imaginative discourse in a variety of ways. I turn first, therefore, to Berel Lang's "The Representation of Evil: Ethical Content as Literary Form" from his 1990 book *Act and Idea in the Nazi Genocide*, in which he contrasts literature to the most highly valued mode of historical discourse: documentary realism. Although Lang discusses only literature, his remarks clearly have a bearing on other imaginative discourses, including visual art.

Compared to most other attempts to cast suspicion on art and literature, Lang's reflections are pertinent because of their careful and elaborate exposition. Lang relies not so much on the accuracy or unmediatedness of historical information to argue his case, but on the moral consequences of various discourses. All discourses, including literary ones, he points out, can be judged as moral acts because in one way or another they affect the reader. Hence, all discourses have a *moral meaning*, which is defined by their performative effects on the reader. This moral meaning is also linked to formal or literary features of a text, and to literary themes. This implies that the ethical judgment manufactured by a literary text depends on its formal features and themes.

This argument depends on the assumption that literary texts do possess formal features and themes that are specific to them. In this manner the literary text and the historical text are separated as essentially different discourses. This formal difference can explain, then, the paradoxical position of Holocaust literature. For in that literature historical concerns are more important than literary concerns. Holocaust literature, entrapped as it is in a competition with historical discourse, denies its literary nature. In Lang's words, "It is as though the writers here are impatient with history for not being 'historical' enough: they thus intend by

their 'fiction' to fill out the historical record—but for the sake of history, not of fiction."[17] It is here, in this mismatch between goal and means, that the dubious condition of imaginative Holocaust writings originates.

The noncorrespondence between imaginative means and historical goals leads, in this view, to moral friction. Literary discourse is assumed to be characterized by figuration, in which the subject of the Holocaust is personalized and stylized. Figuration allegedly implies that the subject could be represented in many different ways and thus that it has no necessary, and perhaps not even an actual, basis. "The figurative assertion of alternative possibilities, in other words, suggests a denial of limitation: *no* possibilities are excluded. And although for some literary subjects openness of this sort may be warranted or even desirable, for others it represents a falsification, morally *and* conceptually."[18]

A too limited view of figurative language underlies this condemnation of Holocaust literature. This view involves a specific notion of figuration, one that Jonathan Culler has called the "via rhetorica."[19] In this formulation a metaphor is considered a substitute for something that in fact could be stated literally, or it is something to which the literal expression is compared. The gain of the metaphorical substitution or comparison is stylistic: the figurative expression is aesthetically more pleasing, more condensed, or more lively.

This, however, is not the only way in which the Western philosophy of language has conceptualized figuration. The other major tradition, called by Culler the "via philosophica," explains metaphor by assuming the existence of situations that cannot be expressed literally. The situation or event is now *thought of as something else*. "This is the approach one generally takes when one wishes to emphasize the cognitive respectability of metaphor because one can argue that cognition itself is essentially a process of seeing something as something. Metaphor thus becomes an instance of general cognitive processes at their most creative or speculative."[20] The gain of this approach to figuration, in other words, is not stylistic but cognitive.

This approach implies the opposite of what Lang ascribes to and criticizes in figuration. For him a figurative expression suggests the possibility of an endless number of alternatives for the literal expression. The cognitive approach, however, sees the figurative expression as necessary. Because a literal expression is lacking, the figurative one is the only one that affords precision. Stylistically, figurative expressions can perhaps be exchanged for one another—everybody knows how subjective beauty is.

But from a cognitive point of view there is always a difference between figurative expressions that represent more or less the same situation or phenomenon, or between a figurative expression and the literal one. And it is exactly this difference that counts, because it alone conveys the precise nature of what is being expressed. This approach to figuration makes imaginative discourse not suspect, but absolutely necessary. Only figurative discourse allows expression of that which is unrepresentable in so-called literal, factual, historical language.

The hierarchical opposition between the historical and the imaginative is thus collapsed into another opposition, that between the literal and the figurative. Of course it is easy to argue that historical discourse is far from "literal," and many philosophers of history have done just that during the last twenty years by demonstrating the rhetorical nature of the writings of historians. Later in this chapter I will discuss what and how these metahistorians argue. My critique of the opposition follows for the moment, however, another route. Rejecting Lang's limited view of figurative expressions with regard to the Holocaust, I instead suggest that a cognitive appreciation of figuration is much more relevant and appropriate. The hierarchy of Lang's opposition between historical and imaginative must therefore be reversed. Figurative expressions are more *precise*; they are able to represent situations and experiences that cannot be conveyed by literal expressions.

But Lang activates yet another opposition to give more substantial content to the hierarchy between historical and imaginative discourse. Imaginative writing is assumed to represent human motivation and individual consciousness to a much greater extent than do other kinds of writing. This is explained, Lang states, by "the requirements of literature itself." The literary subject is "characteristically personal and emotive. . . . The discourse, in other words, is personalized; the writer obtrudes."[21] This characterization of imaginative discourse gives rise to the following opposition: personal, individualistic, subjective versus impersonal, distanced, objective.

In the context of the Holocaust, this opposition leads to an evaluation that, in Lang's formulation, depends on an essential characteristic of that event, namely, the denial of individual consciousness in the act of genocide. Accordingly, the representation of agency of an individual subject is misplaced in a consideration of the Holocaust, for it distorts the historical reality: "where impersonality and abstractness are essential features of the subject, as in the subject of the Nazi genocide, then a literary focus

on individuation and agency 'contradicts' itself."[22] The logic behind this condemnation of imaginative discourse is again that of documentary realism. Literature and other imaginative discourses, Lang believes, should be limited to one goal: to provide historical knowledge in a transparent, distanced manner. But in a bizarre gesture of collusion, to sustain this logic Lang conflates the perspective of the perpetrators with that of the victims of the Holocaust. Impersonality and abstractness indeed did characterize the Nazi genocide: it relied completely on a radical and total denial of individuality. But that does not mean that the victims experienced themselves as abstract or impersonal. However damaged their experiences of their subjectivity and their situation might have been, it is not the same thing to claim that they resolved their experiences in abstraction. Unwittingly, this argument risks yielding to the pressure of Nazi ideology.

The realist position can be countered in yet other ways. To give a voice to personal, emotive experiences is not necessarily characteristic of imaginative discourses. Lang has a strictly romantic view of art and literature; he denies the existence of the many artistic and literary traditions that have overcome a romantic obsession with personal emotions. At the same time, he denies the existence of practices in the historical discipline that pursue the articulation of individual experiences and perspectives. *Alltagsgeschichte* (the history of everyday life), which tries to reconstruct the mundane experiences of ordinary people, is one example. (I will return to this relatively new approach in historical research later in this chapter.) In Holocaust studies, perhaps the most important attempt to reinstate individual subjectivity within history is one initiated at Yale University, the Fortunoff Video Archive for Holocaust Testimonies. One purpose of this project is to collect and reconstruct historical information by recording the testimonies of survivors of the Nazi genocide. Even more important, however, the project manages to counter the effects of the Holocaust on its survivors by reversing the defining features of that tragedy. Whereas the perpetrators of the Nazi genocide treated their victims as impersonal and abstract, this archive for Holocaust testimonies does the opposite: it reintegrates the testifiers into a situation of interrelatedness. By providing them with a listener, it reestablishes their individuality.

History as a Textual Problem

The opposition between historical and imaginative discourse has had serious consequences for artists and literary writers in terms of the rhetoric

of fact they are compelled to adopt. Yet this rhetoric, as we have seen, is in fact empty: not only are the main genres of historical realism far from immediate and transparent, being contingent on the ideological beliefs of the narrator; in addition, the rigid distinction between the historical and the imaginative derives from extremely limited and often dated views of the practice of historical research and of the world of art and literature. In what follows I will describe how the Holocaust as an event has challenged poststructuralist reflections on representation and history, reflections that have questioned the relations between history and historical narrative, between text and context. Subsequently, I will show how the *history*, or interpretation, of the Holocaust has been put forward either as a challenge to those reflections, or as the case that proves the point or fruitfulness of positions that are for many too radical, relativistic, or nihilistic.

As is well known by now, theorists of history like Hayden White, Frank Ankersmit, Hans Kellner, Stephen Bann, and Dominick LaCapra have challenged the truth claims of traditional history writing, arguing that our versions of historical reality are in part determined by conventional mechanisms of textual construction.[23] Kellner, for example, describes the postmodern philosophy of history as an attempt "to challenge the ideology of truth." Historians do not "find" or "discover" the truth of past events; rather, they select events from an uninterrupted stream and invent meanings that create patterns within that stream.

What is continuous is not so much reality, or the form in which reality exists (as artefact) in its obvious discontinuity, but the form in which our culture represents reality. Continuity is embodied in the mythic path of narrative, which "explains" by its very sequential course, even when it merely reports. A strong working suspicion arises that the intuition of historical continuity has less to do with either documentary fullness or personal consciousness than it has with the nature of narrative understanding.[24]

In our culture, history is strongly believed to be a continuum, consisting of a succession of events, while narrativity is a transparent medium serving to represent segments of that continuum realistically. The aforementioned theorists of history, however, argue that the narrative text is in fact a highly specific discourse, the use of which has consequences for its understanding and content. That discourse, in other words, imposes a particular form and meaning on history. These theorists have attempted to persuade their colleagues that hitherto central notions like totality, unity, and coherence are not of the essence of historical reality, but effects of the historians' narrative representation.

This critique has often been taken as a denial of the very existence of a historical reality. But obviously these poststructuralist thinkers do not deny the reality of events like the French Revolution or the Holocaust. As soon as we begin to talk about these events, though, we inevitably attribute meanings to them; we establish relations between events that have preceded them and events that followed. The problem is not that historical reality does not exist; rather, it is that our talking about it does not make it present but, on the contrary, causes it to recede behind the rhetorical and narrative effects of our discourse. Relations between events, beginnings and endings, causal correspondences, the systematic opposition of friend and foe, are not so much present in historical reality but are imposed or shaped by narrative structure, or by stylistic devices like metaphor, metonymy, synecdoche, and irony—devices that are part and parcel of the historian's discourse.

The emphasis on the constitutive effect of narrative discourse brackets the factual, definite status of historical reality. As long as we speak about relatively insignificant events like, say, the coming and going of government administrations, this view that history is shaped by narrative is not especially revealing or challenging. But what does such a view mean for the Holocaust? It is difficult to validate the strength of the poststructuralist view in the case of events that are, in their undeniability, symptomatic for history. Negative responses to scholars like White and Ankersmit always invoke calamitous events like the French Revolution, the Second World War, or the Holocaust. The simplistic nature of these responses, and the lack of understanding they reveal, is tersely verbalized in Graham Swift's 1983 novel *Waterland*. The book's main character is a history teacher, Tom Crick, and he has the following conversation with a student, Price:

> "So where does it lie, this revolution? Is it merely a term of convenience? Does it really lie in some impenetrable mesh of circumstances too complex for definition? It's a curious thing, Price, but the more you try to dissect events, the more you lose hold of them—the more they seem to have occurred largely in people's imagination . . . "
> Teacher pauses. Price's response to all this suddenly seems important.
> He hesitates a moment. Then, boldly, almost insolently: "Should we be writing this down, sir? The French Revolution never really happened. It only happened in the imagination."[25]

The student, of course, like so many historians, is misinterpreting his teacher's position; for him, there are only two possibilities: positive truth and pure fiction.

In terms of the present discussion, one thing is absolutely clear: the recently revived interest in the Holocaust in no way suggests that the Holocaust "only happened in the imagination." On the contrary, the revisionist debate in the 1980's among German historiographers is an almost constantly negative point of reference in the texts of poststructuralist thinkers—a practice that must be fought by analyzing its strategies.[26] The revisionist position that has tried to displace attention from the Holocaust, sometimes even by denying its historical factuality, does not dismiss, but rather reinforces, the need to complicate the view that history is, somehow, textual.

Disciplines and the Way They Structure Understanding of the Holocaust

In *Reflections of Nazism* ([1982] 1993a), Saul Friedlander suggests that disciplines as such form frames that determine the understanding of the Holocaust. He argues that systematic historical research, which uncovers facts in their most precise interconnection, provides little understanding of the Holocaust. Instead it protects us from that past and keeps it at a distance. He holds the language of the historian responsible for that effect. The distance is caused by the attitude the reader is encouraged to adopt by the historian's language. It is the attitude of the expert, responsible for checking the accuracy of the facts and the connections between them: "That [attitude] neutralizes the whole discussion and suddenly places each one of us, before we have had time to take hold of ourselves, in a situation not unrelated to the detached position of an administrator of extermination. Interest is fixed on an administrative process, an activity of building and transportation, words used for record keeping. And that's all." For the historian, Friedlander indicates, there is no way out: "The historian cannot work in any other way, and historical studies have to be pursued along the accepted lines. The events described are what is unusual, not the historian's work. We have reached the limits of our means of expression. Others we do not possess."[27]

I would then pose the following question: Could art and literature, rather than the discipline of history, provide the means to represent the unusual, unique, incomparable nature of the Holocaust? In a 1992 volume edited by Friedlander, *Probing the Limits of Representation: Nazism and the "Final Solution,"* historians such as White and Friedlander declare that for the Holocaust we need "a new rhetorical mode," and they

look to literature and the other arts as possible options. Friedlander points out that much contemporary literature on the Holocaust, for example the novels of Aharon Appelfeld and David Grossman, consists of a mixture of allegory and realism. Yet realistic elements are necessary as well to avoid too much allegorical distance, which might result in a total disjunction. Hence, the function of realistic elements within allegorical representations of the Holocaust is fundamentally different from their function in other literature. "A common denominator appears: the exclusion of straight, documentary realism, but the use of some sort of *allusive or distanced realism*. Reality is there, in its starkness, but perceived through a filter: that of memory (distance in time), that of spatial displacement, that of some sort of narrative margin which leaves the unsayable unsaid."[28]

Walter Abish's 1979 novel *How German Is It* offers an example of "distanced realism," this hybrid of allegory and realism. In fact, this novel is not at all "about" the Holocaust or about our ways of remembering it; nevertheless, it has repercussions for these issues. The book employs a realist setting and plausible characters. The descriptive tone appeals to routine understanding, and the represented world holds no surprises. The frequent use of words like *clearly*, *certainly*, and *undoubtedly* makes sense within this illusory realism. The theme of the novel can be characterized as a realistic depiction of the former West Germany in the 1970's.

In an illuminating interpretation of Abish's novel, Maarten van Delden (1990) has pointed out that the novel, despite its apparent realism, contains at the same time other elements that counter such a reading. For example, it has no clear plot. Time and again characters are introduced without explanation or motivation. Puns and word games determine the course of action. For example, the words *German painting* initiate a scene in which the father-in-law of one of the characters, a building painter, arrives to paint the house of his son-in-law. Thus, van Delden argues, the story is no longer a realist representation of Germany but an artificial construction based on language. This role of construction is allegorically represented by the city in which the novel is largely set, Brumholdstein, which was built after the war on the site of the concentration camp Durst. This situation can be read as reflecting the repression of Germany's past. The cause of this repression is in turn located in the stories we tell. Linguistic constructions help us to tame the unfamiliarity of the world, to come to terms with the past. For, as the character Anna in Abish's novel says, "when something becomes terribly familiar we stop seeing it."

Yet the novel also explains allegorically that the past cannot be so easily repressed by linguistic constructions. During construction works in Brumholdstein, a mass grave of camp Durst happens to come to light. This discovery does not in itself restore the meaning or continuity of history. What does happen is that the *force* of history, the need to understand it, imposes itself against all odds; but this need is, after all, also unknowable, because unrepresentable. Abish's novel suggests that the Holocaust cannot be represented, or made familiar, in the form of a complete narrative. But it also suggests that the Holocaust can be known negatively, in the cracks and tears of the stories we tell.

Abish's novel is one of many examples of postmodern war literature that point to the limitations of a mimetic, realistic representation of the Holocaust. Such a representation is not only impossible but also undesirable: it threatens to make this history familiar. Yet this caution does not imply that the Holocaust cannot or should not be represented. Rather, there is a need to explore and develop manners and means of representation that preserve contact with this extreme history; means that continue to transmit knowledge of it, that simultaneously prevent forgetting *and* making familiar. Because the mimetic, referential quality of language cannot come close to the reality of the Holocaust, the historical truth in need of representation seems to exceed comprehension. That is why so many scholars in the contemporary debate call for the development of "a new rhetorical mode." Through such a mode the Holocaust can, perhaps, be framed in such a way as to avoid the pitfalls of the traditional emplotments.

The work of the postmodern Dutch artist and writer Armando provides an illuminating example of an exploration of such a new mode. Chapters 5 and 7 of this book are devoted to his intricately obsessional relation to the Holocaust. This artist puts the war at the center of his work, but in such a way that practically all historical and geographical markers remain unclear. Through a violent strategy of "annexation and isolation" he represents a history without narrative plot, without beginning, development, or end, without a clear distribution of roles. History is portrayed not as a sequence of events but in terms of isolated and repeated moments or situations. His work is paradoxically antinarrative, actively fighting against the meaningful continuity produced by emplotment. This is so because the mechanisms of narration constitute a coherence, a sense of development and continuity, that is radically alien to the "reality" of history.

World War II and the Holocaust are recurring themes, not only in the humanities but also in postmodern art and literature. This is so because the historical situation of crisis is imagined as apocalyptic: the ideals of the Enlightenment and modernity were unable to prevent the barbaric excesses of the Second World War and, indeed, are read by some as having validated them. This "bankruptcy of modernity" therefore *necessitates* postmodernism. But an artist like Armando demonstrates a connection between postmodernism and World War II of an entirely different kind. He exemplifies the postmodern approach as a rethinking of the relation between representation and reality—one that relies on emphatic, not mimetic, means—and an attempt at proposing new possibilities for that relation. Such an alternative is acutely necessary for the representation of this specific historical happening.

As will be shown in Chapter 5, whereas mimetic war literature is structured on the model of memory, Armando's work is best understood through the model of trauma. This distinction is based on the insight that memory is structurally different from trauma.[29] Memories are representations of the past. According to research in cognitive psychology, memories have a narrative structure and contribute to the formation of identity, both individually and collectively. Memories, including painful ones, thus have a constructive effect. Traumas are very different, both structurally and in effect. A traumatic event cannot be fully experienced at the moment it happens; as a consequence, it cannot be remembered. Only in repetition, after the fact, can a trauma become an experienced event. Whereas a memory is clearly distinct from the event being remembered— it is the memory *of* something—in the case of trauma, reality and representation are inseparable. There is no distinction: the representation *is* the event.

The examples of Abish and Armando both show that imaginative discourse can be clearly and seriously historical in nature. Thus, it no longer makes sense to sustain the rigid dichotomy between historical and imaginative discourse. This does not mean, however, that we should conflate the two discourses as one and the same. For as the two examples also show, the *manner in which* these discourses relate to historical reality can be very different.

As I mentioned above, Friedlander has argued that the work of the historian must be pursued along accepted lines. Yet the discipline of history is quite powerless in the face of many aspects that define the Holocaust as a historical reality. In particular, the mediated transposition of history

into distanced representation, and the model of memory on which that representation is based, offer limited possibilities. The model of memory is, to be sure, indispensable owing to the sheer need to know and to re- member what has happened; however, it falls short as a means of dealing with some of the Holocaust's most essential features.

History brings with it more responsibilities than only knowing and re- membering the facts, especially when that history concerns the Holocaust. Other responsibilities that are poignantly imposed on us involve the working through of the traumatic intrusion of an unimaginable reality, and the foregrounding of the cracks and tears that are concealed by the coherence of the stories being told. It is in relation to those responsibilities that the imaginative discourses of art and literature can step in and per- form functions that, though historical, cannot be fulfilled by the work of the historian.

The Seduction of Directness

Testimonies and the Limits of Representation

I am other. I speak and my voice sounds like something other than a voice. My words come from outside of me. I speak and what I say is not said by me. My words must travel along a narrow path from which they must not stray for fear of reaching spheres where they'd become incomprehensible. Words do not necessarily have the same meaning. You must hear them say, "I almost fell. I got scared." Do they know what fear is? Or "I'm hungry. I must have a chocolate bar in my handbag." They say, I'm frightened, I'm hungry, I'm cold, I'm thirsty, I'm in pain, as though these words were weightless.

—Charlotte Delbo, *Auschwitz and After*

The privileging of historical discourse on the Holocaust is motivated by one other issue that cannot be understood in terms of a too limited, too ideological conception of either the historical or the imaginative. The past of the Holocaust brings with it a general semiotic problem that confronts not so much the historians of the Holocaust or artists and writers, but the survivors. These individuals often share a basic incapacity to express or narrate their past experiences. This semiotic problem underlies the widespread conviction that the Holocaust, in all its uniqueness and extremity, is unrepresentable. This unrepresentability has no moral significance, in the sense that it is dangerous or reprehensible to represent it; rather, its representation

is technically impossible. The problem of this silence as I will discuss it here is therefore fundamentally *semiotic* in nature, not *ethical*.[1]

Given this essential semiotic problem, a historical approach to the Holocaust appears to be the least inadequate. Historical discourse is then seen as more basic, as more closely reflecting experiences that cannot be reached or expressed. From this perspective, the imaginative discourses of art and language are seen as secondary; that is, they can only work upon the historical discourse, which is primary.

In this chapter I am especially interested in defining the cause of this unrepresentability of the Holocaust. Does it stem from some intrinsic restriction or limitation of language, or from the extremity of the events that make up Holocaust experiences? In the latter case, it would legitimate or justify a privileging of the historical approach to the Holocaust, the expressed task of which is to make the past present. But if the problem originates in a technical discursive limitation, the realm of the imaginative might be a solution instead of a liability, and even provide some privileged access, as it pursues its role of creatively challenging the symbolic order.

Yet I have not stated these alternatives quite right. Shifting the issue, I will argue that it is neither language nor the events or history of the Holocaust as such that causes the unrepresentability of Holocaust experiences. Rather, at issue is the fact that language *as a function of history*, that is, as a precondition for experiencing history, was disrupted during the Holocaust. To understand this we need to focus on, and perhaps redefine, the notion of experience.

Semiotic Incapacity

The standard view has it that within the symbolic domain representations of the Holocaust are a case apart because of the inadequacy of mimetic symbolic language and because the historical reality to be represented is beyond comprehension. Given the intrinsic limitations of language in this arena, proponents of this view argue, it makes no sense to develop new forms of representation, or, as Hayden White and Saul Friedlander propose, "a new rhetorical mode."

An illustrative example of this view can be found in S. Dresden's 1991 book on Holocaust literature, *Vervolging, vernietiging, literatuur* (Persecution, annihilation, literature). He also expressed the same view in an earlier essay, "Souvenir inoubliable" ([1963] 1992). Here Dresden discusses the nature of war and Holocaust memories:

The memories have the same structure as always, although their content is totally different. They are fixed, one can talk about them, they have been verbalized by many. Hunger, winter, executions, persecutions, camps, gassings—these seem now, in terms of structure, more or less like the impressions a tourist might have. But only more or less. For their content is such that they hinder and make impossible a total verbalization.[2]

The extreme horror of the historical reality causes language to fall short. Quantitative notions that describe the extent of the historical reality are used by way of explanation. The semiotic problem, then, is caused by a feature of the object of representation. The means of representation remains undiscussed. The cause of the Holocaust's unrepresentability is examined not on the level of representation, but on the level of history. Dresden is explicit in this regard. When he says that Holocaust memories have the same structure as all memories, he locates the problem of representation completely in the *object* of representation, the content of experience—history as an exterior reality outside the realm of representation.

A side effect of this view is that the Holocaust assumes metaphysical dimensions: it becomes the absolute symbol of Evil, and hence is as unrepresentable as Yahweh. Such a metaphysical status is undesirable and even dangerous because it ultimately makes it impossible to see the Holocaust as a moment, albeit apocalyptic, *in human history*. It thus becomes extremely difficult to raise the question of causes or responsibility for it. In the words of Joan Ringelheim, "The Holocaust is . . . seen as ontologically separate from human history; at the same time, it is used to make 'relatively trivial' other events or other people's experience prior to, during, or even after the Holocaust."[3]

In the following pages I will argue that the problems with which representations of the Holocaust struggle are actually better located in the process and mechanisms of representation itself. In so doing I by no means want to relativize the extremity of the Holocaust as a historical event. I presume, however, that in principle representation does offer the possibility of giving expression to extreme experiences. Even so, it must be remembered that representation itself is historically variable. Sometimes there are situations or events—of which the Holocaust is prototypical—which occasion experiences that cannot be expressed in the terms satisfied by language or, more broadly, the symbolic order *at that moment*. I therefore want to stress the fact that for me representation is not a static, timeless phenomenon, of which the (im)possibilities are fixed once and forever. For every language user, representation is a his-

torically and culturally specific phenomenon. Languages, whether literary/artistic or not, are changeable and transformable. This assumption suggests that to answer the question of the causes of the unrepresentability of the Holocaust, it is best to focus not on the limits of language or representation as such, but on the features of the forms of representation available to Holocaust victims/survivors to articulate their stories. The difficulty survivors of the Holocaust have in expressing their experiences can be explained by the fact that the nature of their experiences is in no way covered by the terms and positions the symbolic order offers them. It is exactly this discrepancy, therefore, that must be investigated. The problem, in short, is not the nature of the event, or any intrinsic limitation of representation per se, but the split between the living of an event and the availability of forms of representation with which the event can be (re)experienced.

So far, I have used the notions of "experience" and "the expression or representation of an experience" as if they involved two separate moments. First we experience something, then we try to find an expression for that experience. Such a conception would seem to suggest that experiences are not discursive, that they arise without connection to the symbolic order. The experience of an event or history is, however, dependent on the terms the symbolic order offers. It needs these terms if *living through* the event is to be transformed into an *experience of* the event. For to be part of an event or of a history as an object of its happening is not the same as experiencing it as a subject. The notion of experience, in other words, already implies a certain distance from the event. Hence the experience of an event is already a representation; it is not the event itself.

I contend that the problem Holocaust survivors encounter is precisely that the lived events could not be experienced because language did not provide the terms with which to experience them. This unrepresentability defines those events as *traumatic*. The Holocaust has had a traumatic impact for many because it could not be experienced, because a distance from it in language or representation was not possible. If experience is the result or product of a discursive process, in the case of the Holocaust this discursive process has been stalled: consequently, the experience cannot come about.

I would argue, in fact, that the problem of the unrepresentability of the Holocaust arose *during* the Holocaust itself, and not afterward when survivors tried to provide testimonies of it, whether literary/artistic or otherwise. To put it differently, the later representational problems are a

continuation of the impossibility during the event itself to experience the Holocaust in the terms of the symbolic order then available.

Lawrence Langer's 1991 study *Holocaust Testimonies: The Ruins of Memory* offers many examples of this stalling of the discursive process of experience. Langer discusses the statements of Holocaust survivors that were recorded on videotape by the Fortunoff Video Archive for Holocaust Testimonies at Yale University. He shows how the problems these survivors have in their self-experience are closely bound up with the forms they use to remember the Holocaust.

In what follows I will use Langer's findings to explore more concretely the representational problems that arise in efforts to experience the Holocaust. Langer's goal is to document the forms of memory the Holocaust has engendered, and how the "self" of survivors is determined in a fundamental way by these forms of memory. He distinguishes five different forms of memory, together with five associated personality structures: "deep memory" (the buried self), "anguished memory" (the divided self), "humiliated memory" (the besieged self), "tainted memory" (the impromptu self), and "unheroic memory" (the diminished self).[4]

I am interested here not so much in the relation between memory and self, but in the discursive basis of the unrepresentability of Holocaust experiences. Therefore, the distinctions I will make concern the various obstacles that can stand in the way of experience and representation. In particular, I identify four basic representational problems, two of which concern the survivor's position as subject and two of which concern the narrative frames used to tell about the Holocaust. Each problem involves a discrepancy between the reality of the Holocaust and the positions and terms the symbolic order provided to experience this reality. The four problems can be summarized as follows: (1) ambiguous actantial position: one is neither subject nor object of the events, *or* one is both at the same time; (2) total negation of any actantial position or subjectivity; (3) lack of a plot or narrative frame by means of which the events can be given meaningful coherence; (4) the plots or narrative frames that are available (or are inflicted) are unacceptable because they do not do justice to one's role in the events.

Ambiguous Subjectivity: Between Responsibility and Victimhood

In his chapter "Anguished Memory" Langer discusses the testimonies of survivors whose selves are "split" as a result of what happened to them in

the camps. One informant describes this mechanism at follows: "I'm thinking of it now . . . how I split myself. That it wasn't *me* there. It was somebody else" (48). In some of the testimonies the causes for this bifurcation of the self become evident. Bessie K., for example, was a young woman with a baby in the Kovno ghetto in 1942. She found herself in a situation in which laborers were being selected. Because children were not admitted to the work force (and were killed immediately), she hid her baby in her coat as if it were a bundle of possessions. When the baby began to cry, it was taken by the German soldiers. Until 1979 she was never able to tell anybody about the loss of her baby—in part, as her testimony makes clear, because of the limitations of the language available to her. She remembers the dramatic event thus: "I wasn't even alive; I wasn't even alive. I don't know if it was by my own doing, or it was done, or how, but I wasn't there. But yet I survived" (49). The language fails to let her experience a position where subjectivity and objecthood are ambiguous. Should she bear responsibility for the loss of her baby, or was she a victim of the situation? If she had not hidden her baby in the bundle of clothes, would she not have lost it anyway? She does not know what her role as an actor was. Was she the subject, which means that she had an active role in the loss of her baby; or was she merely the object, a passive victim of the event?

Bessie K.'s bewilderment stems from the fact that she does not know how to answer this question. Another example is the French resistance fighter Pierre T. After his resistance group had killed a Nazi officer, the Nazis executed twenty-seven people of his village in reprisal. His doubts concern the role he had in the execution of his fellow villagers. Is he co-responsible for it, or is he likewise a victim?

In the testimony of Alex H., a slightly different sort of bewilderment is manifested:

It is difficult to say, talk about feelings. First of all, we were reduced to such an animal level that actually now that I remember those things, I feel more horrible than I felt at the time. We were in such a state that all that mattered is to remain alive. Even about your own brother or the closest, one did not think. I don't know how other people felt . . . It bothers me very much if I was the only one that felt that way, or is it normal in such circumstances to be that way? I feel now sometimes, did I do my best or didn't I do something that I should have done? But at that time I wanted to survive myself, and maybe I did not give my greatest efforts to do certain things, or I missed to do certain things. (65–66)

In actantial terms, we can say that Alex H. is not sure if he has been enough of a subject. Did he make enough of an effort to help others?

While Bessie K. is afraid that she might have had too active an actantial role—but she is not sure—Alex H. does not know if he has had enough of one. In both cases, this uncertainty results in an ambiguous, battered feeling of subjectivity. The individuals in question feel themselves neither subject nor object.

Earlier I argued that experiences, hence also self-experiences, can be seen as discursive processes. But what do the battered feelings of subjectivity experienced by Bessie K., Alex H., and Pierre T., and their difficulties in talking about what happened to them, have to do with language? In what sense precisely are forms of representation at least partly the cause of these people's confusion?

As we have seen, Hayden White has argued the necessity for a new kind of language, "a new rhetorical mode," to allow discourse about the Holocaust. The reasoning behind his argument helps me to analyze the expressive problems of survivors like Bessie K. and Alex H. as being of a discursive nature. White further proposes a mode of expression called the "middle voice," which would allow a different subject position in relation to the event.[5] Although both the active and the passive modes situate the agent outside the action as such—that is, the agent is either subject or object of it—the middle voice situates the agent inside the action. The agent takes part in, is affected by, the action or event without being either subject or object of it.

It is hard for me to imagine how we can develop a new rhetorical mode on this basis. Nevertheless, White's proposal contains an adequate analysis of the expressive problems of Holocaust survivors. They have difficulty experiencing the events they were part of because the language at their disposal offered them only two possibilities: to take the role of either subject or object in relation to the events. But the actuality of the Holocaust was such that this distance from the action was not possible; there were no unambiguous roles of subject or object. This is one reason the Holocaust was not "experienceable" and hence, later, not narratable or otherwise representable.

Denied Subjectivity: About "Nothing"

Holocaust survivors Bessie K., Alex H., and Pierre T. had trouble determining the role they played in the events they ended up in: subject or object? Although their actantial role was experienced as fundamentally ambiguous, their subjectivity as such remained intact. I will now discuss the

consequences for representation of situations in which the subjectivity of the inmates of the camps was reduced to "nothing." Here the survivors did not even experience their role/part as that of an object. Their existence as human beings was totally denied.

In Western culture the individual subject is held responsible for his or her own acts and, hence, destiny to an important degree. It is precisely this sense of individual responsibility that allows one to form one's own subjectivity by means of consciously chosen behavior. When one does not make any conscious choices, one is in fact not 100 percent a subject. This view of subjectivity has great implications for those who had to live in the camps. These people had to endure situations that would normally, in the society from which they came, require that one take action and assert oneself. When a family member, a friend, or even a total stranger is mistreated or killed, one is supposed to interfere. The failure to do so corrodes one's subjectivity. In the camps, however, inmates were unable to interfere, even though the situation demanded it. This inability to act had consequences not so much for those who were being abused or killed (the violence would happen anyway), but for those who had to watch it.

These consequences derive from the close link that obtains between subjectivity and ethical norms. As Langer puts it:

The concept of "you cannot do nothing" [sic] is so alien to the self-reliant Western mind (dominated by the idea of the individual as agent of his fate) that its centrality, its blameless centrality to the camp experience continues to leave one morally disoriented. The very principle of blameless inaction by former victims is foreign to the ethical premises of our culture, where we sometimes confuse such inaction with cowardice, or indifference. (85)

The most extreme consequence of this impossibility to act is not even a feeling of impotence but, much more radically, one of apathy. One is forced to recant the concept of subjectivity that associates passive looking on with morally weak or immature subjectivity. In order not to be disqualified as a full subject, the only solution was to abandon the concept of subjectivity on which such a disqualification rested.

The morally based rejection of subjectivity is clearly the issue in the testimony of Joan B. She worked in the kitchen of a labor camp. When one of the inmates was about to birth, the camp commandant gave the order to boil water. "'Boil water. But the water wasn't to help with the act of giving birth. He drowned the newborn baby in the boiling water.' The appalled interviewer asks, 'Did you see that?' 'Oh, yes, I did,' the

witness imperturbably replies. 'Did you say anything?' the dialogue continues. 'No, I didn't.'" Later Joan B. offers the following comment: "I had a friend . . . who said that now when we are here, you have to look straight ahead as if we have [blinders] on like a race horse ... and become selfish. I just lived, looked, but I didn't feel a thing. I became selfish. That's number one" (123). Langer remarks rightly that in the camp situation "selfish" no longer meant being ungenerously indifferent toward others. Selfish must be read as "self-ish": in order to survive, all human norms and values must be ignored. This necessary and purposeful ignoring and abjuring of a system of values kills subjectivity at the very moment one opts for life.

In the 1950's and 1960's situations such as this were presented as involving unavoidable existential choices that exemplify life, the human condition, in general. The testimonies Langer discusses make clear, however, that this is a highly romanticized view, because there were in fact no choices to be made. The situation was defined by the *lack* of choice. One had no option but to follow humiliating impulses that killed one's subjectivity but safeguarded one's life. Langer puts it this way: "It is indeed a kind of annihilation, a totally paradoxical killing of the self by the self in order to keep the self alive" (131). Yet subjectivity is not a fixed, universal category, but a social construction. This raises the question whether this corroding of subjectivity was equally annihilating for everyone involved. Myrna Goldenberg's argument in her article "Different Horrors, Same Hell: Women Remembering the Holocaust" that the camp situation was less immediately deadly for many women than for most of the men can be understood from this perspective. In Western patriarchal society masculine subjectivity depends much more thoroughly on the construction of an independent, initiating subjectivity. When subjectivity must be rejected, masculinity is impaired in its very essence.

This gender difference in constructions of subjectivity can even be used to explain why men died much sooner in the camps than women. Although life in the camps was usually much harder for women than for men—adult men were treated relatively better because they were more useful in the labor camps—in 1943, for example, three times as many men as women died in Ravensbrück. Goldenberg suggests that men were less adept than women in "killing the self in order to survive." Women could more easily renounce their subjectivity because in the cultures they came from their independence and subjective strength had been limited anyway, "and being less dependent on inflated egos, as men were, when

these egos cracked and were swept away, women recovered faster and with less bitterness."[6] This view confirms the constructedness of subjectivity as much as its crucial importance in the possibility to experience.

Thus far I have described the mechanism of survival that forced inmates to kill the self in order to keep the self alive. But how does this mechanism apply to the unrepresentability of the Holocaust experience? Recall that it is not so much the content of the experience that causes the problem, but the fact that the capacity to narrate is lacking. When one had to kill the self, one is no longer able to tell. One lives on, but the voice has been struck dumb. In Charlotte Delbo's words, "I died in Auschwitz, but no one knows it."[7]

The lack of a voice is clearly expressed in the testimony of Joan B. quoted above. In the literal sense, Joan B. has recovered her subjectivity and voice, for she does testify of her camp experiences. The way she does this, however, reveals no hint of her subjectivity at all. She records the factual events without concern or compassion, reporting the event almost mechanically. Pay attention to her language: "'He drowned the newborn baby in the boiling water.' The appalled interviewer asks, 'Did you see that?' 'Oh, yes, I did,' the witness imperturbably replies. 'Did you say anything?' the dialogue continues. 'No, I didn't.'" Although Joan B. speaks (again), she speaks with a minimum of expression, as if disavowing subjectivity. Or to put it more pointedly: it is not Joan B. who is speaking, it is just her mouth. On a literal, superficial level, Joan B.'s testimony undermines the conviction that Holocaust experiences cannot be represented. After all, narration is occurring. But in actuality this testimony makes it clear why so many Holocaust survivors are unable to tell about the events of which they were a part. Although they survived, their selves were killed in the camps. A killed self has no experiences, much less narratable memories.

The Holocaust as Narrative Vacuum

Events never stand on their own. We do not experience events as isolated happenings, nor can happenings be experienced in isolation. Events always have a prehistory, and they are themselves the prehistory of events that are still going to happen. I don't want to suggest that this continuity is present in reality. Reality is, rather, a discontinuous chaos. However, we experience and represent events in such a way—generally speaking, in terms of a narrative framework—as to make a continuous sequence

out of those events. This allows them to be understood as meaningful. When somebody has passed a final exam, for example, the meaning of this event is derived from an anticipation of events that are expected to follow: further study, jobs, a career. When somebody dies, it is a dreadful event precisely because all expectation of coming events is now closed off. Death gets its negative meaning from this lack of a narrative framework that makes it possible to anticipate future events.

In describing this issue of narrative, I have used the term *framework* instead of *context*. During the last decade or so there has been an important discussion about the status of "context" in those disciplines of which history is an element. Is context a factual given that can be reconstructed, or is it the product of interpretive acts? Let me now give some attention to this discussion, for it puts the difficulties of narrating Holocaust experiences in a certain perspective, one that decisively changes the parameters of the issue of the Holocaust's (un)representability.

Jonathan Culler has phrased the problem clearly. Whereas the term *context* contains the noun *text*, the prefix cuts it fundamentally off. "Context" therefore appears to escape the need for interpretation; this, however, is an illusion:

The notion of context frequently oversimplifies rather than enriches the discussion, since the opposition between an act and its context seems to presume that the context is given and determines the meaning of the act. We know, of course, that things are not that simple: context is not given but produced; what belongs to a context is determined by interpretative strategies; contexts are just as much in need of elucidation as events; and the meaning of a context is determined by events. Yet, whenever we use the term *context* we slip back in the simple model it proposes.[8]

In other words, context is itself a text consisting of signs in need of interpretation. The allegedly positive knowledge yielded by history is itself a product of interpretive choices.

Expanding on Derrida's statement that "no meaning can be determined out of context, but no context permits saturation," Culler affirms: "Meaning is context bound, but context is boundless."[9] This textualization of context is no reason to set the relationship between text and context aside as too open, too ambiguous, or too arbitrary. On the contrary, its greater complexity becomes the focus of keen interest. When context is conceived as not a causal chain of single events but as the product of a textual process, contextual "facts" become signs—which, structurally, are iterative: they function in a plurality of contexts. Texts and works of art,

but also "events" in the literal sense of the word, are thus "made" by a multitude of recipients, in different times, in different ways.

This poststructuralist view extends the idea of causality to the notion that texts are in fact elements in chains of meaning production. Relative to the traditional view of the relation between text and context, such meaning productions are not only geared differently; the text or artifact has a different status within them. No longer merely the product of a cultural-historical context that precedes it, the text is now itself a producer of semantic relations. Thus arises the poststructuralist tenet that texts *constitute* identity and culture. In this active conception lies the importance of the concept of *frame* as a replacement of *context*. Culler formulates the advantage of the former over the latter in this way:

It [the frame] reminds us that framing is something we do; it hints of the frame-up ("falsifying evidence beforehand in order to make someone appear guilty"), a major use of context; and it eludes the incipient positivism of "context" by alluding to the semiotic function of framing in art, where the frame is determining, setting off the object or event as art, and yet the frame itself may be nothing tangible, pure articulation.[10]

The frame, in other words, is not contingent—as "con-text" is—but an active combination of forces. It consists of the pressure exercised by the social-historical situation not only on the production of events, art, and literature, but also on the way in which members of a culture deal with events or texts in a historically specific situation to produce specific meanings.

It is exactly this impossibility to activate a narrative framework as an anticipation of coming events that characterizes the unrepresentability of Holocaust experiences. Edith P. states, "You don't think what goes through your mind. You say to yourself, 'Well, here I am in Auschwitz. And where am I, and what is going to happen to me?'" In short, she loses the capacity to reflect on the situation in which she finds herself. We can say "when I get married," or "when I die," or "when somebody dies whom I love," or "when I will have a child," or "when I will find a job"—with these kinds of expressions we automatically create theoretical possibilities of what might happen. It requires no effort. As Edith P. puts it, "Imagining oneself into those situations [is possible] because we know how to think about them—they have precedents in our own or other people's experience. But no one has ever said 'when I get to Auschwitz, I . . . '; therefore the mind remains blank" (103). In Auschwitz,

Edith P. explains, not only did you never know what kind of events could be expected, but you never knew either if you were partaking in the middle, the beginning, or the end of a sequence of events. "Mental process functions not in a vacuum but in relation to something that happened previously, that you had felt, thought, read, seen, or heard about" (104). Life in the camps, in all its aspects, simply had no precedent.

If the experience of an event could be immediate, if the event were not itself discursive, this lack of precedent would not be a problem. On the contrary, in that case the events could be absorbed intensely because of their utter "newness" and unexpectedness. But such is not the case. Because the Holocaust situation did not fit any conventional framework, it was almost impossible to "experience," and therefore later to represent, it.

The Holocaust as a Negation of Narrative Frameworks

So far we have seen situations that could not be experienced because there were no conventional narrative frameworks that allowed them to be worked through. The events seemed to occur in a kind of vacuum. Now I want look at a different kind of discontinuity between reality and discursive experience, one that relates closely to the problem discussed above, that is, the lack of narrative frame. In many testimonies the unrepresentability of Holocaust experiences is explained not by a lack of narrative frames but by the inadequacy of frames that are inflicted on the survivors by the surrounding culture.

Whereas no frames existed for life in the camp during the time of the Holocaust, that situation seemed to change when the Second World War came to an end and the inmates still alive were liberated. Now a narrative frame offered itself within which the experience of imprisonment could be given meaning retrospectively.

According to Langer, this narrative framework structures almost all the testimonies in the Fortunoff Video Archive. The interviewer imposes the frame by asking certain questions and by ordering the questions in a certain way. Again and again the interviewers begin with questions like, Tell something about your childhood, your family, your school, your friends. In short, they begin by attempting to reconstruct the normal life of the survivor that preceded the total disaster of the Holocaust. Although the reconstruction is performed by the survivor herself or himself, the activity is directed by the interviewer. After the period before the Holocaust has been dealt with, the focus shifts to life during the war, life

in the ghetto, the deportation, and camp life. In conclusion the interviewer asks, for example, Tell me about the liberation, in a sense stimulating the survivors to provide a comforting closure to a horrible crisis. The narrative framework imposed is the conventional story of a peaceful youth and beginning that is cut off by a dreadful event or crisis but ultimately comes to a happy end.

Many of the survivors, however, have great difficulty in accepting the liberation as a closure to what happened in the camps. Langer quotes the response of one man who was asked how he felt after his liberation: "Then I knew my troubles were *really* about to begin" (67). The traditional historical plot requires that a situation of a conflict or crisis be followed by a solution, a denouement. This Holocaust survivor, though, refuses this conventional mold for his life. With the liberation his camp experiences had not come to an end; on the contrary, they only became more intense.

Narrative frameworks allow (life) histories to be experienced as continuous unities. It is precisely this illusion of continuity and unity that has become fundamentally unrecognizable and unacceptable for many survivors of the Holocaust. Whereas the camps persist only in the form of Holocaust museums and memorials, the camp *experience* continues. The most elementary narrative framework, comprising the continuum of past, present, and future, had disintegrated. "'So there's no tomorrow, really,' observes the interviewer to this witness. 'No there isn't,' he replies. 'If you think there is, you're mistaken'" (173).

As we have seen, it was often necessary for a camp inmate to kill the self in order to live. And what conventional plot or narrative framework could suffice to tell *that* story? No traditional storytelling continuum allows one to have died in the past and to continue living in the present. This realization lends an additional layer of meaning to Delbo's statement "I died in Auschwitz, but no one knows it." "No one knows it" posits narrative conventions as cultural or social. It means, then, that no one is able to ac*know*ledge it, to give the knowledge back to her.

The implication here is that the basic feeling of being dead, or of continuing to live in the present as if dead, is not narratable. Those who hear such a story will consider it to be true only as a manner of speaking. After all, the narrator of this story is still alive, is actively telling the story. Yet a figurative reading does not acknowledge the problem of the unrepresentability of the experience of many survivors. In fact, it denies it. The conflict between a lived reality and the inadequacy of available narrative

frameworks disappears. The figurative reading is based on the idea that *in language* a similarity can be highlighted between a remembered negative camp experience (the compared) and the concept of death (that which is compared to). But death is much more real than an abstract notion that functions as the object in a comparison. Something has really died, not in a figurative way, but in the most literal way possible. Many testimonies make clear that life in the camp is not being remembered at all. There can be no distance from something that once happened and cannot be remembered. Many survivors still live *in* the situation of the camp, a fact that precludes the possibility of distance from it. For them the past of the Holocaust continues still; it is for this very reason that narrative frameworks that makes use of the sequence past, present, and future are inadequate.

The Experience of the Other Hell

The unrepresentability of the Holocaust is caused not by the extremity of Holocaust experiences as such, but by the fact that this horrible history was *unknown*—not figuratively, but literally. The symbolic order offered no terms, positions, or frames by which the Holocaust could be experienced, because these events had no precedent whatsoever. As Hayden White puts it so well, "It is not the difference of the experience, but the experience of a different 'history' which is hard to represent."[11] The close connection between representability (the possibility to experience) and discourse becomes even clearer when we compare Holocaust testimonies with the testimonies of SS soldiers. Interviews of former SS soldiers from Holland conducted by the Dutch writers Armando and Hans Sleutelaar contain detailed descriptions of horrible events both performed and endured by these men at the front, especially in Russia during the siege of Stalingrad.

In his remarkable book *Ordinary Men* (1992), Christopher Browning explores the extremely violent behavior and experiences of another group of perpetrators, the reserve police, which never saw any battle or encountered a deadly enemy. Their contribution to the war was to "clean out" the Jewish ghettos by killing the inhabitants or transporting them to the camps. It was, in other words, up to them to carry out the "final solution." Their actions and experiences are in a way even more extreme than those of the front-line SS soldiers because the events in which they partook could not be naturalized by any traditional concept of war. They

did not fight against an enemy. They annihilated a race. By seeing the Jews as a dangerous race, they dehumanized their victims, transforming them into objects, which facilitated their killing.

It seems senseless to me to develop a graduated scale on which the extremity of the experiences of such "ordinary men" are set off against the extremity of the camp situation. From a moral perspective there can be no discussion: the experiences of the concentration camp inmates were more horrible simply because they were total victims, whereas the SS soldiers, especially Dutch volunteers, had chosen a profession that they knew might involve them in appalling situations. But this moral difference based on responsibility has little bearing on these people's actual ability to work through the events in question. At issue here is not a moral perspective, but a psychological and, as I have tried to argue, a representational one. Even so, the difference between the two groups is striking.

It is remarkable that these voluntary SSers talk quite easily, sometimes even with eagerness, about their experiences. Consider the following example:

Try to imagine yourself: a battlefield with ten thousand dead bodies. Russians and Germans.
A tank battle followed. And when the tank battle is over, and you find yourself on such a battlefield! . . . What do you think, what kind of chaos did you see there?
I do not have to tell you anything.
When you continue thinking about . . .
That is not possible.
I have seen it often enough. Tank battle. Wounded persons. Killed persons. Again forward. Through the mud. For you had to go forward! You had to seek cover in the mud filled with cadavers! Do you understand this? Sometimes you pulled a couple of dead bodies together to make a shelter out of them. You pulled three or four of them together. Yourself behind them. That is totally normal at the front.[12]

In these interviews, events that at first sight repel the soldiers are made understandable through integration into the framework of the war or of the front. This SS soldier does it very explicitly when he says, "That is totally normal at the front." When the soldiers view the events in the context in which they happened, they do not have to linger on the extremity of violence and destruction.

Consider, for example, the way one SS soldier talks about a cruel event

he had to witness. A Russian partisan was killed after the SSers had used him for a day to carry four boxes of ammunition. The soldier is puzzled by the fact that the partisan was eager to carry the load, even though he probably knew he would be killed afterward. He sees this as a sign of the human inclination to cling to life until the bitter end. He was and is, however, not at all touched by the event. "One could say now, 'A horror.' But things like this are completely normal in a war. I think that the under officer (who performed the execution) slept very well afterward" (306).

The same SSer recalls another event in which a fellow soldier was executed for thievery. The whole battalion had to line up to witness the deed. The easy stance the interviewee adopts toward this execution of one of his comrades is again significant: "Something like that is normal. That man had to be sentenced to death and you know it. I didn't know anything about the circumstances. They didn't tell you that. . . . It was not such an important case. Important of course for him on whom it fell. Those things happen on both sides. I cannot say that it made an enormous impression on me" (304).

This soldier was able to normalize and work through cruel events by means of a "masterplot" of war, a symbolic order that provided him with a general understanding of what is "normal" in war. This enabled him to neutralize extreme events, making them into something that is not striking at all. Later he tells of an episode at the beginning of the war, when he was not yet an SS soldier, when he helped to carry wounded persons from the train to a hospital in the German city of Essen. In that instance he was deeply impressed.

That is how I came in closer touch with the war. That is total horror . . .
There were seriously and less seriously injured people, there were people of whom parts had been amputated, who came from the field hospital.
That made an enormous impression on me. That has always stayed with me. But I was strongly nationalistic, and a strong nationalistic disposition can help to bridge this. (203)

This time it is not a conventional masterplot of war, but rather an ideology of nationalism, that enabled him to deal with an extreme situation.

In none of these interviews is a traumatic return to events mentioned. Some former SSers were bothered by nightmares for a short time, but these were always of a passing nature.

When I came back in '49, I had nightmares. My wife was quite frightened at night. I still had nightmares of [the war]. You don't get rid of it that soon. Now I

have a dream once in a while or something like that, but nightmares, no, I don't
have them anymore. . . .
And then you found your comrades, sometimes your intimate comrades, fallen.
That remains with you.
[But] not eternally! Not forever! (60, 62)

You never get the impression that the subjectivities of these men have
been killed or corroded. On the contrary, a tone of bravura and re-
strained pride is regularly heard in their testimonies. Their use of lan-
guage continues to express a self-confident subjectivity.

There is no strong sense in these testimonies that the former SSers had
trouble working through the horrible events of which they had been a
part. In any event, whatever problems they did have they were able to
solve within conventional narrative frameworks. That is, their symbolic
order offered plenty of possibilities to understand these experiences as
meaningful. Generally speaking, that symbolic order was the ideology of
National-Socialism. For the soldiers, however, that ideology manifested
itself quite concretely, in a specific construction of masculinity.

In his seminal study *Male Fantasies* ([1977] 1987), Klaus Theweleit
analyzes the Nazis' construction of masculinity as consisting of a cultiva-
tion of both sadistic aggression and masochistic discipline and self-sacri-
fice. The construction of masculinity in which the SS soldiers were sub-
merged offered them narrative frameworks as well as subject positions
that enabled them to work through the extreme destruction they inflicted
on others or themselves endured. Browning comes to similar conclusions
in *Ordinary Men* concerning the psychological ability of the Reserve Po-
lice Battalions to carry out the "final solution." These Germans, he states,
were acting less out of a belief in the anti-Semitic Nazi ideology or out of
deference to authority or fear of punishment than from motives as insid-
ious as they are common: careerism and peer pressure.

The Nazi construction of masculinity as analyzed by Theweleit is the
most dominant framework present in the SS soldiers' testimonies. Most
of them knew nothing of the political ideology of National-Socialism, in-
cluding its anti-Semitism. They were simply attracted by the ideals of dis-
cipline, order, strength, and purity as means to shape their masculinities.
The SS based its model of masculinity more extremely and strictly on dis-
cipline than did any other division of the Nazi army; this gave the SS sol-
diers the psychological stamina to survive the events in which they par-
ticipated. As one put it, "You were hardened. Stone-hard. Retrospectively
you think, how is it possible that you could stand something like that. It

is thanks to the discipline and the hardships which they [the soldiers' superior officers] had you endure wantonly" (18).

The situation of the inmates of the camps differs here fundamentally. The extreme forms of destruction and annihilation with which they were confronted could not be understood or dealt with by means of any narrative framework. Whatever political or religious ideologies they embraced, those frames were beside the point, powerless, in the face of the reality of the Holocaust. The crisis of representation caused by the Holocaust is usually characterized as a form of speechlessness in the face of a metaphysical evil. In fact, it was the abyss between the lived history and the frames that normally enable us to experience reality that silenced many of those who survived the Holocaust.

Emplotting the Holocaust

This close connection between discursive possibilities and experiential collapse sheds new light on the binary opposition between historical and imaginative representation. In Chapter 1 I argued that historical literary genres like the diary or the memoir cannot be looked to for unmediated access to a historical past. Event and interpretation cannot be disentangled without violating the situation, because interpretation necessarily occurs as part of the event. My analysis of Holocaust testimonies in this chapter radicalizes this view. We can now say that event and experience of the event cannot be disentangled either, because experience of the event is the only access one has to the event. Experience is not a *transposition* of the event to the realm of the subject; it is an interpretive *transformation* that depends on the symbolic order to occur. It is precisely this discursive process of experience that was disrupted in the Holocaust.

This conclusion forces us to reconsider the status of Holocaust historiography. For if even the inmates of the camps depended on narrative, discursive frameworks to make sense of the reality in which they had ended up, it is arrogant to think that historians of the Holocaust can write about that event without the intrusion of a framing mechanism.

But where does the framing take place? Or rather, how can we recognize the effects of that activity in historiography? Saul Friedlander has convincingly demonstrated the dependence on framing of Holocaust historiography by examining different emplotments of that event.[13] He attempted to grasp the essentials of the new German debate about the

Holocaust through an analysis of the emplotment of the extermination of the Jews in that debate.

First Friedlander defines the elements of the traditional historical representation, in order to outline some aspects of the challenge and to consider the implications of the new German approach in terms of public memory. Differences in interpretations of Nazism as such notwithstanding, a common understanding has been reached concerning the place and meaning of Nazi crimes, that is, concerning historical responsibility. Structurally, within the traditional narrative of historical responsibility for the extermination of the Jews, three collective actors are identified: perpetrators, bystanders, and victims.

One version of this plot, the so-called liberal view of the Nazi period, frames Nazism and the Holocaust with liberal theories of totalitarianism.[14] From this perspective, Nazi Germany is understood essentially as a political and ideological deviation from the Western liberal model. One by-product of this liberal framework is a poor sense of differentiation between Nazism and Stalinism. The specificity of Nazism, especially its anti-Semitism as it led up to the Holocaust, is difficult to address. The framework of liberalism leads to an emphasis on the ideological origins, as well as the political and criminal dimensions, of Nazism.

In this framework the plot is obvious, and the perpetrators are clearly identified: Hitler himself, such organizations as the SS, the National-Socialist Party and peripheral groups, as well as the bureaucratic infrastructure of the party. The bystanders are characterized by only partial knowledge of the crimes being committed and by more or less sustained indifference and passivity. They include German society at large, characterized, with limited exceptions, as "a society widely impregnated with prejudice on the one hand and increasingly enthusiastic adherence to the *Volksgemeinschaft* ideal on the other."[15] The victims include political opponents imprisoned in concentration camps, people targeted for the "euthanasia" program because of (mental) illness, Gypsies, Slavs, homosexuals, and, the ultimate category, Jews. After the war this emplotment of the Holocaust shaped not only official German memory but Western memory in general, a memory that continuously frames, and thus naturalizes, the event. The result is a narrative that recognizes a basic historical responsibility anchored in the pre-Hitler past that found expression in the events of the Third Reich.

Next Friedlander describes a *structural* emplotment of the Holocaust, one that dominates traditional left-wing interpretations and the new left

historiography of the sixties. The theoretical framework now leads to a characterization of Nazism not as totalitarianism, but as fascism. It puts much emphasis on the dynamics of institutions and social structures and relatively little emphasis on the ideology and personalities within the Nazi system.

This framework leads to an emplotment of the Holocaust that is at first sight not very different from the totalitarian emplotment produced by the liberal framework. The difference lies only in the category of the perpetrators. In the structuralist emplotment, the perpetrators are imagined categorically as a complex interaction of subgroups. This makes it extremely difficult to pinpoint where responsibility lies, as each decision flows from some partially perceived context. The consequences of the structural emplotment are as follows:

One may argue that such a view of the perpetrators considerably widens the field of responsibility and encompasses many more elements of German society within the tortuous criminal processes; on the other hand, it bolsters the argument that the very fluid and nebulous aspect of these processes made any kind of opposition extremely difficult. In any case, we are faced with a somewhat paradoxical image of mass murder of a totally unprecedented kind being enacted without any clear representation of a primary locus of responsibility. (27–28)

Another difference between the framework of liberalism and the framework of Marxist structuralism is brought to the fore by the evoked similarities of Nazism with other sociopolitical phenomena. While the totalitarian emplotment of the liberal framework systematically compares the crimes of Nazism with those of Stalinism, the Marxist framework invokes more general comparisons between the criminal policies of fascist regimes.

Whereas the liberal framework and the emplotment of totalitarianism structured the historical debate in 1950's Germany, and the Marxist-structuralist framework predominated in the late 1960's and early 1970's, in the 1980's a conservative, revisionist approach took hold of the debate. This approach, advocated by such historians as Ernst Nolte, Andreas Hillgruber, and Joachim Fest, questioned the specificity of the origin of Nazi crimes in order to liberate German identity from historical responsibility for the Holocaust. The responsibility of the Nazis for their crimes is not denied, but by emplotting Nazism as a defensive reaction to the Red Threat of the Soviet Union a shift in emphasis is achieved. At the same time, Nazi crimes are "balanced" against the responsibility of the Red Army (and the Allied forces) for crimes committed on German soil.

This anti-Communist framework leads to a new narrative. There are now two categories of perpetrators: the Nazis and, facing them, a mixed representation of Soviet and Allied forces, insofar as the latter intend the destruction of Germany. Nolte even goes so far as to argue—reversing the traditional schema—that the Nazis became perpetrators out of anguish at the idea of being themselves made victims of the Red Terror:

> He who does not want to see Hitler's annihilation of Jews in this context [of Communist destruction] is possibly led by very noble motives, but he falsifies history. In his legitimate search for the direct causes, he overlooks the main precondition without which all those causes would have remained without effect. Auschwitz is not primarily the result of traditional anti-Semitism. It was in its core not only a "genocide," but was above all a reaction born out of the anxiety of the annihilating occurrences of the Russian revolution.[16]

Thus the Nazis, the traditional perpetrators of the other narratives, have become the potential victims, while the traditional bystanders are made into actual victims. The effect of this new, sinister emplotment is a displacement of the *source* of all evil one more remove, to the past of the past. Historical responsibility can no longer be situated within an exclusively German context.

Friedlander's readings of emplotment represent, in my opinion, a radical breakthrough in historiographic discussion. The unescapable conclusion is that historicization, or the interpretation of past events, is never done in the domain of "objective history." Historicization can only be done by framing the event. In that moment the moral and political responsibility of the historian shows itself; in that moment history as it reflects the concerns and interests of the historian is made relevant. Frames are never inherent to the object of framing. They are, ultimately, legitimized by the (hidden) agenda of the historian, determined by sets of a priori values. Collective memory, in short, is not in the service of objective historiography; rather, historiography is in the service of collective memory.

This confrontation of different emplotments of the Holocaust also influences the way we evaluate and judge theories, in this case theories of Nazism and the Holocaust. After we have assessed the referential adequacy of a certain approach, we must turn our attention to the performative effect of a theory. How does the theory characterize contemporary collective memory? What (political) values are served by it? Although historical truth is being exchanged for performative effect, we do not therefore end up in a state of utter relativism.

The legitimacy of the performative effect as the conclusive norm for

judging a frame is unescapable in the case of Israeli emplotments of the Holocaust. For a long time the Holocaust was inserted in the historical sequence of Jewish catastrophes leading to the redemptive birth of the state of Israel. This Zionist interpretive framework played a decisive role in building the new Jewish state. The redemptive closure of this narrative, however, started to crack open with the Eichmann trial. On that occasion stories of Holocaust survivors became alive again and challenged the reassuring certainties and their resulting effects. This rupturing of closure resulted in a growing sensitivity to individual testimonies of the Holocaust, which challenged the existing, socially imposed codes of interpretation. The more time that passed since the extermination of the Jews of Europe, and the more Israel was forced to legitimize the size of its territory rather than its birth, the less compelling the initial interpretive frameworks became for Israeli historical consciousness. According to Friedlander, no relevant emplotments—and, I would add, no frameworks producing relevant meanings—have appeared in their stead.

The need for such frameworks remains acute, however, for unless meanings are assigned to them, events cannot be remembered. The issue, then, is not to decide which frame will win the contest of meaning, but to realize that *meaning must be produced* in the service of memory. The ultimate importance of remembering the Holocaust is situated not in the past events themselves, but in the past events as they exist *in relation to* our contemporary and future concerns. In the words of James Young: "We should also ask to what ends we have remembered. That is, how do we respond to the current moment in light of our remembered past? This is to recognize that the shape of memory cannot be divorced from the actions taken on its behalf, and that memory without consequences contains the seeds of its own destruction."[17] In his book on Holocaust memorials, *The Texture of Memory* (1993), Young explores the idea that the understanding of past events depends on the construction, or framing, of memory. He reinvigorates memorials he visited in Germany, Poland, Israel, and the United States with the stories of how they came about and with stories about the responses and discussions they have provoked. In so doing he explores the kinds of meaning created at those sites and the principles around which Holocaust museums organize their memory-telling.

Memory is not shaped in a vacuum—or as Young puts it, "The motives of memory are never pure."[18] The reasons given for Holocaust memorials and the kinds of memory they generate can never be reduced to the past events themselves. In every nation's memorials and museums a

different Holocaust is remembered, often based on conflicting political and religious goals and on a variety of national myths, ideals, and political ends.

Young's crucial question in the above quotation is easier to answer in the light of the testimonies I analyzed in the first part of this chapter. The survivors' ultimate purpose in trying to tell their stories is at last to work through the horrors they had to endure and to integrate themselves *with their past* in our present. I will return to the importance of testimony in Chapter 6 when I discuss Christian Boltanski's art as a humanizing and transactive practice. In the context of the writing of the history of the Holocaust, however, Young's question will never allow a definite answer because it should be asked again and again. Changes in time and in context require continuously renewed engagement with what we can learn from the remembrance of the Holocaust.

The unrepresentability of Holocaust experiences has a discursive basis, and histories of the Holocaust are necessarily the product of emplotment, which implies a framing activity performed by a subject living in the present. Individual experience, as well as the collective endeavor of history writing, happens within the conditions of the discursive or symbolic realm. This may seem a disenchanting conclusion for those who believe in the objective transmission of history by means of transparent language. If we are to make sense of the Holocaust, however, the ontological question of the reality of the event—did it happen?—must be firmly distinguished from the epistemological question of how we gain access to it. Yes, it happened; and Nazi Germany did it. Nolte's insertion of a framework that shifts the responsibility away from Germany and back to an earlier threat attempts to capitalize on the frequent confusion of these two philosophical domains. That is why his view, sinister as well as implausible, is also intellectually objectionable, based on sloppy, or rather perverse, reasoning: he disguises an ontological certainty under the clothing of epistemological doubt. Moreover, I would like to emphasize the positive side of our "dependency" on discursive frameworks and framing acts. It is thanks to this dependency that testimony and history writing remain relevant beyond the production of knowledge of the past. It is because discursive frameworks belong to the present, and framing acts take place in the present, that memory of the past—knowledge of history—can have consequences for the contemporary and future world.

Autobiography as Resistance to History

Charlotte Salomon's *Life or Theater?*

Experience is a subject's history. Language is the site
of history's enactment. Historical explanation cannot,
therefore, separate the two.

> —Joan W. Scott, "Experience"

Charlotte Salomon's painted life history *Le-
ben oder Theater?* (Life or theater? 1941–
43) is a unique work of art.[1] It is unique be-
cause it does not adhere to the standards of its
own genre. Life histories are generally executed
in the form of written autobiography or diary,
illustrated or not with drawings that illuminate
specific passages, themes, or events. Salomon's
life history, in contrast, consists of a complex of
narrative images, text fragments, and music ci-
tations, in the whole of which the visual images
are primary rather than subordinate. The work
took shape in the period immediately before
and during the Second World War, a period
when many German artists fled the country be-
cause they were Jewish, Communist, or homo-
sexual. But not only are the social and political
circumstances in which Salomon lived terrible;
her family history was also unusually dreadful.
Her mother, her grandmother, her aunt, her
great-uncle, her great-aunt, and her cousin all
committed suicide. At the time she was making

Life or Theater? she and her grandfather were the only surviving members on her mother's side of the family.[2]

Life or Theater? can be described as a musical-theatrical piece, with Salomon herself as narrator. It consists of 769 compositions of images combined with text and 13 painted text pages. According to the subtitle it is a *Singspiel* (songplay), a genre that is a predecessor of opera. It makes use of already existing melodies, mostly accompanied by new texts. Salomon's *Singspiel*, however, is not intended to be played and sung, but to be looked at. The tightly structured work begins with a prelude, subdivided into two acts, which in turn are subdivided into scenes. The main body of the work comprises two sections, the first of which has eleven scenes and the second five. An epilogue closes the work. The complete piece is numbered as serial pages. In addition, there are loose, unnumbered sheets—preliminary studies and variants—that Salomon did not include in the finished piece.[3]

The events staged within this classic three-part structure are interrogated in the accompanying texts, which contain statements by the characters, the narrator's commentary, and quotations stemming from literature, opera, and popular songs. The result is a complex text in which several voices speak on various levels.

The multiple layers of this work, the historical moment, and the cultural place the work has been called to occupy after the fact—the work as afterimage, so to speak—make it a particularly good subject for an inquiry into the relationships between history, biography, and art, or public history, personal expression, and the mediating role of art history. Salomon's *Life or Theater?* has so far mainly attracted partial responses, addressing only one of these aspects at a time. Historians, for example, evaluate the work based on its personal or sociopolitical content. For them, it is an important document that illustrates one of the most dramatic moments of Jewish history. The fact that it is the document of a personal, private history makes identification with it easy for postwar readers and viewers. In that respect *Life or Theater?* can be seen as an equivalent of Anne Frank's *Diary of a Young Girl*. After Salomon had finished *Life or Theater?* she was taken by the Nazis and transported to Auschwitz. There she met the same end as Anne Frank: both young women were gassed. Although Salomon's life history is not as well known as Frank's, both have become cultural icons in the commemoration of Jewish history and the Holocaust.

Although Jewish history is an obvious referent in Salomon's work, that very obviousness has caused the art historical significance of *Life or The-*

ater? to be neglected. The historical/documentary value seems to preclude awareness of its significance as a work of art; its autonomy is under pressure. Art historians generally analyze art in relation to other art—to place creative work within an autonomous stream of artistic traditions. Confronted with a work that addresses history so blatantly while transgressing equally blatantly the established genres of art, they have difficulty avoiding a binary opposition and treat it either as history or—more rarely—as art history.

From the standpoint of the art history, the problem is the work's undefinable style. Its visual qualities are often characterized as expressionistic because of the drawing style. This label seems also to be justified by the fact that Salomon's artistic context was the Germany of the 1920's and 1930's, the period of German expressionism. It fails, however, to take into account other aspects of *Life or Theater?* What to do with the texts, for example—not only their content but also their visual qualities? And what about the ironic relations between text and image, and between the musical quotations and represented events? The intertextual references to other works of art, especially Michelangelo's frescoes and sculptures, and to myths of Western culture likewise go unnoticed in the "expressionist" interpretation.

The situation becomes even more complicated when we consider gender, as obviously we must. This is a third framework within which to place this artwork. Salomon narrates a life history in which female family members are made central by their absence: they all commit suicide. Her role model, however, is a man, who initiates her into notions of art in which creativity is an exclusively male asset. Hence, male creativity and female suicide become the two principal motifs in *Life or Theater?* The situation for Salomon herself is of course paradoxical: her life history in art seems to tell the story of the impossibility of the female artist. We, readers of her work, must therefore consider how Salomon's work of art relates to the (male) conceptions of art she articulates *in* her work of art. Subsequently, this raises the question of how *Life or Theater?* differs as autobiography from, on the one hand, the female-authored conventional autobiography and, on the other, the histories of which she partook: her family history, the history of European Jews, and the history of art.

The question of women's autobiography has been addressed with acuity by Shoshana Felman in "*What Does a Woman Want?* The Question of Autobiography and the Bond of Reading" (1993).[4] In this essay, Felman demonstrates the specific complications that present themselves

when women attempt to inscribe the process of their gendered becoming. Under the current symbolic regime, she argues, women can tell their stories only through the stories of others. Women's autobiographical voice must therefore be traced within each text as "its own specific, literary, inadvertent textual transgression of . . . male assumptions and prescriptions" (6). She continues:

None of us, as women, has as yet, precisely, an autobiography. Trained to see ourselves as objects and to be positioned as the Other, estranged to ourselves, we have a story that by definition cannot be self-present to us, a story that, in other words, is not a story, but *must become* a story. And it cannot *become* a story except through the *bond of reading*, that is, through the *story of the Other* (the story read by other women, the story of other women, the story of women told by others), in so far as this story of the Other, as *our own* autobiography, *has as yet precisely to be owned.* (14; emphasis in the original)

The frameworks that women have at their disposal to narrate their autobiographies are the products of a culture dominated by men. This makes it impossible for women to "confess" their stories, because those stories are not self-present to them. Women's lives can *become* stories only in the act of representation or narration, that is, in the resistance to and transgression of the unavoidable male frameworks with their male assumptions and prescriptions. It is only in this negative performance, in this act of resistance and transgression, according to Felman, that women can tell their life history.

I will argue that Salomon, indeed, tells her story "between the lines." She can represent herself only in the ironic distance she maintains toward the story of others she is telling. But if gender is a primary guideline in my reading of *Life or Theater?*, it is also because gender enables me to overcome the binary opposition between history and art history that until now has dominated readings of Salomon's work. Reading through gender allows an integrative approach that not only accommodates but even foregrounds both history and art history and their function in Salomon's work.

Resisting Orpheus

I will focus my reading on two mythic motifs of creativity by means of which Salomon structures *Life or Theater?* Both stories—that of the creation of Adam by God and that of Orpheus and Eurydice—thematize creativity, and in both stories it is male creativity that is at stake. Salomon

has not rendered these myths with the attitude of a serious believer, however. She uses them ironically, and it is precisely the distance created by her irony that enables her to tell her story.

First, the very act of narrating her life history as an act of creativity is elaborated through an implicit "discussion" or working through of the intimate relationship between art and death. Death, and the relationship between death and life, is a recurrent motif in *Life or Theater?* The first images of the first act of the prelude, representing a moment of Charlotte's prehistory, introduce the idea of the strong mutual dependency between life and death. We see, in 1913, a family member leave the house and go to Lake Schlachten outside Berlin to drown herself. This family member is Charlotte's aunt, her mother's sister and for whom Charlotte was named. In the following images Charlotte's mother, Franziska, announces that she wants to become a nurse to save the lives of soldiers fighting in the First World War. Just as Charlotte will, after her grandmother's suicide, decide to do something wildly eccentric by making her life "work" in the form of art, so did her mother. Although the causal relation between Franziska's resolve to save lives rather than join her sister in death and Charlotte's own, later behavior remains implicit, it is clearly suggested by the structure of the narrative. Thus, the opening scenes introduce the leitmotif that continues to structure Charlotte's life and her life work, in which life slips into death and death motivates life, defining moments of transition where the passage between life and death and between death and life is almost indiscernible.

The fixation on the tie between life and death does not mean that this tie is experienced as tragic or dramatic. On the contrary, it becomes the very site of Charlotte's access to art—an access that is strongly gendered. She achieves it through the teachings of a young man called Daberlohn, her stepmother Paulinka's collaborator and teacher and Charlotte's guru with whom she falls in love. He occupies an important place in Charlotte's life history as well as in her personal artistic development, her private art history.

In *Life or Theater?* Salomon has Daberlohn declare that the frontier between death and life is indispensable for the emergence of art, that it is an ideal source of artistic nourishment. This rather conceited young man, inspired entirely by romantic views of art, is searching for moments of transition between life and death because those moments are also the moments of creation. "Between life and death," he asserts, "there must be a stage of high concentration that can be filled by singing."[5]

His teaching is based on a theory of the soul and the voice. Instead of singing to arrive at the transitional state between death and life, he has a death mask made of himself while still alive. As the wax is pressed against his face, the sensation triggers in his mind an impression, revealed to us in Salomon's images, that mixes color with music; that combination in turn produces a theatrical mask of Paulinka, the woman with whom he is in love and whom he wants to use as nourishment for his theory of music and the soul. The commentary on his vision by the narrator (Salomon) is ironic: "He is pervaded by a deep sense of satisfaction from his exhausting labours and he feels that he has penetrated far into the mysterious depths of human existence" (435). "The mysterious depths of human existence," however, are expressed in terms of his utterly personal obsession of the moment: Paulinka. Thus Salomon creates ironic distance by the gap between what she shows us (Daberlohn's vision) and the range of the thoughts she has Daberlohn think.

The link, ironic though it is, between this personal obsession and the universalist view of art is represented by a visual reference to myth. When the mask is removed from his face, Daberlohn thinks of the story of Orpheus going into the underworld to bring Eurydice back to life. Helped by Amor, he has the strength to appease the god of the underworld with his song. In the frontier situation between death and life, supported by love, it is possible to soften a god, or to create art.

The Orpheus myth is a central motif in *Life or Theater?* In Daberlohn's imagination, however, it is transformed into a gendered conception of creativity, and this is the version of the myth, or theory of creation, that Charlotte will resist and transgress in the telling of her story.[6] For Daberlohn, Eurydice is not the ultimate goal of his descent; she is merely its precondition. Orpheus descends into the underworld not to awaken Eurydice, but to seduce the god of the underworld through the art of music. He must excel in his art to impress the god. His ambition to create such art overrules his love for Eurydice; indeed, his love for her *supports* and *sustains* his creative pursuit. His art is no longer a means by which he can reach his goal—Eurydice. Rather, his love for Eurydice is the context, the precondition, for his homosocial competition in creativity with the god of the underworld.[7]

In the text of one of the unnumbered pages, Daberlohn is quite explicit about the serving role of women in the project of creating art. Daberlohn says to himself: "Yet for myself I also I believe in redemption through woman."[8] In *Life or Theater?* Charlotte's stepmother, Paulinka

Bimbam, is used for this eroticized creative project at first. The fact that Daberlohn is in love with her does not mean that she is his love-object, however. She serves rather as a narcissistic mirror for the younger man. He wants her to reflect his own value back to him. Shoshana Felman has described men's use of women in this manner in an analysis of Balzac's short story "Adieu": "In Philippe's eyes, Stéphanie is viewed above all as an object whose role is to ensure, by an interplay of reflections, his own self-sufficiency as a 'subject,' to serve as a mediator in his own specular relationship with himself. What Philippe pursues in the woman is not a face but a mirror, which, reflecting his image, will thereby acknowledge his narcissistic self-image."[9] Salomon gives Daberlohn exactly these words when he reflects on his love for Paulinka: "And when I look deep into her eyes I see only my own face + that mirroring of oneself is for me + nothing more than a symbol for the idea that, when we believe we love someone else, we are ourselves object and subject."[10]

But the situation in *Life or Theater?* is even more complex and, in fact, already transgressive because Paulinka and Charlotte not only serve as narcissistic mirrors or nourishing mediators in Daberlohn's creative pursuit, but they themselves have creative ambitions as well. Paulinka is a well-known singer, and Charlotte is a student at an art school. Both are influenced by Daberlohn's aesthetic conception and by *his* role model Orpheus. But gender is a thorny problem here. In the story Salomon as narrator tells, Daberlohn is not an artist himself but a music teacher. How does he then equal his own role model? And how does Salomon have him deal with the fact that Paulinka and Charlotte as artists have more in common with Orpheus than he himself does?

The text of another unnumbered sheet is revealing:

It is an easy job to prepare Mrs. B. for the fact that this Orpheus, whom she has to portray, is none other than herself, who has suffered this loss of soul and now must descend into her own inner world to find herself again. You'll probably have noticed how much bluster there is in her pretense, which for years she's used to seduce many people. And the interesting thing is that behind her pose is concealed a really fantastic woman, a woman men can look up to . . . ; and shouldn't I deliver that unparalleled figure into life with yearning power? A Mary, a Helen, a Mona Lisa. My God, stop it. . . . Your philosophical babble means nothing more than that you are head over heels in love with her.[11]

As her teacher, it is Daberlohn's task to make Paulinka identify with Orpheus, for Orpheus is the symbol of, and hence role model for, the artist. Yet he presents Orpheus's descent in search of a lost soul (Eurydice) as

an inner quest for her, Paulinka's, true essence. He knows or sees already that she is—in essence—"a really fantastic woman, a woman men can look up to." He wonders if he should pull "with yearning power" this unique inner woman into life. When he starts to compare Paulinka with Mary, Helen, and Mona Lisa, his own fantasy begins to seem absurd, and he suddenly diminishes everything by claiming that his idealization of Paulinka only means that he is in love with her. Here, in her rendering of Daberlohn's thoughts at the moment he himself realizes their absurdity, we can hear the narrator's voice both resist his discourse and transgress the gendered system of thought that he stands for and utters. This scene clearly does not need any ironic comment by the external narrator.

Although Daberlohn suddenly distances himself from his aesthetic and ecstatic outcry, it is important to note that he takes over Orpheus's pursuit with his desire to pull Paulinka's unique essence into life. He as the teacher becomes Orpheus—in his wish to rouse Paulinka—instead of awakening the Orpheus quest in Paulinka. Hence, no room is left for Paulinka as a creator of art. Felman's conception of the conditions under which women achieve access to their own life stories is played out with precision in Salomon's overworking of Daberlohn's gendered vision. Salomon cannot tell her life story without framing it within the ideology from within which Daberlohn speaks, judges, and loves. But while endorsing that framework as the only one available to her, she also resists it through use of irony, and she transgresses it by displaying its inner contradictions. This is for her the only way, the way of indirection, in which she can achieve autobiographical representation—in which, in other words, she can gain access to her own history *and* her own project.

Resisting Adam

Something of the same order happens in Salomon the narrator's relationship to the history of art, in that Daberlohn's ideas about film also influence Charlotte's work. Salomon represents those ideas in a scene in which Daberlohn is sitting in his room at a small table, waiting for inspiration for a book he wants to write.[12] Michelangelo's Sistine Chapel fresco of the creation of Adam appears in the image, suggesting that Daberlohn is thinking of it (Fig. 3). That fresco had appeared in an earlier scene, when Charlotte traveled through Italy with her grandparents. Charlotte was deeply impressed by Michelangelo; his paintings, she noted then, were filled with transcendental power. On the page representing the Sistine

Figure 3. Charlotte Salomon, *Life or Theater?* no. 4685; gouache, 32.5 × 25 cm. Collection Jewish Historical Museum, Amsterdam, © Charlotte Salomon Foundation

Chapel frescoes, she noted that "he hovers on too high a plane, but yet, of course, ça vaut la peine [it's worth the effort/pain]"(177). The expression "on too high a plane," naturally, is to be taken in both its senses, literally as well as figuratively.

Later, then, Daberlohn imagines these same frescoes. Salomon's narrational voice-over does not comment on Daberlohn's thoughts as much as on her own view: "The following images are those which to the author seem the strangest. Without doubt they have their origin in the Michelangelo Rome series of the main section that was sung with the loudest and most penetrating voice of this entire work" (527). The commentary indicates that these images are, in a sense, the core of *Life or Theater?* This arouses a keen interest in the story the images show and tell. Daberlohn begins to write his book. He writes about Michelangelo as the greatest genius of all time. God's creation of Adam, moreover, marks the end of God's unchallenged creative authority. Eve is created by a somewhat changed God. "This," opines Daberlohn, "is the tragedy of the king who must hand over his dominion to his son" (529). Daberlohn turns this (also homosocial) competition into a justification of the fact that women have no role in the story of creation. On the next page Salomon has him say: "That is why the path led from Adam to Christ, so that the words might be spoken: 'Woman, what have I to do with thee?'" (530). According to Daberlohn, Adam is reincarnated in Christ, and he—Daberlohn—resembles Christ in his turn. In the second instance, however, Salomon has Daberlohn assume a more modest position: he is a conqueror and a redeemer, but only of his own underworld. Yet he hopes that many will follow his example. What does that example consist of?

According to Daberlohn, man must learn to know himself, to descend into himself, before he can transcend himself and reach beyond. One way of getting outside himself, Daberlohn thinks, would be through film, because it is a medium by which we can produce ourselves. This holds not only for the hero of the film but also for the viewer who identifies with the hero: "At the movie, on an equal level with the hero passing before his eyes, he feels the equal of his ideal. At the movie he follows his path to the heights, to his refuge, the dream world that is to help him ignore the dingy harshness of daily life" (536). In keeping with the experience of the height of the Sistine Chapel, Daberlohn presents Adam/Christ/Daberlohn, himself/film hero/film viewer, all as God's rivals. Because they all, each in his own way, create a world: a new, alternative world. At the same time, they are able to deny or forget the God-created world.

This view is the framework in which Charlotte will intervene with resistance and transgression. Riddled with rivalry and ambition, the process is emphatically represented as Daberlohn's vision: it is he who sits at the table and conjures it up. Charlotte must now find a way to relate to this array of God's rivals. Eve, the only woman mentioned in Daberlohn's fantasy, is assigned the function of nurturing Adam's creative power; only by means of her can Adam reproduce himself. Once the woman is eliminated, Adam becomes God's rival. God's creative power has thus lost its exclusivity: Adam can create too. Salomon's commentary on this familiar masculinist topos is quite subtle. It provides a wonderful example of resistance and transgression by visual means, and a wonderful example, too, of Salomon's re-vision of the history of art. On sheet no. 321 (p. 541; Fig. 4) we see Charlotte and Daberlohn sitting in a canoe, and Charlotte has the position and pose of Adam in Michelangelo's fresco. Hence, the creative power is here attributed to Charlotte herself, while Daberlohn paddles for her. Salomon draws explicit, albeit convoluted, attention to the reversal of Daberlohn's fantasy in the accompanying text:[13] "Please compare this pose 1) with no. 22 of the prelude (p. 30) [and] 2) with Michelangelo's 'Night', no. 308 (p. 528), also no. 325 (p. 545)" (541).

Before I trace the comparisons Salomon asks us to make, I want to note the significant fact that Salomon painted the same scene several times. Even more remarkable is the fact that on the discarded sheets she reversed the positions of Daberlohn—who sits on the left in Adam's position—and Charlotte—who appears in the middle.[14] Salomon, however, ultimately rejected these variants for *Life or Theater?* One can only guess what her reason was, but the *gesture* of excluding them must be taken seriously and interpreted as part of the work itself. It seems plausible that her motivation, conscious or unconscious, was tied to her resistance to Daberlohn's gendered conception of creativity. This resistance is not explicitly stated but is shaped in the form of an intertextual reference to Michelangelo that draws attention to the reversal of creative privilege from male to female. Thus the figures' positions relative to the prestigious precedent act out her transgression of the restrictions imposed on her as a woman artist.

It seems worthwhile to examine the gesture in more detail. On the first page to which the narrator refers in this convoluted commentary (no. 22 in the prelude, p. 30; Fig. 5), we see Charlotte's mother also in the pose of Michelangelo's Adam. The pose is far from one of empowerment, however, for at the very moment she assumes it she decides to kill herself. The

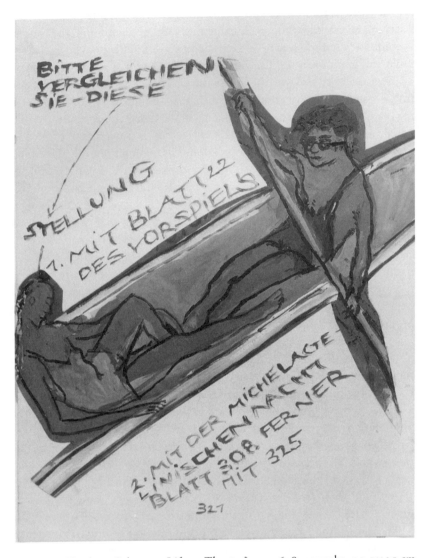

Figure 4. Charlotte Salomon, *Life or Theater?* no. 4698; gouache, 32.5 × 25 cm. Collection Jewish Historical Museum, Amsterdam, © Charlotte Salomon Foundation

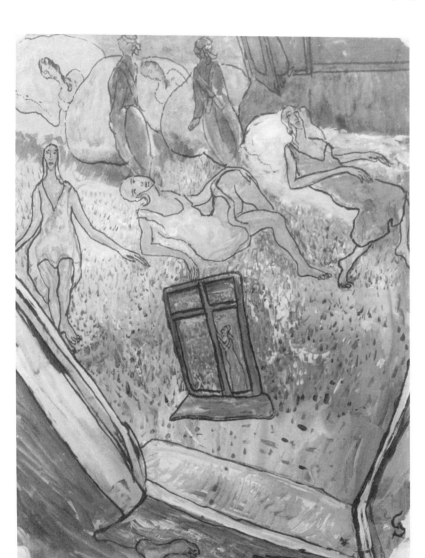

Figure 5. Charlotte Salomon, *Life or Theater?* no. 4179; gouache, 32.5 × 25 cm. Collection Jewish Historical Museum, Amsterdam, © Charlotte Salomon Foundation

second image to which the narrator refers (no. 308, p. 528) contains Michelangelo's own Adam. Yet she mentions another work by Michelangelo: the figure "Night" in the sculpture adorning the tomb of Lorenzo de Medici in Florence. There is indeed a remarkable similarity in pose between Michelangelo's Adam and his personification of "Night." This formal similarity results in a conflation of the meaning behind these two figures: while Adam is the main, victorious character in a story of creation, "Night," together with the figures "Day," "Morning," and "Evening," signifies the fluctuation of time. Hence, the conflation of Adam and "Night" connotes life and death—or the transition of life into death. This meaning is intensified by the fact that the sculptures are part of a tomb.

The double reference to works of Michelangelo foregrounds the idea of creation by death—or the other way around. This narrow link between creativity (art) and death also explains Charlotte's passivity in her Adam-like pose. This pose, signifying creativity, is associated not with activity or productivity, but with death as a productive transgression.

On the third sheet to which the narrator refers (no. 325, p. 545) we see Charlotte again in the pose of Adam—but also that of "Night." Daberlohn lies on top of her and kisses her. The accompanying text states: "But suddenly his hypersensitive nerves are touched by a firelike current—which is only natural considering that this picture was created to the tune of: I love you as no one has ever, ever, loved before!" The indirect style of the text suggests that Daberlohn feels *he* is sending out this firelike current of love/creativity. The next page reveals, however, that *Charlotte* was responsible for this God-inspired moment: "It was only a second. Charlotte is lying there as if it were not she who had brought about this fiery stream. If Daberlohn had known old Mrs. Knarre, he would once again have noted a family resemblance—just as you can after reading the epilogue" (546). We see Charlotte lying down, totally passive, with Daberlohn next to her. It transpires that in the epilogue Mrs. Knarre, Charlotte's grandmother, commits suicide. One might speculate that Daberlohn fails to understand the full implications of Michelangelo's view of creativity because he failed to understand that the relationship at which Charlotte hints here, between art, love, and death, is reversible. Daberlohn assumes that contact with death is a precondition for creativity, while Salomon is frightened by the reverse relation: for her, creativity is equally strongly an enticement to the desire for death. Her grandmother's suicide (and her mother's) may exemplify failed creativity, but it exemplifies creativity nevertheless.

Salomon's resistance to the tradition of megalomaniac creators in which Daberlohn places himself, however, is not focused on the reversal of gendered positions as such. It is in fact Daberlohn who notices the reversal within the story. In chapter 11, "Interesting Discoveries, For Us Too," the external narrator again gives the reader access to Daberlohn's thoughts. *He* makes the following discovery: "He is struck by a remarkable resemblance between Charlotte's pose and that of Michelangelo's 'Night'" (539). Daberlohn then makes a decision: "That is my new religion." Daberlohn's new religion seems to entail bringing creativity to life in fantastic women like Paulinka and Charlotte. While in the earlier scene he projected Orpheus onto Paulinka, now he projects Adam/"Night" onto Charlotte at the moment he notices the resemblance in pose between the two. In both cases, he seems to think he actually possesses the power to bestow creativity on them. But as in the Paulinka-Orpheus scene, after his act of bestowal he is not so much *facing* a creative woman as looking into the mirror of his own creative act.

This becomes clear in the next scene, when the couple has left the canoe. We see Charlotte and Daberlohn lying next to each other, and Daberlohn starts to make love to Charlotte. So far the scene is conventional, framed within traditional representations of relations between men and women. One of the sheets on which this scene is depicted is cited by Salomon the narrator in her cross-references on sheet 321. There Salomon has Daberlohn wrongly assume that *he* produced the "firelike current." The text of an unnumbered sheet that, one assumes, falls before the latter text addresses Daberlohn's failing creativity more explicitly. The following extract from that sheet comments on the amorous scenes of sheets 323 and 324:

Charlotte remains unyielding. That has never happened to him in his longtime practice. He feels something cold that borders on death and is amazed, interested. He continues "his experiments," which interest him very much as always.[15]

These commentaries considerably complicate the seemingly traditional scene: woman lies still, man makes love to her. Now, read in the light of this text, it is as if Daberlohn, even in lovemaking, is the entire product of Charlotte's creative power. From guide, teacher, and guru, he becomes her puppet.

We must conclude that Salomon resists Daberlohn's conceptions of creativity in two crucial ways: by integrating the domains of history and art history, on the one hand, and the representation of personal history

and artistic subjectivity, on the other. And she is effective in that integration because both these oppositions are so strongly bound up with the gendered problems of women's autobiography, as described by Felman. First of all, Salomon has Daberlohn fail in his Orphic project of awakening creativity/love in the women he admires. His "experiment" in creativity by means of lovemaking fails, whereas Charlotte succeeds in emitting a firelike current. Second, she uses this creative energy to set up an alternative tradition for her female family members, who were creative and who committed suicide. Charlotte's Orphic-Adamic moment of creativity is linked to the suicides of her mother and grandmother; they form a continuous line.

That this bond between creativity and death is not only indispensable, but also indispensably gender-specific, is strongly suggested by another gesture of exclusion that Salomon performs.[16] The unnumbered sheets contain two images depicting the suicide of her cousin, the only surviving male member of Charlotte's grandmother's family. In the upper half of one sheet we see this man gas himself; the lower half shows Charlotte's grandparents reading the letter informing them of the cousin's suicide. The letter itself is depicted on the second sheet (Fig. 6). It is framed by the Charlotte's head in the upper left and by her grandmother's head in the lower right; Charlotte's hair partly covers the letter, which in turn partly covers the grandmother's face. The grandfather has disappeared, and the two women form one continuous line with the letter.

It is significant that Salomon decided not to include these images in her final work. In all likelihood the inclusion of these images would have disrupted Salomon's project of creating a link between her struggle to become an artist and the suicides in her family. In her "fictional" account of these suicides she left out the death of the male cousin, perhaps because it blurred her conviction that her transgression of male conceptions of creativity must be seen in the context of her family's failed "transgressions" of life, of history.[17]

Musical Strategies of Resistance

Torn between life and death and sustained by her love for Amadeus (!) Daberlohn, Charlotte is in a state of heightened concentration that enables her to carry out her life work—in both senses of the expression: she can make her life effective, make it work; and she can create the work of her life, the work that becomes the story of her life, her autobiography.

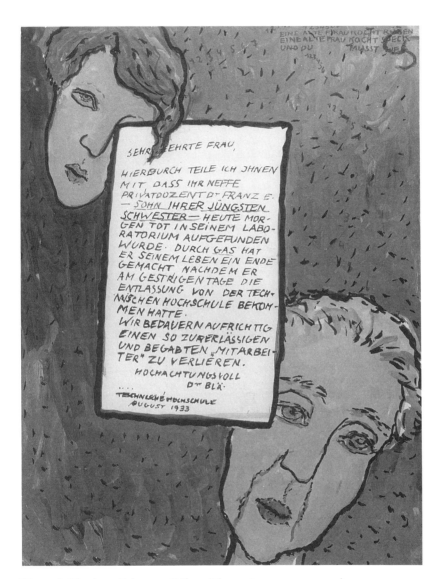

Figure 6. Charlotte Salomon, *Life or Theater?* no. 5025; gouache, 32.5 × 25 cm. Collection Jewish Historical Museum, Amsterdam, © Charlotte Salomon Foundation

On the first sheets of *Life or Theater?*, as a kind of foreword to the prelude, the narrator tells the story of the emergence of that work. Powerless to stop them, she experienced melodies that formed a unity, encompassing what she wanted to express:

The creation of the following paintings is to be imagined as follows: A person is sitting beside the sea. He is painting. A tune suddenly enters his mind. As he starts to hum it, he notices that the tune exactly matches what he is trying to commit to paper. A text forms in his head, and he starts singing the tune, with his own words, over and over again in a loud voice until the painting seems complete. (5)

In accordance with Daberlohn's theory, Charlotte arrives at the heightened concentration that becomes possible at the transitional moment between life and death and that, as Daberlohn claimed, should be "filled" with singing. When she paints, a melody enters her mind like a Proustian involuntary memory. By singing that melody all the time, she is able to detach herself from her surroundings, from the world of everyday experience, and follow her stream of concentration. Thus, temporarily detached from life and death, she is able to make her life work.

But Salomon uses music not only to "fill" the gap between death and life; she also uses it to create distance, another sort of gap, within the work. Music enables her to resist narrative, to oppose the events and the experiences of her characters.[18] Let me give an example.

In the first scene of the first act of the prelude we see the wedding of Charlotte's mother, Franziska, to her father, Albert, and are asked to imagine the melody "We twine for thee the maiden's wreath." A fairy tale of happiness ever after seems to begin. We see the marriage party, represented in ceremonial festivity, and we are supposed to imagine as the background the appropriate German song. But when Franziska and Albert leave the party to go to a fancy Berlin hotel, the melody wavers: "No tune. Presumably: 'We twine for thee the bridal wreath.'" Then, in the hotel room, the melody is silenced ("No tune"). Only after Charlotte has been conceived does the melody begin again. The departure of Albert for the front and the lovingly detailed countryside surrounding the house are both presented "to the tune: 'We twine for thee. . . .'" Albert returns in 1917 ("No tune"), and Charlotte is born. Her first years pass in blissful happiness. However, for reasons unknown, Franziska has lost the joy of living. She tells her eight-year-old daughter that heaven is much more beautiful than earth. When she subsequently throws herself out the window, we hear the old melody again as Charlotte's grandmother looks out of the window ("We twine for thee . . . "). Then, as in the cinematic rep-

resentation of subjective seeing called suture, we follow the eyes of the grandmother and see what she sees: the mutilated body of her daughter below ("We twine for thee the maiden's wreath with violet-coloured ribbon").[19] The song jingles on. Father Albert scratches his face open in despair ("We twine for thee the maiden's wreath"). Little Charlotte runs through a dark corridor, and the melody is noted again—it seems to persecute her like a nightmare. Suddenly she sees a skeleton as in a vision. When she flees into the bathroom, the truth about her mother suddenly hits her ("To the same tune").

At first, music and image were almost too sweetly adapted to each other. But the gap grows ever wider. The music becomes more and more significant, because the relationship emerging from the gap replaces iconicity with ironic self-reflection. The final, merciless irony of the trivial little song intensifies the effect of the sinister images.

Textual Resistance

So far, I have read words and images in *Life or Theater?* as if they were complementary elements, illustrating—re-presenting—the narrated events or giving form to—presenting—Salomon's narrational comment on those events. This reading implies that we experience both the series of texts and the series of images as a continuity, and that the two series are mutually supportive. But this interpretation ignores the visual and material features of the written texts. All that is usually said about the texts is that they are visually very expressive. That strong visual quality bolsters the content of the narrated story, which is in turn mediated by coded language and illustrative, realistic images. In this view, the materiality of the texts does not "tell" anything, it only "adds" emphasis.

It is hard to sustain this reading when we consider the physical form Salomon adopted for her work. The texts accompanying the first 210 sheets (the prelude and the first few sheets of the main section) were written on sheets of tracing paper, which were pasted on top of the gouache images. Thereafter, the texts were written on the gouaches directly. One assumes that Salomon ran out of tracing paper and was forced to take a more immediate course.

The published version of *Life or Theater?* reproduces the gouaches but omits the transparent sheets of tracing paper that belong on top of the first 210 images. Instead the texts have been transcribed as image captions. Publisher Gary Schwartz explains this decision in the book's fore-

word: "It was decided that we could not do justice to the complete allusive complexity of *Life or Theater?* in the 'reading edition' we had in mind. The decision was made to limit ourselves to the gouaches and to a typographically neutral rendition of the text" (xiv). This explanation tacitly acknowledges only the expressive features of Salomon's writing. The fact that her words partly cover the images is ignored. But this is an important feature of Salomon's work—important because it results in a relation between word and image that, rather than being complementary or simply illustrative, is conflictful.

When we read the work in the form in which it was made, the texts on transparent sheets partly hide or even distort the visual images underneath. The first thing we see is the written text; only on second sight do we see the images through the tracing paper. In some cases the texts correspond in their form to the composition of the underlying image. In any event, the image is always overlayered, being "reached" only after we have removed the tracing paper texts.

In the second part of *Life or Theater?*, however, Salomon wrote her texts directly on the images. Rather than occupying a space isolated from the image, as in comic books, the texts appear *within* the representational space of the narrated story, supplementing the characters and events being depicted. Then in the "epilogue," which tells of the grandmother's suicide and Charlotte's decision to make her life work, the words begin to overrule the other representational elements. Until then, the words are modest supplements to the characters. In the epilogue, however, they begin to obtrude more and more. Increasingly they resemble graffiti, forming aggressive inscriptions on the surfaces they cover (Fig. 7).

One could argue that the epilogue is the most dramatic part of the whole work, for it is there that Charlotte is compelled to choose between also committing suicide and starting her life work. From that perspective, the fact that the words are placed increasingly to the fore might be considered an expressive means for giving form to this dramatic situation. But such an interpretation fails to account for the fact that the overruling of images by words is already the case in the tracing paper–covered sheets, where it happens in an even more literally material way.

The epilogue also yields another possible reading of the increasing inscription of words onto images. One sheet shows Charlotte's grandfather in bed, after his wife has committed suicide (no. 4905, p. 753; Fig. 8). The text covers almost the whole area; only the man's head is free of text. This sheet forces us to choose between the ambiguous meanings of the

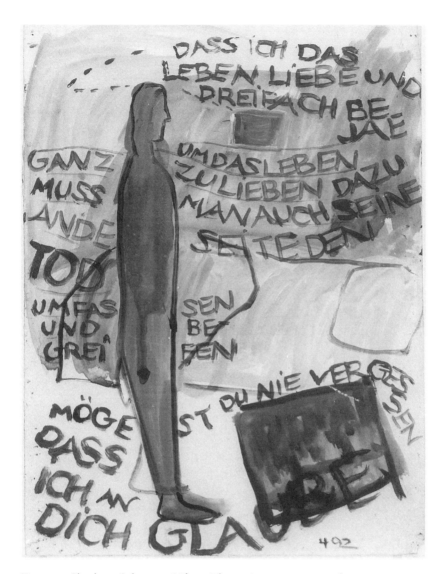

Figure 7. Charlotte Salomon, *Life or Theater?* no. 4870; gouache, 32.5 × 25 cm. Collection Jewish Historical Museum, Amsterdam, © Charlotte Salomon Foundation

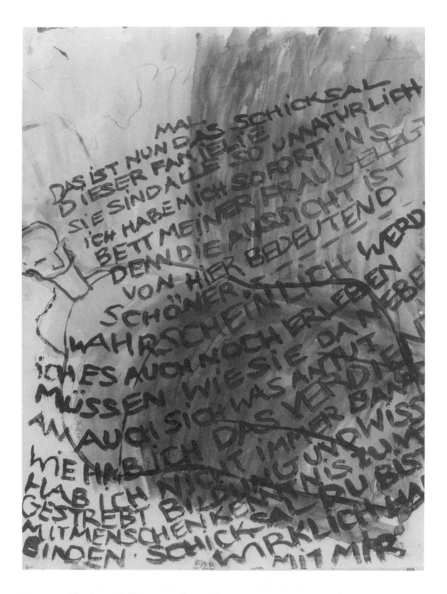

Figure 8. Charlotte Salomon, *Life or Theater?* no. 4905; gouache, 32.5 × 25 cm. Collection Jewish Historical Museum, Amsterdam, © Charlotte Salomon Foundation

verb *to cover* (in German, *decken*). The words here no longer *match* the grandfather, whom we see in the image, except in content: they render what he says. The words literally cover him up, *hide* him, much as the blanket covers him within the representational space. Salomon has covered her grandfather with words because that is her artistic way of resisting—covering up—this male family member. She cannot avoid or silence him as a character in her life history, but in the act of telling his story she resists him by covering him with words.

The act of resisting her grandfather has several meanings, all equally dramatic for Salomon. In the sheets shortly after this crucial image, Charlotte refuses her grandfather sexually. After his wife kills herself, he presses himself on Charlotte. Salomon has him say the following words: "I don't understand you. What's wrong with sharing a bed with me—when there's nothing else available. I'm in favour of what's natural." Charlotte answers: "Don't torment me. You know that I know exactly what I have to do" (764). This reply effectuates the integration of Charlotte's gender-specific life history: as a young woman she is all but overwhelmed by a powerful man and opts for her artistic vocation. The grandfather thus stands for the tradition in family life that subjects female children to the power of the father, and for the tradition in creative life that excludes women from artistic subjecthood.

She resists her grandfather artistically in another way as well. When she tells him her feeling that the whole world has to be put together again, his response is cynical: "Oh, go ahead and kill yourself and put an end to all this babble" (774). Instead of taking his advice, she begins making her life work. Her life work thus not only tells her life history, but it does so as an act of creation that remakes the world. The sheets that follow contain only text. Only with the very last sheet does another visual image appear (no. 4936, p. 784; Fig. 9). We see Charlotte at the beach working. She is about to draw or write on a still-empty transparent sheet. Like Proust, who ends his autobiographical masterpiece with a scene of writing, in which he begins the work we have just finished reading, so Charlotte ends with the start of the very work her grandfather told her not to bother to make.

Finally, there is a third way in which she resists her grandfather. This man plays a negative role for Charlotte in the history of her family, but also, as Salomon the narrator puts it on an unnumbered sheet, "My grandfather was for me the symbol of all the people I had to fight against."[20] This statement is remarkable in two respects. First, it suggests

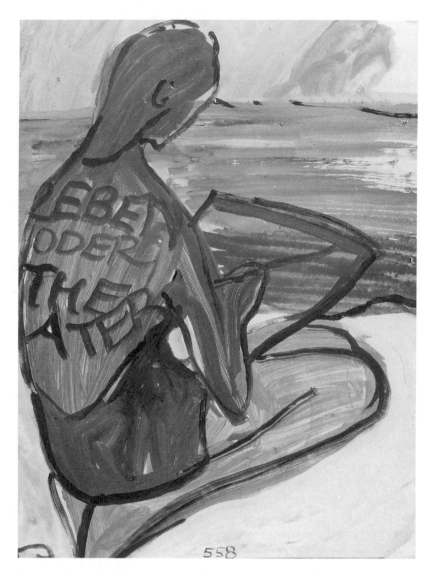

Figure 9. Charlotte Salomon, *Life or Theater?* no. 4936; gouache, 32.5 × 25 cm. Collection Jewish Historical Museum, Amsterdam, © Charlotte Salomon Foundation

that her grandfather also symbolizes the people of Nazi Germany—for she made her life work not only to repudiate the family fate of suicide, but also to reassemble a world being destroyed by the Nazis. In making her work, she tries to turn around the fate not just of her family but of all European Jews.

This symbolic condensation of functions projected onto the character of the grandfather explains the astonishing absence of any explicit resistance to the Nazis within Salomon's project. The history of Nazi oppression that affects Salomon's life so dramatically is not represented as such; rather, it is presented as the context for her narrative, and invades it only tangentially. By stating her ambition to remake the world, however, Charlotte does include that history within her personal struggle. The grandfather thus embodies evil and destructiveness on all levels of her life at once.

But second, her remark "My grandfather was for me the symbol of all the people I had to fight against" also makes it explicit that her work is a way of *fighting history*—her family history and political history both. This fight takes place between the words and images of which her works consists. Visually, she writes history, she renders the story of her family, and in so doing she exemplifies the history of the European Jews that is now known as the Holocaust. But she also writes the history of her gendered and her artistic becoming. These latter two histories could be written only as inscriptions of the other histories. In her texts, Salomon comments on the stories she tells; in her intertextual references, she appropriates the artistic conceptions of others; in her ironic composition of words, images, and music citations, she opens up gaps in which she is able to tell her story and to work through the histories in which she partook.

The triple resistance against the grandfather demonstrates her gendered and artistic becoming. It also shows why interpretations of Salomon's work in the exclusive terms of either Jewish history and the Holocaust or a phase in the history of art profoundly misread this work. Her fictional representation concerns her alter ego's struggle against this man who threatens her private life, her art, and, by extension and symbolically, even the collective history in which she lived. Salomon transgresses the boundaries between the categories that confine our readings, and she resists the traditions—of art, of history, of autobiography—that precluded her access to creation . . . or would have, if it hadn't been for her resistance.

Part II

The Historical Approach to
Memory, with a Difference

Deadly Historians

Christian Boltanski's Intervention in Holocaust Historiography

> My work is not about xxxxxxx it is after xxxxxxx.
> —Christian Boltanski, interviewed
> by Georgia Marsh

Charlotte Salomon inserted herself into the histories she struggled against by means of resistant participation; she positioned herself ambivalently in relation to family history, political history, and art history by creating her own personal history, but giving it an against-the-grain structure. Likewise do artists today, decades later and influenced by the course of history, engage ambivalently with the history from which she was violently excluded when she was murdered in Auschwitz.

Despite disagreements, the debate about Holocaust representations has been strikingly unanimous on one point: the survivors of the Holocaust and successive generations have a special responsibility to keep the historical events alive. This presumption as such should come as no surprise, for the Holocaust has disrupted every conventional notion of history heretofore constructed. Although the actual events are over and belong to the past, the experience of those events continues: many survivors live still inside them. This history, in other words, is at once in the past and in the

present. The cultural responsibility that befalls those living now, therefore, is to establish contact with the "past" part of the present survivors; to integrate them, with their past, into our present.

But what does this cultural responsibility toward the historical events mean? As we have seen in Chapter 1, for most critics and scholars active in Holocaust studies the artistic and literary genres that are most appropriate—most effective and proper—to depict the Holocaust are those that are realistic par excellence, those that do not attempt to fictionalize history but that offer history in its most direct, tangible form: to wit, testimonies, autobiographical accounts, and documentaries. This preference is based not on aesthetic but on moral grounds. Those modes of representation best serve our moral responsibility toward this gruesome past because they stay closest to the factual events.

When I use expressions like the "moral imperative" of Holocaust studies, I am not exaggerating or being oversensitive.[1] Terrence Des Pres, for one, has formulated prescriptions for "respectable" Holocaust studies in all seriousness. Appropriating the voice of God in his use of the "genre" of the Commandments, he dictates:

1. The Holocaust shall be represented, in its totality, as a unique event, as a special case and kingdom of its own, above or below or apart from history.

2. Representations of the Holocaust shall be as accurate and faithful as possible to the facts and conditions of the event, without change or manipulation for any reason—artistic reasons included.

3. The Holocaust shall be approached as a solemn or even sacred event, with a seriousness admitting no response that might obscure its enormity or dishonour its dead.[2]

Setting aside the question of the Holocaust as a "sacred" event, in this chapter I want to explore what is implied by "faithfulness to the facts and conditions of the event" and how this relates to artistic representation. I will focus on the commanded accuracy, as well as on the conceptions of history and of representation that it leads to.

The pressure exercised by and on Holocaust studies is based not only on a moral imperative, but equally on a particular conception of art and literature that seems to apply to the Holocaust specifically. These twin notions of art and of the Holocaust require that authors and artists model themselves in the image of the archivist or the historian—in short, in the image of those professionals whose task it is to inventory facts and reconstruct them in the correct place and time. They likewise require that artists use modes of representation that characterize the out-

put of the historian, ones that allow past events to be made objectively present.

The pressure I have in mind specifies the available modes of representation even further. The pursuit of the barest representation of the factual events gives preference to the practice of the archivist, who merely catalogs the events, over that of the historian, who transforms those events into a historical narrative. This preference may come as a surprise to students of literature, because realism as a literary mode of representation has always used narrative plot as its most elementary and seductive device. Aristotle already pointed it out: to be successful, the mimetic impulse must focus on action. Narrative plot is the inevitable result.

But when considering the historical more closely, the inevitable conclusion is that even history writing is not good enough for the purpose of keeping in touch with the Holocaust. Many twentieth-century historians, influenced, I would almost say determined, as they are by neopositivist thinking, approach even the most elementary narrative plot with suspicion. They do have a point: narrative retellings are always simplifications compared to the complexity of historical reality. And the coherence and unity of traditional plots produce meaning effects that may not have been present in the past. One problematic aspect of the traditional, realistic plot, for instance, is its closure: everything comes to an end, an end that somehow satisfies. And more often than not, that end is good.

If the very shaping of facts into a narrative, however truthful, is inherently unable to do justice to those facts, then the only mode of representation that might do, however poorly, is the archival mode: the collecting, ordering, and labeling of facts, items, and testimonies. The rigorous endorsement of that conclusion is what made Claude Lanzmann's 1985 film *Shoah* such a compelling work. Convinced of the basic untruthfulness and negative effects of any realist narrative account of the Holocaust, he did not try to represent, tell, that event. Instead he *collected* the memories of the victims of that past and *presented* the stories of survivors one after another (themselves representations, of course). *Shoah* is, however, not a documentary in the traditional sense. In fact, Lanzmann insists that his film is not a documentary but a performance, for in it he asks survivors to go with him, back to the places where they lived the events of the Holocaust. Marianne Hirsch and Leo Spitzer summarize his filmic practice well: "Like an analyst, he brings each of them to the point of re-experiencing their most profound encounter with the Nazi death machinery."[3] From that moment on, though, Lanzmann becomes a real

archivist: he collects the traces the Holocaust left in the form of reexperienced memories.[4]

In terms of the critical debate about Holocaust representation, Lanzmann's refusal to adopt the narrative function himself is the logical consequence of the general suspicion of realist narrative plots. It therefore came as no surprise when he criticized Stephen Spielberg for his depiction of the Holocaust in the 1993 film *Schindler's List*. Spielberg does not present traces of the Holocaust, he re-presents the Holocaust in the traditional realist mode. The result is a coherent narrative account with redemptive closure. Relying thoroughly on realist conventions, he creates the illusion of transparent entry to the historical events. Lanzmann criticizes Spielberg, for instance, because the film's closure seems to suggest that the Holocaust was meaningful in that it led to the birth of the state of Israel. (At the end of the film, surviving "Schindler Jews" and the actors who played them visit Schindler's grave in Israel and place stones on it.) The closing sequence, in color while the rest of the film is in black and white, strikes Lanzmann as a reconciliation with the Holocaust. To avoid this idea of reconciliation Lanzmann ended *Shoah* with the images of a moving train, to signify his conviction that the Holocaust never ends. Redemption is impossible. Although this symbolic ending betrays Lanzmann's rigorous refusal of the narrating subject, it is nonetheless possible to claim that he has modeled himself on the image of the archivist. Spielberg, in contrast, identifies himself as a storyteller. He is the narrativizing historian who uses all the devices of fictional realism to tell a rounded narrative.[5]

Given this pressure on artists and writers to represent the Holocaust in the mode of the historian, or even better in the mode of the archivist, it is notable that the French artist Christian Boltanski presents his works so consistently as archival products. At first sight he gives the impression of being an utterly docile artist, giving in readily to the moral imperative of the discussions about Holocaust representations. Some of his works are explicitly titled *Inventories* or *Archives*. And although Boltanski did not approach the subject of the Holocaust head on until 1988, with his installations *Chases High School* (1988; Fig. 10), *Canada* (1988), and *The Purim Holiday* (1989; Fig. 11), one can argue—as I will do later on—that *all* his works deal with some aspect of the Holocaust, albeit not necessarily iconically or in a traditional historical mode. The question that arises, then, is: What does this engagement with the preferred modes of the Holocaust historian mean as an artistic practice?

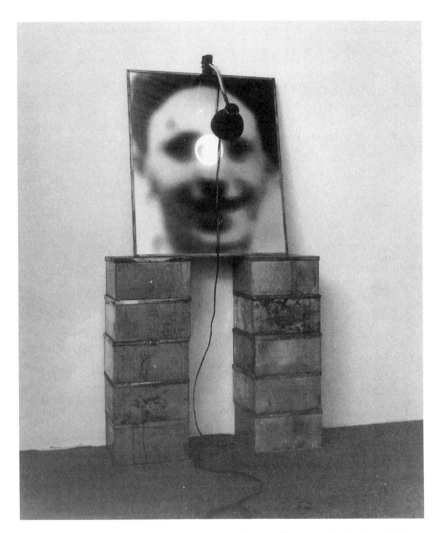

Figure 10. Christian Boltanski, *Chases High School*, 1988 (detail); installation: black-and-white photographs, photomechanical prints, metal lamps, approximately 120×60×23 cm

The first and third installations just mentioned evoke the Holocaust more or less directly in that Boltanski relied on images of specifically Jewish children. In *Chases High School* he used a photograph of the graduating class of a private Jewish high school that he found in a book on Jews of Vienna. He rephotographed the eighteen students individually, enlarging their faces until their features became a blur. As a result, their

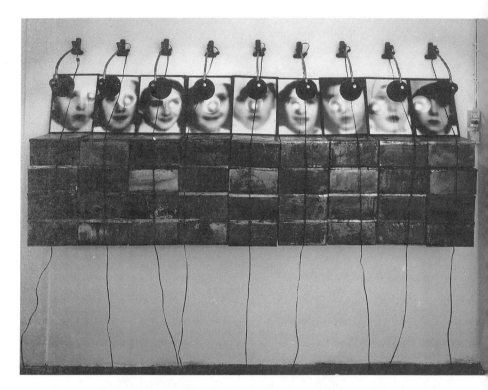

Figure 11. Christian Boltanski, *Monument: The Purim Holiday*, 1989; black-and-white photographs, photomechanical prints, metal lamps, tin boxes, wire, approximately 97 × 212 × 23 cm

eyes were transformed into empty black sockets while their smiling mouths turned into grimaces of death. The photographs, presented in tin frames perched on double stacks of rusty biscuit tins, were lighted from above by extendable desk lamps. The aggressive glare of the these lamps evoked the lights used in interrogation rooms. Instead of illuminating they are blinding, obscuring the enlarged faces even further.

The exhibition catalog includes the original photograph with the following caption: "All we know about them is that they were students at the Chases High School in Vienna in 1931."[6] This caption stresses the fact that the remaining picture has no correspondence with a present reality: the faces of the children as they appear in the photograph have disappeared. This disappearance is acted out in extreme close-ups. We now see not the realistic illusion of a living subjectivity, as the standard view of photography and of the portrait would have it, but empty, blinded

faces. And blinding is a figurative way of objectifying or even killing a person.

It is more than likely that most, or even all, of the represented Jewish students did not survive the Holocaust. *Chases High School*, as well as *The Purim Holiday*, is in that sense an explicit and direct *reference* to the Holocaust. This act of referring to a factual reality allows Boltanski the artist to qualify himself as a historian. He has traced a handful of victims of the Holocaust and now shows them to us. This aspect of his work is based on the same historical, archival principle as, for instance, Lanzmann's *Shoah*.

Yet in Boltanski's work the Holocaust is evoked not only by reference to its victims, but also by means of the connotative effects of the photographic signifiers. The enlarged images, which transform the faces into skeletal vestiges, remind us of the photographs published after the Second World War had come to an end, of the emaciated survivors of the death camps. This effect complicates Boltanski's position as a "good" practitioner of Holocaust studies.

Once this complication is foregrounded, one notices that these works evoke the Holocaust in yet another nonreferential way. Both *Chases High School* and *The Purim Holiday* can be seen as archives, for they bring together, without overt comment, images of Jewish victims of the Holocaust. In so doing they remind us of the lists of people who died in the camps, compiled by the Red Cross after the war so relatives could find out if their family members had survived. Seen in this light, the pictures evoke the incomprehensible number of concentration camp victims. Nevertheless, the object of these representations remains the archive as institution, not the "archived" subjects themselves.

It is important to realize that the last two ways in which Boltanski evokes the Holocaust—by reminding us of photographs and lists made at the time as documentation—are not based on reference per se. He produces what I call a "Holocaust-effect" by means of a reenactment of principles that in a sense define the Holocaust—a radical emptying out of subjectivity as a road leading to the wholesale destruction of a people: genocide. The reenactment of these principles and the Holocaust-effect they produce is, however, not at all confined to the works in which Boltanski addresses the Holocaust head on. His ability to produce the Holocaust-effect even in works that do not deal with that event in a direct—that is, referential—way defines not only his style but also the engagement with the debate on modes of representation that his art embraces.

I do not want to suggest that use of photographic enlargement or the archival mode to empty out subjectivity automatically gives rise to a Holocaust-effect. Rather, it is Boltanski's deliberate manipulation of these devices that brings it about. That is, by reenacting one specific, defining aspect of Nazism—one that would not in itself lead necessarily to overarching destruction—he represents the whole of Nazi practices, including their consequences. This he does by means of the rhetorical mode of synecdoche. It is the conjunction of this use of reenactment (concerning the practices of the perpetrators) with the overwhelming awareness of the total loss it evokes (concerning the victims of Nazism) that I call the "Holocaust-effect."

The two elements of Boltanski's works that give rise to this Holocaust-effect are his consistent use of photographic portraits and of the archival mode. But what makes these elements so effective? What do portraits and archives have in common that allows the creating of this Holocaust-effect? Mindful of Charlotte Salomon's resistant appropriation of genre, in the following pages I will explore the portrait, its generic premises, and Boltanski's appropriations of the genre for his own ends. That discussion will enable me to relate Boltanski's use of portraiture to the archival mode as the epitome of bare realism.

The Absence of Portraiture's Presence

The pictorial genre of the portrait, whether painterly or photographic, doubly cherishes the cornerstone of bourgeois Western culture: the uniqueness of the individual and his accomplishments. In the portrait, originality comes into play twice: in the "original," "unique" subjectivity of the portrayer, and in that of the portrayed. As Linda Nochlin puts it, in the portrait we watch "the meeting of two subjectivities."[7]

This traditional characterization of the genre foregrounds those aspects of the portrait that depend on specific notions of the human subject and of the practice of representation. As for the represented object, its subjectivity can be equated with notions like "self," "personality," or "individuality." A person's subjectivity is then defined in terms of its uniqueness and originality, not its social connections; one's interior essence or presence is key, rather than some moment of short duration in a differential process. Continuity or discontinuity with others is denied so that the subject may be presented as a personality.

As for the representation itself, the notion we get from this standard

view of portraiture is equally specific. That is, the portrait is seen to *refer* to a human being who is (or was) present outside the portrait itself. A recent book on portraiture makes this point on its first page: "Fundamental to portraits as a distinct genre in the vast repertoire of artistic representation is the necessity of expressing [an] intended relationship between the portrait image and the human original."[8]

The artistic portrait differs, however, from the photographic portrait, especially as used in legal and medical contexts, by doing slightly more than just referring to, or documenting, a person.[9] Rather, the portrayer proves her or his originality and artistic power by *consolidating* the self of the portrayed. Although the portrait refers to an original self already present, this self needs its portrayal in order to increase its own being. The portrayer thus enriches the interiority of the portrayed's self by bestowing exterior form on it. For without that outer form, the uniqueness of the subject's essence might be doubted.

By consolidating the self, portraiture gives authority not only to the person being portrayed, but also to the mimetic conception of artistic representation which enables that increase of authority. Since no pictorial genre depends as much on mimetic referentiality as the traditional portrait, it becomes the very emblem of that conception. The German philosopher Hans-Georg Gadamer is a clear spokesman for this exemplary status of the portrait.

The portrait is only an intensified form of the general nature of a picture. Every picture is an increase of being and is essentially determined as representation, as coming-to-presentation. In the special case of the portrait this representation acquires a personal significance, in that here an individual is presented in a representative way. For this means that the man represented represents himself in his portrait and is represented by his portrait. The portrait is not only a picture and certainly not only a copy, it belongs to the present or to the present memory of the man represented. This is its real nature. To this extent the portrait is a special case of the general ontological value assigned to the picture as such. What comes into being in it is not already contained in what his acquaintances see in the sitter.

In the portrait, according to Gadamer, an individual is represented not as idealized, or in an incidental moment, but in "the essential quality of his true appearance."[10]

This description of the portrait as exemplum of the (artistic) picture reveals the contradictory nature of mimetic representation. In this view, the traditional notion of the portrait depends on the rhetorical strategy

of mimesis, of make-believe.[11] Let us look at Gadamer's argument more closely. In the portrait, more than in any other kind of picture, he says, an "increase of being" comes about. This increase of being turns out to be the "essential quality" of the "true appearance" of the sitter.[12]

By extension, we can conclude that the portrait has two referents, both of which exist outside the work. The first is the sitter as body, as profile, as material form. The second is the essential quality of the sitter, his or her unique authenticity.[13] In the traditional notion of the portrait, it is almost a truism to say that the strength of a portrait is judged not just in relation to the appearance of a person, but also in relation to this essential quality. This explains the possibility of negative judgments on photographic portraits. Although a camera may capture the material reality of a person automatically and maximally, photographers have as many problems capturing a sitter's "essence" as do painters. Camera work is not the traditional portrayer's ideal but its failure, because the essential quality of the sitter can be caught only by the artist, not by the mechanism of a camera.

In Gadamer's text, however, we don't read about an essential quality being *captured*. The essential quality of the sitter, the "increase of being," is instead *produced* by the artist by means of the portrait. "What comes into being in it is not already contained in what his acquaintances see in the sitter." The portraitist makes visible the inner essence of the sitter in a visualizing act that is at once creative and productive. More than a passive rendering or capturing of what was already there, though interior and hence invisible, is involved. The portraitist actively gives this interiority an outer form so that we viewers can see it. This outer form, then, is the signifier of the signified, of the sitter's inner essence.

What to do with the addendum in this increase of being? Gadamer makes us believe that what comes into being in the portrait is the same as the referent or origin of the painting. Semiotically speaking, he presumes a *unity* between signifier and signified, between increase in being and the essential quality of the sitter. In presuming that unity, he denies that the increase of being is a surplus, thus exemplifying the semiotic principle of economy of mimetic representation, or the identity between signifier and signified.

This relationship is not inevitable. Andrew Benjamin historicizes the semiotic conception that also underlies Gadamer's view as follows:

The signifier can be viewed as representing the signified. Their unity is then the sign. The possibility of unity is based on the assumed essential homogeneity of

the signified. The sign in its unity must represent the singularity of the signified. It is thus that authenticity is interpolated into the relationship between the elements of the sign. Even though the signifier and the signified can never be the same, there is, none the less, a boundary which transgressed would render the relationship unauthentic.[14]

Most surprisingly in this argument, Benjamin attributes authenticity to neither the signifier nor the signified, but to the special relationship between the two. In the case of the portrait, this semiotic economy implies that the qualities of "authenticity," "uniqueness," and "originality" do not belong to the portrayed subject, the portrait, or the portrayer, but to the mode of representation which makes us believe that signifier and signified form a unity. In connection with the issue of authority, this entails a socially embedded conception: the bourgeois self depends on a specific mode of representation for its authenticity.

The link between a mimetic rhetoric and the production of authority can be illustrated with the example of Rembrandt. We think we know the face of Rembrandt from his self-portraits, even though other painters have presented him quite differently, simply because we adopt the mimetic way of reading them.[15] Perhaps Lievens's or Flinck's Rembrandts are closer to what the artist "really" looked like, but how can we doubt that such a great artist would tell the truth about himself?

Now my earlier remark that the portrait embodies a dual project becomes clearer, because more specific: it gives authority to the portrayed subject *as well as to* mimetic representation. The illusion of the presence and authenticity of the portrayed subject presupposes, however, a belief in the unity of signifier and signified. As soon as this unity is challenged, the homogeneity and authenticity of the subject falls apart.

This is exactly what happens in Boltanski's work with portraits. He challenges the unity between photographic signifier and signified by focusing intensely on the very idea of reference, the presumed premise of portraiture as well as of photography. Boltanski is outspoken in his desire to "capture reality." Many of his works, for example, consist of rephotographed "found" snapshots. The "capturing of reality" happens twice in these works: first the images are found, then they are rephotographed—captured and recaptured.

These doubly-captured images are incorporated within larger installations. In *The 62 Members of the Mickey Mouse Club in 1955* (1972), for instance, Boltanski presents rephotographed pictures of children he collected when he was eleven years old from the children's magazine *Mickey*

Figure 12. (left) Christian Boltanski, *The 62 Members of the Mickey Mouse Club in 1955*, 1972; 62 black-and-white photographs in tin frames with glass, each photo 30.5 × 22.5 cm. Collection Ydessa Hendeles Art Foundation, Toronto. *(right)* Detail from *The 62 Members of the Mickey Mouse Club in 1955*

Mouse Club (Fig. 12). The children had sent in pictures that represented them best. We see them smiling, well groomed, with their favorite toy or animal. Seventeen years later, Boltanski is confronted with the incapacity of these images to refer: "Today they must all be about my age, but I can't learn what has become of them. The picture that remains of them does not correspond any more with reality, and all these children's faces have disappeared."[16] These portraits don't signify "presence," but exactly the opposite: absence. If "interiority" or "essence" actually existed in a portrait, as traditional belief would have it, these photographs should still enable Boltanski to get in touch with the represented children. But they don't. They evoke only absence.

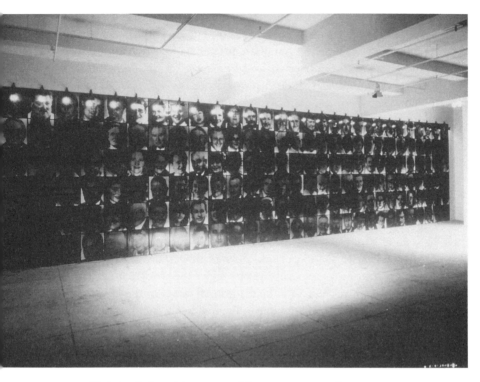

Figure 13. Christian Boltanski, *174 Dead Swiss*, 1990; installation view, Marian Goodman Gallery, New York: black-and-white photographs, metal lamps

In some of his later series—as we saw in the case of *Chases High School* and *The Purim Holiday*, but also in works that do not refer to the Holocaust by any direct means (that is, through the use of pictures of Jewish children)—he intensifies this effect by enlarging the photos so much that detail disappears: eyes, noses, and mouths become dark holes, the faces white sheets. Despite the lack of direct referentiality, the Holocaust-effect of these blow-ups is inescapable.

Boltanski provocatively addresses the importance and possibility of dealing with the Holocaust in a nonreferential or nonhistorical way in his installation series *The Dead Swiss*. In *174 Dead Swiss* (1990; Fig. 13), for example, he cut out illustrated obituaries from a Swiss newspaper. The photographs of the recently deceased were usually snapshots or studio portraits taken to commemorate events such as a wedding or a graduation. Just as in his other photographically based works, Boltanski reshot the already grainy images, enlarging them to slightly bigger than life size.

The size of the portraits, as well as the depiction of Swiss rather than Jews, was intended to evoke normality. These portraits did not refer to humans who were victimized in an unimaginable way, nor did they refer to the absoluteness or overwhelming power of death. As Boltanski put it, "Before, I did pieces with dead Jews but 'dead' and 'Jew' go too well together. There is nothing more normal than the Swiss. There is no reason for them to die, so they are more terrifying in a way. They are us."[17]

Boltanski has done everything to make identification and correspondence possible between the living spectators and the images of the dead Swiss, who are represented, however, as alive. Nevertheless, two features of this work make the Holocaust-effect unavoidable. First is the sheer number of similar portraits, which transforms the sense of individuality typically evoked by that genre into one of anonymity. The work can thus be seen as a reenactment of one of the defining principles of the Holocaust: the transformation of subjects into objects.

This transformation occurs as one views the work. On seeing the first image, one can still activate the traditional belief in the capacity of portraiture: the presence of a unique individual being is palpable. As one proceeds from picture to picture, all similar—ultimately, all the same—the opposite effect takes over, and one senses only the lack of presence, indeed, the profound absence, of unique human beings. The sameness of all the faces is reinforced by the second aspect of this work that actuates the Holocaust-effect: the fact that the photographs have been dramatically enlarged. This process causes individual features to be obscured, diminished. One sees only a collection of exchangeable objects. This transformation of one's experience as a spectator by means of repetition and obscuration is precisely what reenacts the Holocaust. This reenactment is an *effect*, not a representation; it *does* something instead of showing it.

The Holocaust-effect thus produced undercuts two elements of the standard view of the portrait. By representing these people as (almost) dead, Boltanski foregrounds the idea that the photographs have no referent; and by representing these human beings in the "Nazi mode," that is, without identifying features, he negates the "presence" in the portrait of an individual. All the portraits are exchangeable: the portrayed have become anonymous. Likewise, they all evoke absence: not only absence of a referent outside the image, but absence of presence within the image as well.

About his *Monument* (1986–87; Fig. 14), for which he used photographs of himself and seventeen classmates, Boltanski says:

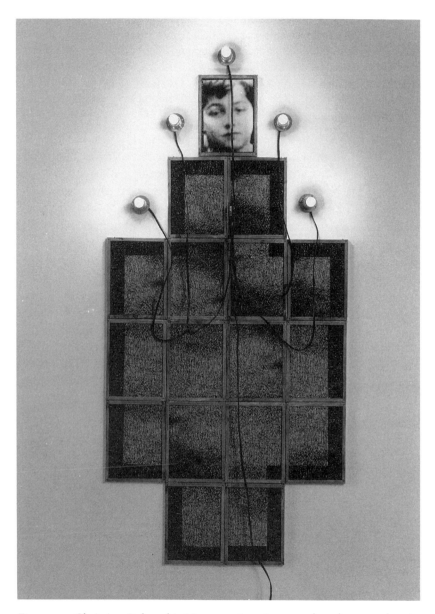

Figure 14. Christian Boltanski, *Monument*, 1987; 17 color photographs, tin frames, 5 lights with wires, 130×60 cm

Of all these children, among whom I found myself, one of whom was probably the girl I loved, I don't remember any of their names, I don't remember anything more than the faces on the photograph. It could be said that they disappeared from my memory, that this period of time was dead. Because now these children must be adults, about whom I know nothing. This is why I felt the need to pay homage to these "dead," who in this image, all look more or less the same, like cadavers.[18]

The photographs don't help him to recover memories of his classmates. He calls his fellow students "cadavers" because the portraits of them are dead. The portraits are dead because they provide neither presence nor reference. He only remembers that which the picture offers in its plain materiality as a signifier: faces. Any "increase of being" is clearly denied.

The dead portraits are in tension with another important element of his installations, which is their frequent framing as monuments, memorials, altars, or shrines (for example, *Monuments*, 1985; *Monuments: The Children of Dijon*, 1986; *Monument [Odessa]*, 1991). The portraits are in many cases lit by naked bulbs, as if to represent candles, emphasizing the work's status as memorial or shrine. The intention of these installations is explicit in the way they are framed: they want to remember, to memorialize, to maintain contact with the subjects portrayed. The photographs, however, conflict with this stated intention. Instead of making the portrayed subject present, they evoke only absence. As a result, the memorials serve to memorialize not so much a dead person or, less ambitiously, a past phase of somebody's life, but a dead pictorial genre. The portrait is memorialized in its failure to fulfill its traditional promise.

Boltanski has also constructed photographically based works that make a slightly different point about the portrait as a genre. In these works, the Holocaust-effect is driven by another mechanism. *The Archives: Détective* (1987) and *Reserve: Détective III* (1987; Fig. 15), for example, incorporate images from the French tabloid *Détective*, which reproduces photographs of murderers and their victims. In the first of these he rephotographed and enlarged the images; in the second he used the newspaper photographs themselves, taping them onto cardboard cartons on which a random date from 1972 was written. The cartons were stacked on crudely constructed wooden shelves. It was intimated that the cartons contained documents concerning the individuals whose images appeared on the outside, but because one was not supposed to open the cartons, there was no way of knowing for sure.

As is often the case in Boltanski's work, *Reserve: Détective III* is not

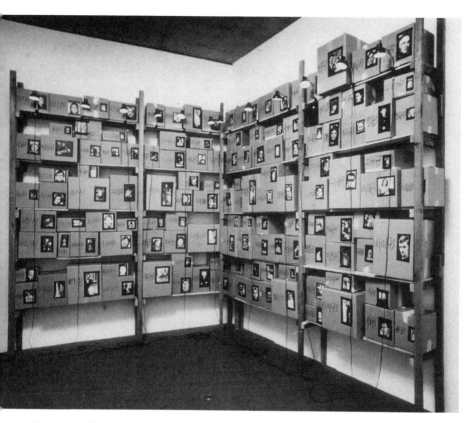

Figure 15. Christian Boltanski, *Reserve: Détective III*, 1987; wooden shelves with cardboard boxes, photographs, stories, and twelve black lamps

a "real" archive, it only has that effect. In reality the boxes contained only unrelated newspaper stories. But let us take its effect seriously. As a consequence of the separation of image and text, it is impossible to distinguish the murderers from the murdered. We see only smiling faces. Another part of the same installation focused even more explicitly on the impossibility of distinguishing the criminal personality from that of the victim. In addition to the sets of shelves and cardboard boxes, the installation consisted of twelve framed collages of the same photographs lit by clamp-on lamps, which again created the impression of interrogation and scrutiny as if the portraits themselves were being pressed—without success—to reveal their truth. Again, both portraiture and photography prove unable to supply the presence of someone's subjectivity; instead they have turned the subjects into objects. All we see are faces.

Figure 16. Christian Boltanski, page from *Sans-Souci* (Frankfurt-am-Main and Cologne: Portikus & Walther König, 1991)

Boltanski creates a similar effect in works that use snapshots from German family photo albums which he found at a flea market, such as *Conversation Piece* (1991) and his book *Sans-Souci* (1991; Fig. 16). "These albums," notes Lynn Gumpert, "documented the lives of ordinary people during extraordinary times. Among the ritualized shots of birthdays and anniversaries were uniformed Nazi soldiers—smiling and holding babies, happy, it seems, to have a respite from their duties."[19] *Sans-Souci*, for example, reproduces found snapshots of several German families. Although the people represented probably did not know one another, the book presents itself as the photo album of a single family. As in "real" photo albums, the pages are separated by sheets of tissue paper.

Intriguingly and disturbingly, in *Sans-Souci* the traditional meanings of the family photo album overrule the subjectivities that are supposed to reside in the snapshots. The Nazi soldiers in these photographs show no signs or symptoms of the ideology and destruction in which they partake. We

see only affectionate friends, lovers, husbands, and fathers. Gumpert reads the impossibility of recognizing the Nazi character or subjectivity in these pieces as a reflection of Boltanski's disinclination to ascribe blame. He is presumed to "underscore the potential evil that resides in us all."[20] This reading, however, strikes me as implausible because it neglects the very mode of artistic practice that Boltanski relies on: the photographic portrait.

In her study Gumpert quotes a remark by Boltanski that allegedly illustrates his intention behind works like *Conversation Piece* and *Sans-Souci*. In 1987, when the trial of the infamous Nazi war criminal Klaus Barbie in Lyon was reported in all the newspapers and on television, Boltanski said, "Barbie has the face of a Nobel Peace Prize winner. It would be easier if a terrible person had a terrible face."[21] In my view, however, Boltanski is not making a claim about the potential evil that hides in us all; on the contrary, he is labeling one specific person, Klaus Barbie, a terrible person. His remark exposes the problem that this terrible subjectivity simply cannot be recognized when we see this person only as an image in newspapers or on television, or even when we see him in person. In the process of the terrible subject Barbie being represented as an image, he is transformed into something else and he loses his terribleness.

"In most of my photographic pieces," explains Boltanski generally, "I have manipulated the quality of evidence that people assign to photography, in order to subvert it, or to show that photography lies—that what it conveys is not reality but a set of cultural codes."[22] In the case of *Sans-Souci*, it is the family album as a traditional medium bound up in a fixed set of meanings that blocks access to the Nazis as subjects. This suggests that the snapshots that fill family albums in fact do the opposite of capturing and representing the reality of a family.[23] Boltanski observes, "I had become aware that in photography, and particularly in amateur photography, the photographer no longer attempts to capture reality: he attempts to reproduce a pre-existing and culturally imposed image."[24]

The photographic portrait fails to fulfill its promises in yet another way. Recall that in the traditional view, the photographic portrait captures the reality and truth of a person's subjectivity; it makes the portrayed subject present. Most of Boltanski's photographic works, however, confront the viewer with absence, not presence; with objects, not subjects; with cadavers, not living human beings. Yet the works featuring images of murderers or Nazi soldiers confront us not with absence, but with lies. With these works Boltanski is not attempting to show that Nazi soldiers were also loving husbands or fathers; his purpose, rather, is to convince

us that the photographic medium is inherently incapable of capturing the reality of the Nazi subject. Any such efforts result only in lies.

By demonstrating that photography is a medium of lies, Boltanski creates yet another Holocaust-effect. This time he does not reenact the absolute dehumanization of Nazism, but another aspect of Nazism intrinsic to the Holocaust. He stimulates viewers to activate a set of cultural codes (such as the family album) that projects false meanings and lies onto the portrayed subjects. By accepting these cultural codes as transparent, it is as if we the viewers step into the shoes of the Nazi soldiers who believed they were acting as decent citizens by doing what they were doing, who believed, to cite the most famous Nazi lie, that *Arbeit macht frei*.

The portraits in Boltanski's work repeatedly produce the same disturbing effect. They do not evoke the presence of a human being in all her or his individuality; instead they evoke the idea of absence or of the projection of lies. Boltanski deconstructs the promise of the photographic portrait of providing an exact, faithful correspondence to a historical or living reality. One is confronted, rather, with the split between signifier and signified or, worse, with the disappearance of the signified altogether. Provocatively and consistently, his works succeed in failing to provide living realities that correspond with the represented persons.

Leftovers of Reality

The two modes of representation that produce a Holocaust-effect in Boltanski's work are photographic portraiture and the archive. As we have seen, both modes exemplify bare realism, the representational effect so sought after in Holocaust commentary. The photographic portrait and the archive apparently share the ability to convey a sense of (historical) reality in a seemingly objective way, such that we can almost speak not of representation, but of a presentation of reality. In both cases there seems to be a minimum of intrusion or "presence" of either subject or medium of representation in the ultimate product. Another aspect that links these two modes in Boltanski's practice is the foregrounding, and then questioning, of the notion of individuality.

I now want to explore Boltanski's use of the archive in order to uncover possible consequences of that mode for our understanding of the Holocaust itself. In only one of his archival works, *Canada* (1988), is the Holocaust evoked by direct reference. The title is based on the euphemistic name the Nazis gave to the warehouses where the personal belong-

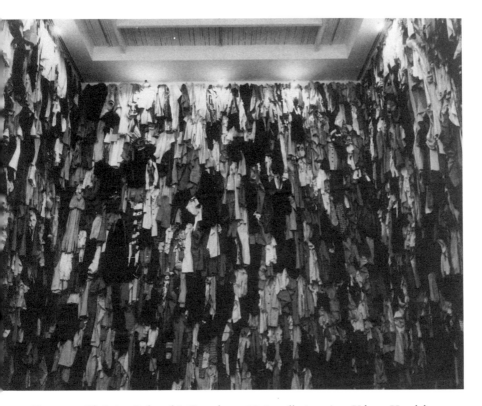

Figure 17. Christian Boltanski, *Canada*, 1988; installation view, Ydessa Hendeles Art Foundation, Toronto: secondhand clothing

ings of those killed in the gas chambers or interned in the labor camps were stored. "Canada" here also stands for a country of excess and exuberance where one wants to emigrate because it can offer a living to everybody. In this series of works Boltanski displayed piles of secondhand clothing (Fig. 17). For the first version, at the Ydessa Hendeles Art Foundation in Toronto, he used six thousand garments. The brightly colored clothes hung by nails on all four walls, covering every inch of the room. The sheer number of garments evoked clearly the incredible number of people who died in the camps and whose possessions were stored in "Canada."

Like *Chases High School* and *The Purim Holiday*, *Canada* evokes the Holocaust referentially. This time it is not the material used—photographs of European Jewish children before the war—that connote the Holocaust, but the title of the work. The garments, probably obtained

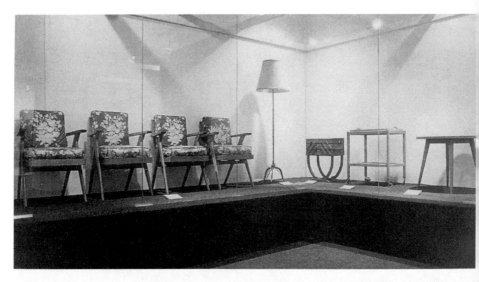

Figure 18. Christian Boltanski, *Inventory of Objects That Belonged to a Woman of Bois-Colombes*, 1974; installation view, Centre National d'Art Contemporain, Paris

from the Salvation Army in Toronto, therefore represent a specific historical space: the warehouses of Auschwitz. Boltanski, however, has made other works, based on the same archival, inventorial principle, that do not overtly refer to the Holocaust by denominating a specific element of it. They, too, exercise a "Holocaust-effect."

In 1973 and 1974 Boltanski made several installations, generically called *Inventories*, that consisted of the belongings of arbitrarily selected individuals. In *Inventory of Objects That Belonged to a Woman of Bois-Colombes* (1974; Fig. 18), for instance, he presented the furniture of a woman who had just died. These belongings had the function of witnessing that woman's existence. Semiotically speaking, these "Inventories" are fundamentally different from the installations that rely on photographs for their impact. Whereas the photographs refer iconically—or better, fail to do so—the inventories refer indexically. The pieces of furniture represent the woman, not in terms of similarity or likeness, but in terms of contiguity. The woman and her belongings have been adjacent to one another. Or rather, the belongings pretend to be, and thus represent the idea of having been, contiguous to the woman, for later Boltanski admitted that he had "cheated" the audience by exhibiting furniture he had borrowed from personal acquaintances. This cheating only enhances

the semiotic status of the work, in that the sign, according to Umberto Eco, is "everything which can be used in order to lie."[25] The installations are not "real" indexes but "look like" such; just like fake signatures, they are icons parading as indexes.

The point here is the shift from icon to index.[26] The difference between the iconical and the indexical works, namely, is a matter of pretense. The photographic portraits claim, by convention, to refer to somebody and to make that person present. As I have argued, however, they fail in both respects. The indexical works, in contrast, claim no particular presence: they simply show someone's belongings, not the person herself. And strangely enough, they seem to succeed in referring to the person to whom they allegedly belonged.

At first sight, it is rather unexpected that Boltanski's installations based on the archival mode come closer to fulfilling the standard claims of portraiture than do his photographically based pieces. This success is due to the fact that a traditional component of the portrait has been exchanged for another semiotic principle: likeness, similarity, has gone; contiguity is proposed as the new mode of portraiture. When we stay with the standard definition of the portrait,[27] Boltanski's indexical works fit much better in the genre of the portrait than do his photographic portraits.

Although referentiality is more successfully pursued in the indexical installations, the problem of presence in these works is again foregrounded as a failure. In *The Clothes of François C.* (1972; Fig. 19), for instance, we see black-and-white, tin-framed photographs of children's clothing. The Holocaust-effect is created once more. Not only do we wonder who and where the owner of the clothes is, but we also inevitably think of the warehouses in the death camps, where all the belongings of the inmates were sorted (thus depriving them of individual ownership) and stored for future use by the Germans. After the war, some of these storage facilities were found; they became symbols—or better, indexical traces—of the millions who were put to death in the camps.

In other indexical "portraits" the Holocaust-effect is pursued even more directly. Part of the installation *Storage Area of the Children's Museum* (1989; Fig. 20), for instance, consisted of shelves bulging with clothing—again suggesting the incomprehensible numbers who died in the concentration camps. In contrast with the *Canada* series, though, these works do not refer overtly to the Holocaust; they have a Holocaust-effect because they reenact a principle that defines the Holocaust, to wit, the extreme deprivation of individuality. Denied their personhood, the

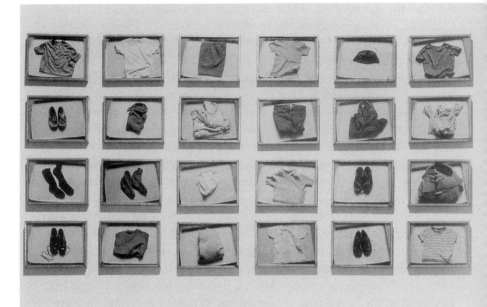

Figure 19. Christian Boltanski, *The Clothes of François C.*, 1972; black-and-white photographs, tin frames, glass, each photograph 22.5 × 30.5 cm. Musée d'Art Contemporain, Nîmes, on loan from the Fonds National d'Art Contemporain, Paris

victims of the Holocaust were treated as specimens of a race that had to be collected and inventoried before they could be used (in the labor camps) or destroyed (in the gas chambers). Not only did the Nazis inventory the possessions of their victims; they applied the same principles to the victims themselves.

The notions of usefulness and uselessness are crucial for understanding how Boltanski's archival works produce a Holocaust-effect. The "inventories" or selections that were performed when one entered the camps, but that returned almost daily when one had the good luck to be allowed into the labor camps, were based on that very distinction. The mechanisms of the Holocaust were such that ultimately everybody ended up in the "useless" category.

This idea of uselessness overwhelmed Boltanski when, like many other artists in the 1960's and 1970's, he became interested in anthropological museums. The Musée de l'Homme in Paris made the following impression on him:

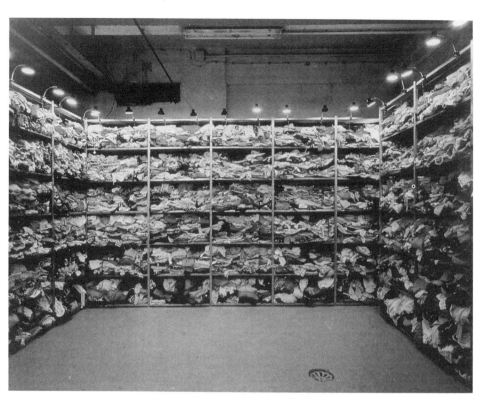

Figure 20. Christian Boltanski, *Storage Area of the Children's Museum,* 1989; installation view, "Histoires de musées," Musée d'Art Moderne de la Ville de Paris: children's clothing, metal shelves, lamps

It was . . . the age of technological discoveries, of the Musée de l'Homme and of beauty, no longer just African art, but an entire series of everyday objects: eskimo fishhooks, arrows from the Amazon Indians. . . . The Musée de l'Homme was of tremendous importance to me; it was there that I saw large metal and glass vitrines in which were placed small, fragile, and insignificant objects. A yellowed photograph showing a "savage" handling his little objects was often placed in the corner of the vitrine. Each vitrine presented a lost world: the savage in the photograph was most likely dead; the objects had become useless—anyway there's no one left who knows how to use them. The Musée de l'Homme seemed like a big morgue to me.[28]

Boltanski expected to find "beauty" in the museum, an expectation perhaps inspired by the cubist eye for the objects of African cultures; instead he found lost worlds in the vitrines. The inventories reveal the same

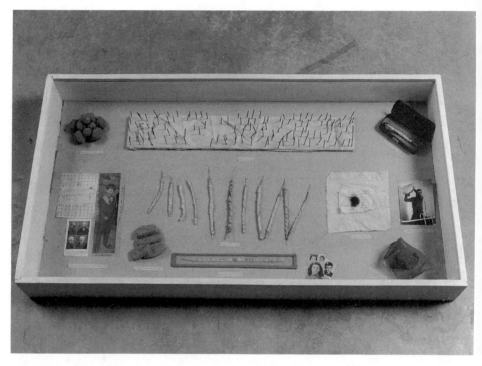

Figure 21. Christian Boltanski, *Reference Vitrines*, 1969–70; various objects in wooden vitrine with plexiglas, 120×70×15 cm

meaning to him as photographic portraits do. He sees absence rather than presence. The anthropological museum was no fine arts museum; it was transformed into a morgue of useless objects.

In the late 1960's and early 1970's Boltanski made two series of works in which he turned to the museological vitrine, *Attempt to Reconstruct Objects That Belonged to Christian Boltanski Between 1948 and 1954* (1970–71) and *Reference Vitrines* (1970–73; Fig. 21). In the latter he displayed a sampling of the work he had made since 1969, including small piles of dirt balls, handmade knives and traps, carved sugar cubes, and pages from his books and his mail-art. Each item in the vitrines had a label, usually listing the title and the date of the work. With this series Boltanski turned himself into the archivist of his own work. In the similar series *Attempt to Reconstruct*, he was the archivist of his childhood.[29]

These "reconstructions," however, fail utterly *as* reconstructions, for they prove incapable of reconstituting either his childhood or his artistic career. Instead all we see is useless objects. The frame of the museological

vitrine or the archeological museum—in short, the archival mode of representation—withdraws objects from the contexts in which they originally belonged and defines them, finally, as useless. This focus on practices that transform the useful into the "useless" again evokes the Holocaust. The same principles constituted the practice of the Nazis in the Holocaust. In both his archival work and his photographic work, then, Boltanski, rather than "obeying" the prescriptions of historians, challenges and subverts them.

Boltanski as Historian

As I mentioned in Chapter 1, in *Reflections of Nazism* the historian Saul Friedlander suggests that systematic historical research, which uncovers the facts in their most precise interconnection, provides little understanding of the Holocaust; on the contrary, it protects us from the past, keeps it at a distance. The distance is caused by the reading attitude the reader is encouraged to adopt by the historian's language. The attitude of the expert, in charge of checking the accuracy of the facts and the connections between them, protects the reader: "That neutralizes the whole discussion and suddenly places each one of us, before we have had time to take hold of ourselves, in a situation not unrelated to the detached position of an administrator of extermination. Interest is fixed on an administrative process, an activity of building and transportation, words used for record keeping. And that's all."[30]

Paradoxically, this detached position of the historian involves more than a neutralization of the discussion about the Holocaust; indeed, the historian could in a sense be said to *reenact* the Holocaust or what led to it precisely by assuming the "detached position of an administrator of extermination." Thus, instead of providing real understanding of the Holocaust, the historian provides his or her readers with, in effect, a Holocaust performance. The result can be quite uncanny in the hands of a historian who is neither self-reflexive nor aware of the effects of historical practice. Friedlander, however, *is* aware, *is* self-reflexive. Yet he indicates that for the historian there is no way out: "The historian cannot work in any other way, and historical studies have to be pursued along the accepted lines. The events described are what is unusual, not the historian's work. We have reached the limits of our means of expression. Others we do not possess."[31]

Boltanski the artist presents himself not as a "believer," but as a self-reflexive historian like Friedlander.[32] He adopts and explores the archival

modes of the historian as if he *wanted* to follow the rules as formulated by so many Holocaust commentators. He consistently uses modes of representation that are supposed to provide the most truthful, objective account possible of past realities. From this perspective the photographic portraits, the vitrines, the reconstitutions, the inventories all belong to the same historical paradigm: they are all extreme examples of nonnarrative genres that stand for bare realism. They embody the promise of the presence of the past. Yet this promise is never fulfilled. Nor, by implication, is the historian's.

Boltanski foregrounds the Janus face of historical realism. He shows us, again and again, the presence of absence. His acts of reconstruction and making present hit us with the awareness that what is being reconstructed is forever lost. But Boltanski does much more than inflict a general idea of death, loss, and absence on the viewer. He specifies the modes of production semiotically as well as historically. Foregrounding the principles of the archival mode, he foregrounds the Holocaust, its presentness in its pastness, in the same act. The way he does this is summarized by the epigraph with which I began this analysis: "My work is not about xxxxxxx it is after xxxxxxx."[33]

The word *Holocaust* is not mentioned in this sentence. Twice we see an unreadable mark, the result of Boltanski's "corrections" in the text of an interview. It is quite plausible, however, that the crossed-out word was *Holocaust*. Boltanski has said in several interviews that he considers his work to be post-Holocaust work, suggesting that for him the Holocaust marks a fundamental break in history. If the unreadable word is indeed *Holocaust*, the implication is that the Holocaust itself is unreadable or incomprehensible. That is precisely why his work is not "about" the Holocaust.

For creating work "about" the Holocaust would be a hopeless project—hopeless because of the impossibility of having a detached position from which one could write "about" it. Although one cannot make work about the Holocaust, one can focus on the fundamental changes in our perception of life after the Holocaust.

The break caused by the Holocaust consists for Boltanski in a loss of hope or of utopia:

For a long time humanity was in a childhood-like state believing that things would get better and better, that man would become more and more wise. What is terrible is that after the Holocaust we can see that it was not true. And now with the end of Communism, which is something very sad, we no longer have a

good utopia any more. Communism was the last Christian utopia. Holocaust was the worst thing that could happen. In the 19th century it was possible to believe in a moral utopia and a scientific utopia. Today we have lost everything.[34]

This is an important historiographic statement, albeit unelaborated. For as Hayden White has argued, the nineteenth century is also the century of the professionalization of historical thinking. In order to transform itself into a modern scientific discipline, it had to disengage from political and ideological modes of thought. "History," that is, had to repress utopian thinking if it wished to claim authority as a discipline. Only at that point could historical modes of representation be defined by distinguishing them from fiction and imagination. Historical thinking was thus de-rhetoricized, an effort that proved to be, as White puts it, a "rhetorical move in its own right, the kind of rhetorical move that Paolo Valesio calls the rhetoric of anti-rhetoric."[35]

Disciplinization led to an image of history as something that can be ordered, understood, explained. Until then it had been subordinate to political and utopian thinking, which looked on history as unrepresentable, "a spectacle of crimes, superstitions, errors, duplicities, and terrorisms."[36] This moral anarchy and unrepresentability, it was thought, justified visionary and utopian recommendations for a politics that would anchor social processes in a new, rational ground. Yet in the domestication of history as an understandable and explainable domain, a respected object of disciplinary study, its ineffability, its spectacle of the sublime, vanished.

Boltanski seems to suggest that the disciplinization of history and its modes of representation, with the consequent loss of utopian thinking, defines the Holocaust in a crucial way. Again and again he turns to the archival mode of representation as a way of evoking the Nazi structuring of history and genocidal practices. His works, then, evoke the Holocaust by being not "about" that event, but "about" the disciplinization of history. Another danger lurks here, however. This conclusion might seem paradoxical if his distance from the disciplinization of history entailed a nostalgia for the view of history that preceded it. For as Hayden White has remarked, fascist ideologies can be seen as a return of utopian thinking following the disciplinization of history: "It is possible that fascist politics is in part the price paid for the very domestication of historical consciousness that is supposed to stand against it."[37] The nostalgic desire for sublimity serves in this case to legitimize the project for the future.

This opens the possibility that Boltanski's work, in its critique of historical modes of representation and of the domestication of the past, un-

consciously taps into the Nazi project that he assumes to have laid bare. I do not think that is so, but the reason needs spelling out. It cannot be denied that Boltanski is turning the past—specifically, the past of the Holocaust—into something that suggests the sublime, that recedes into absence when we try to grasp it. By *failing* to domesticate the past, he presents the very opposite of a well-ordered and understood image of history.

Significantly, however, this resublimation of the past is not performed, as in the case of Nazism, as a way of legitimizing the utopian thinking of fascism. For Boltanski, the Holocaust signified the end of any utopia: "Holocaust was the worst thing that could happen. In the 19th century it was possible to believe in a moral utopia and a scientific utopia. Today we have lost everything. . . . We have no more hope."[38] He defines not only the past, but also the future, in terms of a sublime chaos that defies order.

It is here, in this different conception of the future (rather than the past), where Boltanski's critique of Nazism comes to closure. The only space that is left for him is the present—a good starting point for a contemporary artist. In Chapter 6 I will discuss how some of his works indeed fight the absence of the past *and* of the future, by depending radically on being processed in the present.

Before examining this alternative to the historical approach, however, I want to look at another critical response to history: that of the Dutch artist Armando.

Touching Death
Armando's Quest for an Indexical Language

The crucial point here is the changed symbolic status of an event: when it erupts for the first time it is experienced as a contingent trauma, as an intrusion of a certain nonsymbolized Real; only through repetition is this event recognized in its symbolic necessity.
—Slavoj Žižek, *The Sublime Object of Ideology*

Death Versus Representation

Whereas Boltanski's work is in only a few cases explicitly about the Holocaust, the work of Dutch writer and visual artist Armando is consistently about World War II—in Dutch, simply "the war." Yet neither artist "talks about" this subject overtly. Boltanski's engagement with it is performed negatively—its failure or impossibility is shown; Armando's engagement is indirect or oblique. The seemingly simple formulation often heard about Armando's work, that it is "about the war," turns out to summarize well the paradox of his project. For the phrase "the war" refers not to the concept of war in general, but to that one particular war that dwarfs all others: the Second World War. That war was so traumatic that its history has become the model for the very concept of war.

In this chapter, I will not use the word *Holocaust*; instead I will refer to "the war," World War II, or the Second World War. For Armando

is not himself a victim of the Holocaust or the war, but, living near Amersfoort Transit Camp as a young boy, he was "close to" the Holocaust and in that sense a witness of it. Although Armando was not confronted with the Holocaust directly, he felt and noticed its traces outside the camp. His work is precisely about this witnessing of symptoms of the event, rather than the event itself. In what follows, therefore, the war is treated not so much as the context in which the Holocaust took place, but as the plane of activity that allows an oblique, indirect view of that overwhelming event. Armando adopts this oblique position in the debate about historical modes of representing the Holocaust: like Boltanski, he develops ways of engaging differently with that history.

Reading "the war" as World War II entails a qualification of the genre to which Armando's work belongs. His visual work belongs to history painting; his literary work to historical literature. His work thus represents a specific historical period, comparable to the novels of Walter Scott or the paintings of Delacroix or David, which represent episodes from Scottish or French history. Yet this is not the way Armando's work is read. Most interpretations rightly suggest that it is not "historical" in any traditional sense, because the moments or events described cannot easily be pinpointed temporally or spatially. In semiotic terms, time and space are not referential; Armando's war appears to occur in an archetypal vacuum. Even if his war experiences are the *occasion* or catalyst for his work, their *meaning* is allegedly much more broad and can be expressed only in generalizing terms. As a result, his work tends to be interpreted as metaphorical, standing for the human condition.

I contend, and will try to demonstrate, that this view of Armando's work as metaphorical rather than historical has far-reaching consequences; that it is fundamentally escapist—eliding both the war and the artist's attempt to keep in touch with it. According to R. L. K. Fokkema, for example, "Nowhere in his poetry does Armando describe specific events or a specific place. His work is not at all anecdotal; rather, it is a visual examination of the abstractions of war and battle, of relationships between people. Essentially the war is for him a metaphor for *la condition humaine*, and Amersfoort as a location is a metaphor for the world."[1] Carel Blotkamp makes a similar claim, even using the same phrase, about Armando's visual images. In the catalog for an exhibition of Armando's work at the Fruitmarket Gallery in Edinburgh he wrote: "It isn't the specific situation in which he found himself which is conveyed in his paintings and drawings, poems and prose. It is more as though war

has become, for him, a metaphor for the human condition."[2] Blotkamp accomplishes this metaphorical transfer by deleting the definite article before the noun *war*. It is this deletion, not Armando's images, that leads to generalization.

In Western culture, the notion that the value of art and literature lies in their metaphoric quality is so self-evident that Fokkema's and Blotkamp's understanding of Armando's work seems indisputable. For it is precisely the *similarity* between the specific work and the general condition under which the reader or viewer also suffers that supposedly enables artists to seduce the public into seeking out their work. In Armando's case, however, the implications of such a metaphorical reading are far from innocent.

The focus on the Second World War as a metaphor for the human condition implies a leveling out, a neutralization, of that war's horror. The implication is that everyone is equally able to grasp the suffering of the victims by the sheer fact of our shared humanity. The logical consequence of that reading is clearly unacceptable. Whether we see the war as a pathetic aggrandizement of our own suffering or as a trivializing of war's experiences, the effect is the same: the Second World War is not unique; we can make experiences of that chunk of history speakable by way of our own experiences. Or conversely and even more abusively, we can make our own experiences speakable by making those of the Second World War the point of comparison.

In this chapter I develop an opposite reading of Armando's work and, by extension, of the problem it poses. His texts and images do not "use" World War II as a motif to make the human condition speakable. Rather, they strive to make us understand the absolute uniqueness of that war, a war that lies *outside* the human condition. That the war is incomparable, that each experience of it is or was unique, has consequences for the manner in which it can be represented. The war's uniqueness implies that those tropes aimed at expressing similarity between two items, such as comparison and metaphor, are by definition inadequate. For the claim to similarity automatically renders the unique quality of the experience radically but slyly unspeakable, violently overruling it with the notion of similarity to something else. That uniqueness, in other words, must be shown by different devices. One must construct a nonmetaphorical language capable of approaching the very unspeakability of death as experience,[3] where the war is the most extreme purveyor of that experience, unique as well as exemplary. Armando develops such a language.[4]

Tropes such as metaphor, but also metonymy and synecdoche, use conventional language—or as semiotician Jurij Lotman calls it, the "primary modeling system"—to shape a new language—the secondary modeling system.[5] Precisely because the meaning of the Second World War is unique, the metaphorical impulse assumes that the primary system of language does not yet contain elements useful to the secondary system. Strictly speaking—if we look only at the grammar and idiom of a language—the need for metaphor might already be evident. But perhaps a more encompassing view of meaning, like that of Peircean semiotics, is better able to provide the primary modeling system with a means of expression not based on similarity and, hence, communality. The very distinction between primary and secondary modeling systems becomes superfluous from this perspective. To explore this question, let us take a closer look at modeling systems in general and the ways meaning is produced in them.

The American philosopher Charles Sanders Peirce distinguished three categories of signs based on the relation between sign and meaning, categories that are not limited to language: icon, index, and symbol. An icon is a sign that has some feature in common with the thing or concept it stands for; it is motivated by similarity. A footprint, for example, resembles the foot that makes it, so it is capable of functioning as a sign meaning "foot." An index is a sign motivated by contiguity or continuity; that is, there is a juxtaposition in time, space, or causality between the sign and the object it stands for. In the case of the footprint, there is an existential relation of contiguity with the human or animal that left it; footprint and creature are "in touch." The footprint thus *refers* to the presence of a person or animal. The same holds for causally connected items, such as smoke as an index of fire. A symbol, finally, is an unmotivated, arbitrary sign. It becomes a sign by virtue of convention, implicit agreement. The traffic sign is the classic example; but most elements of verbal language are also symbols. There is no motivated relation between the word *horse* and the animal we immediately think of when we hear the word.

Peirce's own definitions of icon, index, and symbol highlight a crucial aspect of difference among them:

An *icon* is a sign which would possess the character which renders it significant, even though its object had no existence; such as a lead-pencil streak as representing a geometric line. An *index* is a sign which would, at once, lose the character which makes it a sign if its object were removed, but would not lose that character if there were no interpretant. Such, for example, is a piece of mould with a

bullet-hole in it as a sign of a shot; for without the shot there would have been no hole; but there is a hole there, whether anybody has the sense to attribute it to a shot or not. A *symbol* is a sign which would lose the character which renders it a sign if there were no interpretant. Such is any utterance of speech which signifies what it does only by virtue of its being understood to have that signification.[6]

As these definitions demonstrate, the similarity implied in iconicity entails the redundancy of presence; indexicality, in contrast, stubbornly maintains presence, whether there is an act of interpretation to activate it or not. This presence of the index is a source of effectivity for Armando, for it makes the index a threshold of history.

These distinctions among categories of signs enable me to describe the language that Armando develops to render the uniqueness, the incomparability, of deadly war experiences speakable without neutralizing them. *His language is radically indexical.* He "encircles" the unspeakable quality of the war by voicing, or representing, what is contiguous to it, what touches it. He formulates not the violence and destruction of death itself, but that which was present when it happened. Just as the footprint is a silent witness to the past presence of a human being, so the signs Armando employs are indexical traces of the unspeakable and the unrepresentable.

In an influential two-part article titled "Notes on the Index," the American art historian Rosalind Krauss argues that much of contemporary art can be understood only in terms of the principle of indexical meaning production. Her definition of the index clarifies that which characterizes Armando's work: "Indexes are the marks or traces of a particular cause, and that cause is the thing to which they refer, the object they signify."[7] The intriguing effect of the index, she says, is caused by time, which provides the past (by definition transient and ungraspable) with an existential and physical presence. Krauss explains the effectiveness of indexicality in a set of works by the artist Lucio Pozzi. This series consists of small panels that reproduce the colors and color division of the wall of an old school building on which they are hung. "It [indexicality] fills the work with an extraordinary sense of time-past. Though they are produced by a physical cause, the trace, the impression, the clue, are vestiges of that cause which is itself no longer present in the given sign. Like traces, the works I have been describing represent the building through the paradox of being physically present but temporally remote."[8] Similarly, Armando employs motifs that reveal the traces the unbearable and unrepresentable horror of the war has left. He is engaged in a struggle against time, memory, story line, and nature, all of which conspire to erase those traces.

The Edge of the Forest

The threshold Armando constructs between past and present is often embodied by literal, spatial boundaries, such as the edge of a forest. In his literary as well as his visual work, Armando has declared the landscape culpable. Paintings and drawings bear titles like *Guilty Landscape*; in his literary texts, he describes trees (Figs. 22, 23), and in particular the edge of the forest (Fig. 24), as bearing blame. What can we make of this? Perhaps it is possible to consider a tree as a metaphor for the culprit. Both are in a sense imperturbable. Trees continue to grow regardless of surrounding events, just as the perpetrator, untouched by the destruction he commits, the death he deals, continues with the violence and with his life. The very absurdity of the gesture of declaring trees guilty suggests metaphoricity. The personification of trees would then be an indictment of people: people are accused of being as impassive as trees.

Such an interpretation becomes impossible, however, when we realize that for Armando not just any tree is guilty. He addresses his indictment to those trees that were actually present at the scene of violence. In an interview in 1985 he said,

They grow and keep still. Whatever happens. Quite a bit happened near those trees. Stalking and shooting, thrashing and humiliating. One could therefore say that the trees are complicit, are also guilty. But no: they're just trees. They cannot be blamed. The edge of a forest, for example. The trees in the front must have seen a thing or two. Those behind them can hardly be blamed, they could never see anything. But the edge, the seam of the forest, that has seen it. There are quite some edges, here and there, of which I know a few things.[9]

The presence of the trees at the scene of violence, the contiguity between the edge of the forest and the perpetrator, are the conditions for pronouncing the trees guilty. The meaning is produced not by metaphors concerning the imperturbable perpetrator, but by the traces of the violence that occurred at that particular place. The trees were witnesses, but they don't testify. Their refusal to testify, to serve as traces of the war, determines their guilt:

Look at the images in which the enemy is busy doing his business: there they are, laughing in the background. And not just the pines and firs; the other trees as well.

 Shouldn't something be said about that, for once?

 I thought so, because some of them are still there, the trees, the edge of the forest, the timber, at the same spot where they used to stand. Don't think they have changed places; they are still there as indifferent witnesses.[10]

Figure 22. Armando,
The Tree, 23.xi.1984;
oil on canvas, 240×
110 cm. Hess Collec-
tion, Napa, California

Figure 23. Armando, *The Tree*, 9.xii.1985; oil on canvas, 210 × 145 cm. Collection of the artist

Figure 24. Armando, *Forest Outskirts,* 19.iv.1984; oil on canvas, 155 × 225 cm. Stedelijk Museum, Amsterdam

Trees are guilty not only because of their inability or unwillingness to testify, but also because they cover over the traces left by the violence. "Finally the time came when the trees could talk about the old days. How admirable. How noble. But they covered a lot up, if not everything."[11] The trees' "covering up" (*verbloemen* in Dutch, literally "to cover with flowers," means to disguise or camouflage) must be taken figuratively as well as literally. By bearing flowers time and again, by continuing to grow, the trees conceal the absolute uniqueness, and the absurdity, of the event that took place there; it has been buried by flowers. The trees' growth demonstrates and embodies the work of time: time produces forgetting, just as nature overgrows the place of action.

In *Dagboek van een dader* (Diary of a perpetrator, 1973) in particular, Armando denounces this destructive activity of nature, of time, but also of representation (on which more shortly):

August 16
This landscape has committed evil. I can surmise the armies. It is peaceful here, but unfitting. Silence sometimes comes after noise: here was pain, here a fellow-

man thrashed. Time has guilt, everything grows again, but thinking is forgotten. Betrayal! This battlefield remains my property, however badly I live.

September 2
Nature has really gotten into my black books. First She was cowardly, then She abandoned me continuously. And don't the trees eternally allow the wind to push them, without any resistance to speak of? . . . And the Soil. The Soil lends a hand to the fall of the heroes. Places tolerate first, overgrow later. Oh, the spot must have been covered with growth. Yes, spots are always overgrown.[12]

The guilt of the trees resides in the invisibility of the violence and the evil that took place at their feet, an invisibility they "caused." Thus they betray the indexical meaning of their presence.

Postcards as Indexes

The indexical effect brought about in these fragments can also be felt in Armando's visual art. In the 1970's Armando made drawings that incorporated old photographs or postcards. For example, in *The Unknown Soldier* (triptych, 1973), *Guilty Landscape* (triptych, 1973), *De plek, der Ort, the spot* (1974), and *The Unknown Soldier* (1974; Fig. 25), he blew up photographs taken during the war, to get a grainy effect. He then mounted the pictures on paper and made marks with a pencil or crayon to connect the two. In *Riesengebirge* (Huge mountains, 1980), *Waldsee* (Forest lake, 1980; Fig. 26), and *Anmerkungen zur Vergangenheit* (Remarks on the past, 1982) he pasted postcards onto cardboard and again applied traces of pencil as connective marks.

Of course, in some cases the photographic images do represent the war iconically. Whereas Boltanski uses photographs to undermine the illusion of the presence of the past in such imagery, Armando seems to suggest that such a present-ation of the past in photos is possible, by means of iconicity. He emphasizes the presentness of the past by literally touching it, drawing a line through it. By the time he ceases to blow the pictures up, however, he appears to have abandoned his illusion. He is now aware that the past keeps on receding.

For Boltanski, this awareness led to an ongoing obsession with the failure of the photograph to make the past present; Armando was motivated to look for a different strategy for keeping in touch with the past. He stopped relying on the iconicity of the image, and turned instead to exploring its material presence as a leftover. With his pencil and crayon

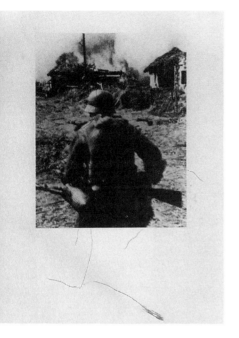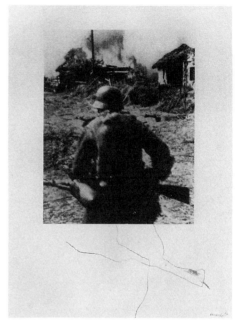

Figure 25. Armando, *The Unknown Soldier*, 1974; dyptich: pencil on photographs and cardboard, each 100×75 cm. Kupferstichkabinett, Berlin

lines, Armando shows himself to be less interested in the iconic aspect of the postcards and photographs than in their indexical aspect. For him, there is contiguity between the postcards and photograph images and the people who made them, wrote on them, or looked at them. Similarly, the marks he makes are tangible objects that put him in touch with those same people—they provide a connection between present and past.

Photographs are perfect icons because of the high similarity between the image and the object being referred to; but they are often seen as the exemplary index as well because of the existential relation of touch between the light the object reflects or emits and the sensitive layer of film on which the light fell.[13] Armando, however, is interested not in this general indexical relation, but in that between the photographic postcard and its makers or users: the people who had it in their hands. What matters is not the iconic image of a past long gone, but the indexical trace that the postcard offers, an almost spatial presence, that makes us aware of the distance and absence in time being referred to.

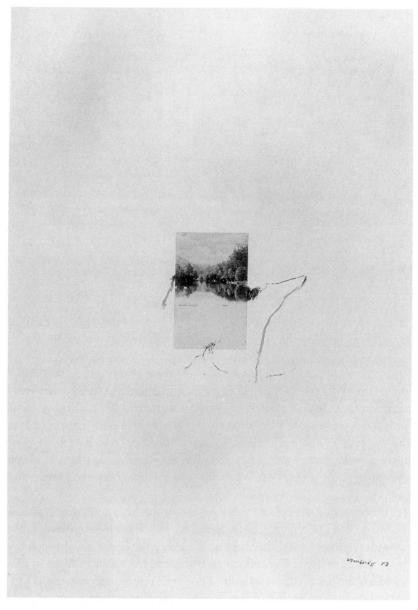

Figure 26. Armando, *Waldsee* (Forest lake), 1982; pencil on postcard and cardboard, 73 × 51 cm. Collection Sanders, Amsterdam

In an interview with Martijn Sanders, Armando explained his motivation for using postcards in his drawings:

These are German postcards, things history has stepped on. Leftovers. Very tangible remnants of the past, with traces of people on them. At home I have a postcard of a soldier in the uniform of the First World War, with traces of pencil on it. I haven't done anything with it yet. . . . The drawings with postcards are, for me, total melancholy. . . . The people who had such a card in their hands and who wrote on it are dead.[14]

Armando does not care about the soldier on the postcard, but about the world where the card circulated and to which it now refers as an index, because as a part of that world it still exists. Unlike the guilty trees, the postcards not only make the past visible, but they make it present again, in an acute literalization of re-presentation.

Isolation and Annexation as Indexical Strategies

In 1964 Armando published a programmatic text in the journal *Gard Sivik* in which he exposed the common principles of the so-called Zero movement and "total poetry."[15] This often-quoted text, titled "An International Primer," is still relevant to understanding his work from the Zero period, from which he later distanced himself. But the poetic he formulates there also holds, though in a less strident, more subtle, more fundamental way, for his work of the 1970's and 1980's. In that text he defines the vocation of the artist or poet:

Not to stifle Reality with moralism or interpretation (to art-ify it), but to intensify it. Starting point: a consistent acceptance of Reality. Interest in a more autonomous appearance of Reality, already noticeable in journalism, TV reports, and film. Working method: isolating, annexing. Hence: authenticity. Not of the maker, but of the information. The artist, who is no longer an artist: a cool, efficient eye.[16]

The methods Armando recommends here, those of isolation and annexation, are practices typical of the Second World War: it was by these means that the Nazis tried to shape Germany. Jews, Gypsies, Communists were isolated, countries were annexed. Armando's poetic does not so much *deal* with the war as it *is* that war. As he put it in an interview in 1971, "I have hated the war so much that I came to identify with it. I have become the war."[17] Whereas Armando's early work concerns not so much the war but violent situations in general, his poetic consists of strategies that char-

acterize "the war"—that particular, singular one. A poem from the "Karl May cycle" demonstrates this convincingly:

> He had spat blood and lost two teeth,
> which proves
> that his club blow had not been particularly caressing.[18]

This poem is in fact *readymade* or an *objet trouvé* in the manner of Marcel Duchamp. Armando annexes one of the Karl May westerns—boys' reading—isolating a passage and presenting it as a poem. This strategy breaks open the story line of the original *fabula*, thus foregrounding the violence it contains. That gesture is necessary because story lines work like time. The progression of the story line leads us away from the violence inherent in the *fabula* by pushing us toward the ending.[19] This working method of disrupting the *fabula* allows Armando to bring to light this overgrown violence.

The agency of time in a story line is similar to that of context in space. Just as Armando breaks up story line in the "Karl May cycle," he breaks up context in the "agricultural cycle" by making poems out of instructions for use of farm machines. In this manner the text ceases to serve the practical purpose for which it was written, being presented instead as autonomous. Two examples from the cycle demonstrate this rupture:

> 5
> the machine is equipped with 4 chopping boards
> the machine has 3 wheels with air tires
> the machine also operates with 3 groups of 2 boards
>
> the machine requires little maintenance
> the machine's operation is very clean
>
> 13
> the steel teeth
> do not damage the roots of the seedlings.
> weeds are nipped in the bud.
> with steel teeth.
> the effect of "clean land" must be flabbergasting.[20]

Here we see the strong effect of the isolation and annexation policy as suddenly our attention is directed toward the values these texts propagate: those of the perfectly functioning oiled system. The violence presupposed by such a system has been brought painfully to light by Nazism—the ultimate perfectly functioning oiled system.

Again, work of these poems is done indexically. Death is nowhere

named, described, or rendered visible by means of comparisons. Like the footprint that signals the presence of an animal or human being, this isolated discourse merely suggests cold-blooded and perfectly organized murder. Because the death perpetrated in the Second World War was so traumatic that it could not be spoken, all Armando can do is show its traces. Such traces of a power that was also the foundation of the war can be found in language. The implication here is not that a similarity exists between language and war, but that one can trace the war—and the power that lay at its center—in language.

Traces can also signify negatively, by referring to something with which they have no connection. In *Aantekeningen over de vijand* (Notes about the enemy, 1981) Armando wrote: "The so-called 'neckshot.' Strange that you have never heard of that. Neckshot: the word is telling. You really never heard of it? Never mind. Odd word, anyway, don't you think: *neckshot*. Oh yeah."[21] In brief passages in this work, Armando isolates single words—also readymades. Precisely because these words lack the context of a sentence or a narrative, because they are surrounded by silence, they enigmatically refer to a situation of violence. The following example does not quite come across in translation, for the word isolated here, *boekstaven*, means to record, to register, but it can be also decomposed into the nouns *boek* (book) and *staven* (clubs), used by the military police to beat people in mobs. "By all means let's 'record' it. He said: 'record.' Again such a word, do watch out."[22] The silence or emptiness surrounding the word is indispensable: it is there that the violence, to which the word refers by contiguity, takes place—as the following example from *Diary of a Perpetrator* demonstrates:

June 22
Oh, the cries of a bird!
I listen to the bird. It talks now this, now that.
Short sayings. Silence between the sayings is always of equal length.
. . . The animal is firm and strong-willed, thus I too must sing my own song.
Good example, the bird.[23]

The sounds the bird produces are not important in themselves because they are not clearly distinguished—"it talks now this, now that." This effect is underscored by the unusual combination of the intransitive verb *to talk* with a direct object—"now this, now that"—whose content remains vague and futile. Yet the silences in between are precisely defined: "always of equal length." It seems as if the bird sings in order to produce the silence in which something can be heard. The song delimits the si-

lences; the sayings are juxtaposed to them. Each saying is an index for the silence that follows or precedes it. Only in that silence the unspeakable can be heard; only there can the war be memorialized and remembered, because in the end, no words, no images, no similarities exist that can sustain symbolization, nor is there any memory in repetition.

Isolation is an indispensable tool for producing such meaningful indexical silences. The *readymade*, the principle on which so many of Armando's early texts as well as his visual works of the Zero period are based, produces its specific meanings by means of isolation. Krauss explains: "The ready-made's parallel with the photograph is established by its process of production. It's about the physical transposition of an object from the continuum of reality into the fixed condition of the art-image by a moment of isolation or selection."[24] The idea of isolation "from the continuum of reality" is acutely relevant for an understanding of Armando's work. It helps us see the failure of many attempts to deal with this work, such as Pieter de Nijs's encapsulation of Armando's method of isolation and annexation with the term "the montage principle."[25] The way montage produces meaning is exactly the opposite of what happens in Armando's work. Montage collates arbitrary elements into a new continuum. Armando, by contrast, breaks up an existing continuum and presents loose elements of it in isolation. He refuses, precisely, to create a reassuring new whole. Those very dimensions of our reality that appear to form a continuum—language, nature, and time—are ruptured by means of isolation.

Armando's oeuvre contains many reflections that explain his distrust of time. For example:

July 29
Time pushed again.
How can I ever come to a stop?

August 8
Today a dismal awareness: survivors grow older. It is ever longer ago. Centuries. And fellowman knows but to linger and forget.[26]

The continuum of time is doubly deceptive: it leads us away from the traumatic moment for which no expression has yet been found; and at the same time it suggests coherence, hence, meaningfulness. The experience of war, however, destroyed any sense of coherence that might have given it meaning. "Look, coherence is missing, you see? And it has to be that way: for no coherence exists."[27] The paradox is that without coherence, no meaning production is possible. That is why Armando looks for

semiotic salvation in the index, the ground to stand on where not coherence, but only coexistence, is possible.

Against Narrativity

Armando also keeps at bay the comfort of the continuum of the narrative. Even *De straat en het struikgewas* (The street and the shrubbery, 1988), though clearly an autobiography, is antinarrative in structure. Although the short chapters of this work do follow each other in chronological order, presenting the life history of the narrator, each chapter focuses on the same themes: heroism, fascination with violent death. Each moment of the protagonist's prewar childhood is presented as a proleptic index that announces the war, and postwar moments are presented as analeptic indexes referring back. In this autobiography the principle of *repetition* predominates; the idea of succession and change is fought off as a semiotic enemy. The continuum of the narrative story is transformed into a skipping record.

In one chapter Armando reflects on the working of memory. This reflection can be taken as an explanation of his antinarrative stance, in which the narrative story becomes an imagined memory of a sequence of events.

You have the past, you have the present, and then there is also the future.
That makes three.
But there is a fourth: the past of the memory, of the imagination. And that is a different past. It has been colored in with the index finger, it has been kneaded and bent, it has been shifted and shrunk, it has been crumpled, thickened here, thinned there, and people think that's how it should be.
There is a question here of the unswerving desire for *the idyll*.[28]

Just as memory turns the past into idyll, so classical narrative manipulates events. Classical narrative consists of a distinct sequence: a beginning—childhood, for example; a crisis, followed by a denouement, preferably a happy ending; return to idyll. And because we read for the ending, we overlook the crisis.[29]

The British painter Francis Bacon appears to struggle in his paintings with the same problem that preoccupies Armando: How can one represent events in a nonnarrative manner?[30] In an interview with David Sylvester, Bacon explains why he objects to narrativity:

In the complicated stage in which painting is now, the moment there are several figures—at any rate several figures on the same canvas—the story begins to be

elaborated. And the moment the story is elaborated, the boredom sets in; the story talks louder than the paint.

. . . I think that the moment a number of figures become involved, you immediately come on to the story-telling aspect of the relationships between figures. And that immediately sets up a kind of narrative. I always hope to be able to make a great number of figures without a narrative.[31]

The final sentence, in particular, renders succinctly the crucial feature of Armando's own short narratives in his later literary work. His visual works take a different direction, however. Even if some of his paintings, lithographs, or drawings contain figurative representations (flags, trees, Prussian crosses, heads, skulls), these represent not so much events or situations, as in the case of Bacon's paintings, but rather things, objects. As far as narrativity exists, it is not the representation or illustration of an event that produces it, but rather the tension triggered by the way in which the pencil or paintbrush has been handled.

This effect is most evident in his drawings that are obviously abstract. Armando never draws smooth lines along which the spectator's eye can smoothly wander. Just as he avoids story lines in his narrative, so he rejects fluid compositions in his images. His drawings are rather collections of dots or scratches; lines are not allowed to form a continuum. He says about his drawings of the 1950's:

I can't deny it: these kinds of drawings emerged out of hatred. . . . It was the continuation of a process. I once said to somebody: "Such a drawing, a human being was murdered in it." I have done away with quite a few people that way. And that is then art. It does have to do with a kind of hysteria. You have to gear yourself up quite a bit to make such a drawing. You can't do it every hour of the day. It is not a relaxed kind of drawing, it is very cramped and done with a lot of force, but not fast.[32]

The lines in the drawings are deliberately cramped (Figs. 27, 28). In them one can read the traces of an obsessed hand.

Obsession also speaks in another aspect of Armando's visual art: repetition. The series of paintings of flags, trees, edges of woods, convey a preoccupation with repetition rather than continuity, change, or innovation. The task of repetition is to allow us to experience *for the first time* the traumatic event that could not be truly experienced because there was no language available to express it directly. The repeated images of black flags (Fig. 29) or trees do not *represent* the war so much as *cause* it and thus, paradoxically, make it possible to experience it *as an event* for the first time.[33]

Figure 27. Armando, *Drawing*, 1982; pencil on paper, 18 × 13 cm. Collection
Ernst van Alphen, Amsterdam

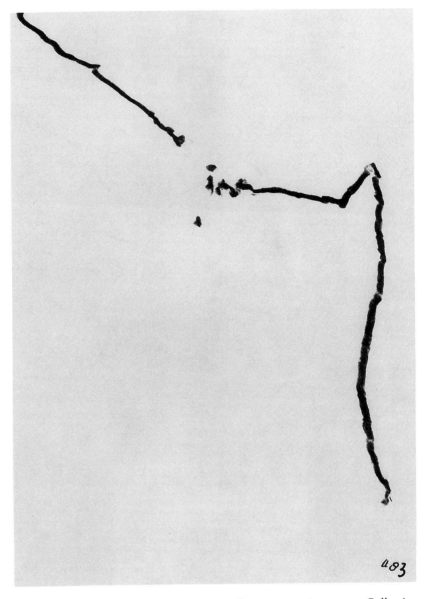

Figure 28. Armando, *Drawing*, 1983; pencil on paper, 18 × 13 cm. Collection Helen van der Mey, London

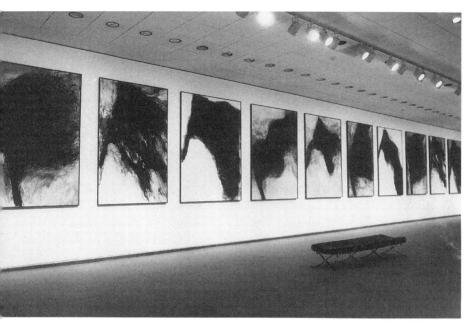

Figure 29. Armando, *Flags*, 1984; paintings at the National Gallery, Berlin

The Sublime as Index

There is another aspect to Armando's obsessive use of the index—one that I will return to toward the end of this book—and that has to do with the sublime.[34] In the mid-eighteenth century, early romantics became fascinated with the boundless and unrestrained forces of nature, against which man was but a puny little being.[35] Man is both attracted and repulsed by that nature because it can be neither controlled nor understood. The experience of that ambivalence has been described by the term "the sublime." Perhaps the most famous example of this romantic sublime is the paintings of Caspar David Friedrich.[36] Friedrich shows "man" on mountaintops, on the seashore, in the forest, in all his smallness *over against* an endless, boundless, indomitable nature that exceeds all understanding. Another famous example is the paintings of J. M. W. Turner, in the great seas and dominating skies that appear as if possessed by supernatural and inhuman forces.

Armando seems attracted by the paintings of the German romantics, in particular Friedrich's, whose painting *Chasseur im Walde* (Hunter in the forest) appears on the cover of *Diary of a Perpetrator*, a meaningful

choice. Yet Armando's work is not comparable to that of the romantics. On the contrary, I contend that the concept of "the sublime" applies to Armando's work for an altogether different reason than holds for the German romantics.

The romantics located the sublime first of all within nature. Subsequently, art had to contend with nature—that is, it had to attempt to embody the quality of the sublime. Nature thus came to stand for, in the words of de Nijs, "timeless and endlessly innovating beauty."[37] According to de Nijs, nature has the same meaning in Armando's work. Yet in light of the analysis above, this conclusion is hardly plausible. Whereas in the romantic concept man was a spectator on the border of, but still outside, sublime nature, in Armando's work nature itself is a spectator of something—something "sublime"—that has occurred in its presence: the violent, evil war; death. The common element in Armando's work and the work of the romantics—man on, or as, a threshold—extends in incompatible directions.

But how is it possible to call the violence of war, this evil, "sublime"? To answer this question, Kant's *Critique of Judgment* is enlightening. In that treatise Kant draws a distinction between beauty and the sublime, qualities that are each other's opposite. That opposition becomes meaningful when juxtaposed to such other oppositions as quality versus quantity, shape versus shapelessness, limitation versus boundlessness. Whereas beauty calms, the sublime inspires restlessness and excitement. Beauty results when a supersensuous Idea manifests itself harmoniously in a material form; the sublime, in contrast, is an experience caused by poorly limited, chaotic, and awe-inspiring phenomena like a furious sea or craggy mountains. Whereas beauty is a property of objects, the sublime must be located in both the object and the subject: it is an experience.

For Kant, however, the sublime is opposed to beauty principally because the latter produces a pleasant feeling of well-being, whereas for the sublime "the object is experienced with pleasure only when well-being is mediated by discomfort."[38] The paradox of the sublime can thus be summarized as follows: In principle there is an unbridgeable gap between the empirical, phenomenologically experienced world of objects and the supersensuous Idea. No empirical object, no representation (*Vorstellung*), can adequately make present (*darstellen*) the Idea. The sublime is an object that triggers the experiencing of precisely this *impossibility*, the permanent failure of representation to render the true dimension of the Idea. It is by means of the very moments when the shortcomings of represen-

tation become clear that we get a sense, a proleptic indication, of the true dimension of the unspeakable, unrepresentable Idea. This also explains why the sublime triggers pleasure as well as discomfort. It triggers discomfort because it is a relentlessly inadequate representation of the Idea; but it triggers pleasure precisely because that inadequacy is indexically a promise, a foreboding, of the true, incomparable greatness of the Idea. In Kant's words:

> The feeling of the Sublime is therefore at once a feeling of displeasure, arising from the inadequacy of imagination in the aesthetic estimation of magnitude to attain to its estimation by reason, and a simultaneously awakened pleasure, arising from this very judgement of the inadequacy of the greatest faculty of sense being in accord with ideas of reason, so far as the effort to attain to these is for us a law.[39]

Hence the sublime is the paradox produced by an object when, as a representation, it allows us negatively, through its failure as such, to catch a glimpse of what cannot be represented. This is precisely what the June 22 fragments of *Diary of a Perpetrator* suggested, where the song of a bird delimits the silences in which something can be heard.

Kant's definition of the sublime is also the tersest characterization of Armando's imaginative commemoration of the Second World War. Each of the motifs that mark his works triggers experience of the sublime. Although they explicitly fail as direct representations of the war, that very failure provides a view of the unspeakable that is the trauma of war experience. It is the consistently negatively indexical quality of his work that evokes the sublime. His work points out to us, time and again and by repetition, what it is that by definition cannot be represented because it is experienced as incomparable.

This negative mode of touching the past is still a historical approach, for it remains a form of re-presentation; but it is radically different from iconic representations, in that it is based on a different *semiotic* principle. Both Boltanski and Armando, however, explore yet more radical alternatives, ultimately stepping out of representation altogether. In the following chapters, these artists will be shown developing ways to stand outside history, not participating in but overseeing the past. As we shall see, they replace re-presentation by presentation—history by reenactment.

The Imaginative Approach to Memory

The Revivifying Artist
Christian Boltanski's Efforts to Close the Gap

There is a quest to recover or reconstruct a recipient, an "affective community."
— Geoffrey H. Hartman, "Reading the Wound: Holocaust Testimony, Art, and Trauma"

All my work is more or less about the Holocaust.
— Christian Boltanski, interviewed by Steinar Gjessing

Testimony, though colored by personal experience, is favored by Holocaust scholars because of the historical information it provides. It is generally seen as one of the most effective means by which we, who did not witness the events ourselves, can get an impression of what happened. Although the testimonial mode, in contrast with the archival mode, is colored by personal experience and could thereby be disqualified as historical documentation, from another perspective it has preeminence because it is the direct account of a witness who was present at the place of action. From time to time, however, testimony is bereaved of its privileged status by someone who doubts the truthfulness of the account it provides. Michael André Bernstein, for example, has challenged the myth of the unmediatedness of first-person testimony— the idea that language, gesture, and imagery can "become transparent if the experience being ex-

pressed is sufficiently horrific."[1] He argues that there is no reason to assume that testimony about the horrific is more unmediated and complete than any other kind of speech.

The Israeli novelist Aharon Appelfeld likewise expresses a distrust of memories, the building stones of testimony. Much in the spirit of my argument in Chapter 2, he claims that testimonies are actually acts of repression, "meant to put events in proper chronological order. They are neither introspection nor anything resembling introspection, but rather the careful weaving together of external facts in order to veil the inner truth."[2] By "inner truth" Appelfeld does not mean the most interior, personal experience, but rather that which made experience impossible—as Geoffrey Hartman puts it, "the survivors' sensation of non-identity, of a ghostly self damaged by years of suffering [that] slowly erased the image of humanity within."[3] Appelfeld explains: "The survivor himself was the first, in the weakness of his own hand and in the denial of his own experiences, to create the strange plural voice of the memorist, which is nothing but externalization upon externalization, so that what is within will never be revealed."[4]

Appelfeld's disqualification of testimony has some aspects in common with Boltanski's explorations of the photographic portrait and the archival mode as means of providing truthful accounts of the Holocaust. Both Appelfeld and Boltanski confront us with the awareness that historical accounts, whether in the form of photographs, archives, or testimonies, cover up, hence make absent, the truth that they are supposed to be revealing. Having reached this conclusion, Appelfeld does not claim the Holocaust experience to be unspeakable or unrepresentable. Instead he finds a solution in the representational domains of art and literature: "We must transmit the dreadful experience from the category of history into that of art."[5]

For Boltanski it makes no sense to call for a turn to the arts. As we have seen, he reveals in his own work how art that tries to *refer* to the Holocaust accurately and meticulously tends instead to repeat the Holocaust in its ordering, classifying, objectifying, and dehumanizing impulse. In the face of Appelfeld's hope that art can be of use, however, it is exactly this disenchanting conclusion that forces us to consider other qualities of art, including historical genres such as testimony, as possible means for rethinking the very purpose of representing the Holocaust. Hartman has convincingly argued that Appelfeld's understanding of the function of testimony is too limited. Appelfeld narrows the function of

testimony to that of providing historical information. Testimony, in fact, does more, and according to Hartman it does precisely that which Appelfeld wishes art and literature to do.

Testimony does not only provide a product—that is, historical information; it is also, according to Hartman, "a humanizing and transactive process. . . . It works on the past to rescue the individual with his own past and proper name from the place of terror where that face and name were taken away."[6] Hartman sees testimony as necessary not only because of the information it provides, but also because it reestablishes in its process and in its contact with the listener the voice and subjectivity of the testifier. As psychoanalyst Dori Laub puts it, "The survivors did not only need to survive so that they could tell their story; they also needed to tell their story in order to survive."[7] The past need that first led to the story continues in the present, where the telling is an indispensable means of surviving the post-traumatic stress. This temporal shift will become a key element in what follows.

Laub also describes testimony as a "transactive process." Here, however, the process takes place not only between the testifier and the past, but also between the testifier and the listener or addressee of the testimony. Thus the listener, the witness of the testimony, has a constructive as well as passive role.[8] This function is, again, a consequence of the temporal shift-in-permanency of the events. The listener is necessary as a kind of double of the witnessing position that, impossible for the victim *during* the Holocaust, must be reclaimed or reconstituted afterward in the testimonial process.

Laub explains the impossibility of witnessing the Holocaust at the time:

It was not only the reality of the situation and the lack of responsiveness of bystanders or the world that accounts for the fact that history was taking place with no witness: it was also the very circumstance of *being inside the event* that made unthinkable the very notion that a witness could exist, that is, someone who could step outside of the coercively totalitarian and dehumanizing frame of reference in which the event was taking place, and provide an independent frame of reference through which the event could be observed.[9]

The lack of an independent frame of reference in which to situate Holocaust events implies that the failure to bear witness to the truth of the Holocaust must be seen as the missing of "the human cognitive capacity to perceive and to assimilate the totality of what was really happening."[10] This lack explains also why the testimonies of Holocaust survivors are fundamentally different from those that testify to "normal" events. The

Holocaust survivor does not testify from the position of having been a witness, but out of the need retroactively to constitute the possibility of witnessing.

This shifts the emphasis from product to process. In this view, then, the addressee is an absolutely indispensable part of the process. Laub formulates that role as follows: "To a certain extent, the interviewer-listener takes on the responsibility for bearing witness that previously the narrator felt he bore alone, and therefore could not carry out. It is the encounter, and the coming together between the survivor and the listener, which makes possible something like a repossession of the act of witnessing. This joint responsibility is the source of the re-emerging truth."[11] Up until the possibility of the testimonial process was presented, the narrator was "alone in the event," for no culturally transmitted frame of reference existed in terms of which the lived and observed events could be made understandable or meaningful. This being alone comes to an end when the missing frame of reference is filled in by a listener who by his or her very participation contributes to the construction of a retrospective frame of reference in the present. To put it another way, a new frame of reference is constructed as the narrator shares the fragments of experience with a listener, psychoanalyst, or interviewer. It is here that the addressee has an important role and responsibility: "Paradoxically enough, the interviewer has to be, thus, both unobtrusive, nondirective, and yet imminently present, active, in the lead. Because trauma returns in disjointed fragments in the memory of the survivor, the listener has to let these trauma fragments make impact both on him and on the witness." Without the listener, the process cannot succeed:

Testimony is the narrative's address to hearing; for only when the survivor knows he is being heard, will he stop to hear—and listen to—himself. Thus when the flow of fragments falters, the listener has to enhance them and induce their free expression. When the trauma fragments, on the contrary, accelerate, threaten to get too intense, too tumultuous and out of hand, he has to rein them in, to modulate their flow. And he has to see and hear beyond the trauma fragments, to wider circles of reflections.[12]

It is in this joint responsibility that the trauma fragments are shaped into a history that, having now been witnessed, can be told to others. The listener's introduction of "wider circles of reflections," an activity of which the survivor is personally incapable, can be seen as the construction of a context for the traumatic event. This context, intersubjectively and culturally shared, functions as a frame of reference that heals the trauma.[13]

Laub remarks that, paradoxically, the listener/interviewer becomes the Holocaust witness *before* the narrator does. For the narrator must reclaim her or his position as witness by first *living through* the testimony. Only then can the testifier reflect on the narrated story as an externalized, hence external, story.

During the testimony the survivor gains access to his or her self, to his or her own *body*. This reintegration of subjectivity and body is the result of the healing process. The survivor is "reembodied" in several aspects. First, she reclaims the position of witness to the history she has lived through. But second, thanks to the externalization of the traumatic events, she has inserted herself into the historical dimension of the listener. No longer isolated within a past event, she now finds herself in the present dialogical situation with a listener. This being-in-the-present during testimony makes it possible to look back and tell, or testify to, her story—hence, to reclaim the past, but also to relate to other human beings in the present. The interhuman situation of testimony is in that sense not only a precondition for continuing to live, but also, because of the interrelatedness, emblematic for life after testimony.

So far I have examined two conceptions of testimony. The first, which sees testimony as a source of historical information, is endorsed by the majority of Holocaust scholars, though it motivates the novelist Appelfeld to reject the validity of testimony. The second conception focuses on testimony's performative quality as a humanizing transactive process. Hartman and Laub, for example, value testimony not only as a product, but in particular as a process that enables the survivor to reclaim his or her position as an interrelated subject and as a witness of history. These two conceptions of testimony reflect two different conceptions of language, which focus, respectively, on language's referential capacities and language's ability to constitute subjectivity.

The latter view of language has become known especially through the work of the French linguist Emile Benveniste.[14] For him, the essence of language resides not in reference but in subjectivity, defined as relational and contrastive. The key to understanding this crucial aspect of language is deixis: terms like the personal pronouns *I* and *you*, whose content is consubstantial with the situation of language use. Deixis requires presence; it signifies only within the historical present and in relation to others.

Because of the "moral imperative" to represent the Holocaust by means of historical modes of representation, scholars have focused mainly on the referential capacities of Holocaust art and literature, ignoring the

second view of language and testimony as a means for understanding the function of representation.[15] In the rest of this chapter I will argue that Christian Boltanski's work can be seen not only as an attempt to reveal the Janus face of the historical, referential mode of representation, but also as an effort to foreground this other aspect of testimony and language. His artworks should be seen, then, as performative events in which the relationship with the viewer in the historical present is actively and insistently pursued.

Phatic Art

In the early 1970's, when Boltanski was just beginning to show his work in group and solo exhibitions, he was also exploring a new genre called "mail art." In January 1970, for instance, he sent the following letter, written in longhand, to a number of people (Fig. 30):

You have to help me, you have no doubt heard of the difficulties I have been having recently and of the very serious crisis I now find myself in. I want you first to know that everything you might have heard against me is false. I have always tried to lead an honest life, I think moreover, that you know my work; you certainly know that I dedicate myself to it entirely, but the situation now is at an almost intolerable point and I don't think I will be able to stand it much longer, which is why I ask you, why I implore you, to answer me *as quickly as possible*. I am sorry to bother you, but I have to find some way out of this situation.[16]

Boltanski did not explore mail art because it was new and fashionable. This letter makes it clear that he took the epistolary genre *à la lettre* and that he was seriously interested in that which defines the letter *qua* letter: that is, it is addressed to a specific person, whether real or fictional, and that person frames its text.

Boltanski's letter turns the function of establishing contact with the addressee into its content. That is, it has no content besides its effort to establish contact. We learn nothing about the difficulties he is having. Implicitly the letter suggests that Boltanski is accused of something, but of what the accusation consists remains unclear. The effect is strongly Kafkaesque.

In the article "Linguistics and Poetics" (1960) the Russian linguist and semiotician Roman Jakobson proposes a model in which six different functions of language are distinguished. This model can help us to define the nature of Boltanski's letter. In principle, according to Jakobson, any

Figure 30. Christian Boltanski, *Il faut que vous m'aidiez . . .* (You have to help me . . .), 1970; mail art: handwritten letter sent to sixty people

expression must comprehend all six functions if it is to be successful, but usually one dominates. When language is used as an expression of the attitude of the speaker, the *emotive* or expressive function is dominant. When language attempts to motivate the recipient to act in a purposeful manner (for example, when the imperative is used), the *conative* function is dominant. When language is used to speak about the meaning or code of an expression, the *metalinguistic* function is dominant. When an expression is focused on the object world, the context of language, the *referential* function is dominant. When language foregrounds the message as such, the *poetic* function is dominant. And when language is used primarily to guarantee the proper functioning of the preconditions of communication in their most basic form of material and physical presence, the *phatic* function is dominant.

In Boltanski's letter, the phatic function has clearly overruled the other five functions of communication and, indeed, has become its only content. Lynn Gumpert sees Boltanski's mail art as a therapeutic means of creating distance between himself and a depressed emotional state: "By writing the letter and copying it over and over again by hand, he had found a way to separate himself from its highly charged contents. Perhaps more importantly, he had also found a way to engage his readers, whether they liked it or not, in his life and his art."[17] Although the engagement of the reader—the conative function—is indeed a crucial point of this letter, I don't think that Boltanski wanted them to engage in *his* life and *his* art. If that were his intention, he would have provided information about his problems, his situation, the things he is being accused of—information that is provocatively missing.

The artist's owns remarks about these letters in an interview of 1975 differ in a significant way from Gumpert's reading:

I had five responses, which wasn't bad at all, five people who wanted to help me. But I made this piece because I really was very depressed. If I hadn't been an artist, I would have probably written only one letter and then maybe jumped out of the window. But since I'm a painter, I wrote sixty of them, that is, the same one sixty times, and told myself, "What a good piece and what a fine reflection on the relationship between art and life!" . . . When you want to kill yourself, you make a portrait of yourself in the process of committing suicide, but you don't actually do it.[18]

It is remarkable how, by means of the word *but* in the second line, Boltanski establishes an opposition between his depression and the fact that five people wanted to help him. It is as if he wanted to say that these

kind people misunderstood the nature of his depression, thinking that it was psychic, when in fact it was an artistic depression. That conclusion becomes almost unavoidable in light of what he told himself after having finished the sixty letters: "What a good piece and what a fine reflection on the relationship between art and life!" He does not say that the letter has anything to do with *his* life or *his* art. On the contrary, the letter contains, or embodies, a *general* reflection on life and art.

Clearly, the point Boltanski wants to make with his mail art is that the phatic aspect of these letters is an important aspect of art in general. A work or art is no longer to be seen as an autonomous object to be appreciated only for its aesthetic qualities. If we see the phatic letter as emblematic of Boltanski's overall conception of art, we can say that for him art must be defined in its relation with the viewer, in the way the viewer processes it.

One could argue—and rightly so—that this conception of art was typical of the 1960's and 1970's. Indeed, many artists in that era distanced themselves from the hermetic, autonomous, aesthetic art that was presented strictly for contemplation and interpretation.[19] Instead they made happenings and performance art, artworks that had to be processed by viewers in time. In this context the viewer's experience was not seen as something evoked by yet occurring outside the work of art; instead it was a defining aspect of the artwork itself. To promote such a view, or better, such an experience, of art, artists (for instance, Robert Morris and Richard Serra) made works that could never be viewed or taken in in one glimpse; the viewer had to walk around or through the work in order to see it. The experience in time by the viewer was thus inscribed in the work of art.[20]

Boltanski's art, however, to a certain extent transcends the artistic culture of the 1970's. As I discussed in Chapter 4, it also belongs in the framework, or even "genre," of Holocaust representation. And given the central, indeed exemplary role of testimony in the latter framework, the idea of the importance of the addressee becomes that much more compelling—though there the ramifications are somewhat different than in 1970's art generally. In "Reading the Wound," Hartman argues that the act of addressing an external other, as a means of accessing the self, is a major problem for Holocaust survivors and a major issue in Holocaust art and literature. According to him, the automatism of address has been disrupted; survivors must therefore construct a new system within which the act of address can again take place.

Hartman discusses Paul Celan's work as an example of Holocaust literature in which the act of addressing another person is thematized as a highly difficult yet utterly necessary act. These lines from Celan's prose text "Conversation in the Mountains" (1958), in which a Jew invokes another Jew, contain nothing other than phatic address: "Do you hear me, do hear me, you do, it's me, me, me whom you hear, whom you think you hear, me and the other. . . . "[21] These words are reminiscent of the mail-art letter Boltanski wrote on January 11, 1970. In both cases we witness nothing but the desperate attempt to make contact.

In a speech titled "The Meridian," delivered in 1960 in Darmstadt upon receiving the Georg Büchner Prize, Celan touched on the same theme of insistent calling out. Poetry today, he said, has a strong tendency toward silence; but this tendency has little to do with difficulties of vocabulary, the faster flow of syntax, or a heightened sense of ellipsis. On the contrary, it is not language as a product of speech that has become problematic, but the act of speaking.

The poem holds its ground, if you will permit me yet another extreme formulation, the poem holds its ground on its own margin. In order to endure, it constantly calls and pulls itself back from an "already-no-more" into a "still-here." Thus "still-here" can only mean speaking. Not language as such, but responding and—not just verbally—"corresponding" to something.[22]

Celan seems to say that poetry has withdrawn within its own margins, its own preconditions. It is no longer possible to believe in one's voice and in the language that is produced merely by speaking. The poem tends toward silence because its preconditions are endangered. Is something or someone still listening, responding, corresponding?

By saying that the poem today is "still-here," Celan seems to say that the poem is not autonomous language, but the individualized language of a single person who is trying to communicate. It is language coming from an individual human being, a human being who tries to *correspond* to an interlocutor.

This "still-here" of the poem can only be found in the work of poets who do not forget that they speak from an angle of reflection which is their own existence, their own physical nature.

This shows the poem yet more clearly as one person's language becomes shape and, essentially, a presence in the present.

This need for response and correspondence turns the poem of today into an insistently phatic calling out. It is in search of an encounter.

The poem is lonely. It is lonely and *en route*. Its author stays with it. . . . The poem intends another, needs this other, needs an opposite. It goes toward it, bespeaks it. For the poem, everything and everybody is a figure towards which it is heading.[23]

In order to better explain what Celan's insistent calling out in "Conversation in the Mountains" has to do with the historically specific crisis of the Holocaust, Hartman presents the view of Maurice Blanchot on Holocaust literature.[24] Blanchot, in answering his own question of whether the stories he wrote before the war are now dated, says that every story, "no matter when it is written, . . . from now on will be from before Auschwitz." Storytelling as such, in other words, has become dated, because it displays "the glory of a narrative voice that speaks clearly." After the catastrophe of the Holocaust, narrative fiction lost all its "happiness of speaking," its solipsistic pleasure, Blanchot seems to say, in its own abundance.[25] Speech is threatened at its source, as Hartman remarks, not because of any technical inability to represent what happened, but because something went out of our voice: the innocence or joy of speaking.

This view of how the Holocaust changed speaking enables Hartman to better interpret Celan's "Conversation in the Mountains." It also enables me to further define the Holocaust-effect, in particular in Boltanski's work. Hartman argues that the "happiness of speaking" has abandoned Celan's text. "The compulsion to talk remains, but the hope for a genuine encounter, a genuine conversation, seems desperate."[26] In "Conversation in the Mountains," voice is betrayed into an ongoing and inconsolable monologue as all attempts to reach the addressee fail. Because of this failure, the text consists solely of the urge to "correspond." This, I find, is a precise characterization of Boltanski's early art as well, and also, I will argue, of his shadow plays.

Against Art

The ambition to make phatic art, that is, to make art that is the material condition and the scene of action of an encounter, is an impossible ambition within the confines of modernist conceptions of art. The locales set aside for art, the museum and the gallery, create a distance between viewer and object that is usually already anticipated and programmed by the work of art itself. The so-called autonomy of the work of art likewise prescribes an aesthetic response, which distances the viewer from his or

her own subjectivity. Instead the viewer is afforded access to an aesthetic realm that exceeds the space of interaction between work and viewer—a space that should be more limited, because subjective and defined by the present.

When Boltanski sets out to make art that endorses precisely the individualized engagement with the viewer, art itself becomes an obstacle. This is so because as soon as the viewer's expectations are confirmed, he or she will activate a mode of looking that transforms the viewing experience into a grasp of the aesthetic. Boltanski does not want this to happen:

For me the most interesting period is the one in which the spectators are not yet aware that what they are experiencing is art. During this moment—which is relatively short—you can engage spectators by presenting them with something that is art without telling them that it is art. But very soon they realize that it's art, complacency sets in, and all they see is an outer form. That's also quite sad, because out of all you've created, the only thing left is the aesthetic form. Everything you have wanted to say disappears.[27]

Although Boltanski presents here the transformation of art into aesthetic form as inescapable, he has made works that seem actively to counter this process. This is especially the case in a number of short color films he made in 1969. Intended to be inserted without announcement or explanation within screenings of popular movies, these films were all extremely violent, yet at the same time obviously staged and made by an amateur who was unschooled in the technical aspects of filmmaking. Boltanski used life-sized dolls that he fabricated himself, or masked actors. One of the films, titled *Tout ce dont je me souviens* (All I remember; Fig. 31), lasted only eighteen seconds and appeared to show the violent murder of a woman. As Boltanski explained, "One has the impression that a man kills a woman by hitting her with a stick, but it happens so quickly, it almost seems one didn't see it."[28] Another very brief film, *L'homme qui tousse* (The man who coughs; Fig. 32), showed a seated figure in a narrow room who incessantly coughs up a river of blood.

Boltanski's intention to have these short films inserted into screenings of commercial films was never realized. They were, however, shown at several international film festivals, where the intense, violent scenes attracted considerable attention. Within the context of the present study, two aspects of these striking experimental films are remarkable. In content as well as structure, the scenes depict events so gruesome and violent that we can only assume that they represent in an exemplary way events that cause trauma. But when we take the intended (though unrealized)

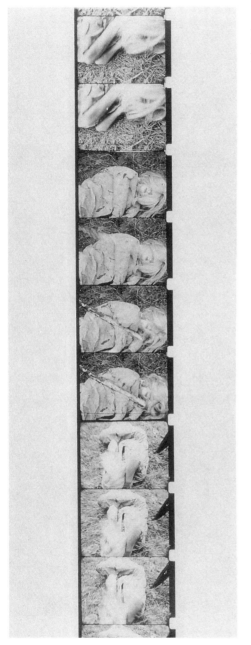

Figure 31. Christian Boltanski, *Tout ce dont je me souviens* (All I remember), 1969; color film, 16 mm, 24 sec.

Figure 32. Christian Boltan-
ski, *L'homme qui tousse* (The
man who coughs), 1969; color
film, 16 mm, 3 min. 30 sec.

structural context of these scenes into consideration—as insertions within feature films—the concept of trauma is actualized in yet another and more fundamental way.

As I pointed out in Chapter 2, a trauma arises when an event cannot be worked through, understood, within the frames of reference provided by the symbolic order. When an event makes "no sense" in terms of the culturally provided meaningful frames, it cannot be experienced or memorialized. This lack of a reference frame, which would allow a certain distance from the event, can only lead to a repetition of the event in its full, immediate directness. This repetition or return of the event has nothing to do with memory; the very possibility of memory implies distance from the event. On the contrary, memory means indirectness.

It is exactly this lack of a meaningful symbolic frame that is staged in, and virtually acted out by, Boltanski's short films. Inserted within other, existing films, the scenes would be totally unexpected. The viewer would then be confronted with events that have no relation whatsoever with the context in which they occur. They literally make no sense, yet their reality is inescapable; that is, distance from them is impossible because they don't relate to the film in which they occur/appear. The scenes cannot be understood in terms of earlier events, nor are they redeemed by the closure of the framing film.

But there is more. A lack of distance also exists between the viewer and the violence. Without really seeing what is happening in the brief scenes, the viewer is drawn into them and, confronted with the sudden brutality, unbelieving, for a moment becomes lost. The films flashed by so quickly that, as Gumpert remarks, they left viewers "feeling uneasy, even vaguely terrorized."[29] The viewer is forced into a direct response to the images. Boltanski extorts, compels, an immediate engagement between the viewer and the victim of the event, before the viewer is able to achieve distance from it. Certainly distance in terms of aesthetics, avant-garde experimentation, or sadistic pleasure is impossible, because the films are too short to allow one to work through the violent scenes. One cannot make out what is really happening, nor can one disengage or distance oneself from the event after its general nature has been grasped. One is drawn into a situation in a manner that is as brutal and violent as are the filmed events themselves into which one is being drawn.

This violently enforced engagement of the viewer can again be understood in terms of a phatic precondition for the conative appeal to the viewer. In these brief films, the phatic function of artistic expression en-

compasses the conative and overrules all other functions. As was the case in Boltanski's mail art, the films, which are almost too short to have true content, insistently and intensely provoke the viewer into a direct response to them by creating the material condition for such a response. The films do what they are about: they try to relate in the present to a viewer who has neither the time nor the framing possibilities to disengage from them. In this way, they are not just *about* trauma; rather, they convey cinematic trauma in a *performance* that is itself traumatic.

One might wonder if Boltanski's cinematic performances of trauma are potentially dangerous. If they exemplify trauma not only in content but also in structure, might they not also have a traumatic effect on the viewers? This important question, which is central to the recent work of Geoffrey Hartman, leads to a radically new dimension in the discussion about the "representability of the Holocaust."

In "Public Memory and Its Discontents," Hartman deals with the problem of "how to focus public memory on traumatic experiences like war, the Holocaust, or massive violations of human rights." He suggests that public memory is in the process of being overwhelmed by the very efficiency of modern media, their unprecedented realism and representational scope. The contemporary viewer, he charges, suffers from "an information sickness, caused by the speed and quantity of what impinges on us, and abetted by machines we have invented that generate endless arrays." The individual cannot "process" all the incoming information. The public and the personal experience are thus moving not closer, but ever farther apart. In this way the media have placed a moral demand on us that is impossible to satisfy. "Terrible things, by continuing to be shown, begin to appear matter-of-fact, a natural rather than man-made catastrophe."[30] The effect on viewers is ultimately, according to Hartman, that of *desensitization* or, as Robert Lifton puts it, "psychic numbing."[31]

In "Holocaust Testimony, Art, and Trauma," however, Hartman goes further still, ascribing even stronger effects to the abundance and realism of the modern media. In this article he shifts the discussion about the limits of representing extreme events from technical issues (how can we find *means* strong enough to depict what happened?) to performative issues (what do these representations do?). When we focus on this moral meaning of the phrase "limits of representation" we are compelled to consider seriously the power of forms of representation "to move, influence, offend, wound."[32]

In the discussion above of Holocaust testimonies, I relativized the im-

portance of their historical accuracy while stressing their performative qualities. Testimony, as we have seen, leads to a humanizing transactive process between testifier and audience/listener/interviewer. Because the situation of testimony inscribes the elicited words on the minds of the audience, the survivor/testifier is able to reclaim her or his position as an interrelated subject. Hartman is concerned, however, about other ways of representing the Holocaust that do not heal the traumatic event but instead are themselves traumatic: "I am hardly the first to worry about the increasing prevalence of psychic numbing accompanied by fascination, and which is usually the consequence of *primary* trauma. It would be ironic and sad if all that education could achieve were to transmit a trauma to later generations in a secondary form."[33] The transmission of knowledge about the Holocaust by means of the modern media, Hartman suggests, has led neither to a healing of the primary trauma of the survivors nor to compassionate feelings on the part of the audience. On the contrary, the present is characterized by what he calls a "secondary trauma," the result of representing the Holocaust, wars, and other massive violations of human rights in modes that are themselves traumatizing.

Of course, there are crucial differences between the primary trauma experienced by Holocaust survivors and the secondary trauma experienced by the audiences of traumatizing modes of representation. For one thing, the audience of any Holocaust representation will never be *part* of the event being witnessed, despite the confrontational immediacy of the representation. One might also wonder if, and how, a secondary trauma can manifest itself in a repetition of the traumatic event, in this case a representational event. But primary and secondary trauma do have one thing in common, and that is the impossibility of coming to terms with the event, of working through it.

Modes of representation capable of causing secondary trauma are those which seek to overwhelm the viewer with naked imagery: docudramas, the journalistic images and reports that attempt to expose the "bare truth" or "naked facts"—in short, those realistic modes that strive to convey historical truth. This does not mean that Hartman favors heavily literary or symbolic modes of representing the Holocaust. Although such modes will never cause secondary trauma, they are too distanced from the events in their aspiration to mystery and generality to be effective in bridging the gap between public and individual memory. For Hartman, the genre most promising in its balance of realism and reticence is that of testimony.

Hartman's concept of secondary trauma seems to me immensely useful in all discussions that lead to the question of whether or not we should put limits on representations. Is too much unmotivated violence in films or on television harmful—that is, does it produce secondary trauma? The concept enables us to differentiate between the representation of violence as such and the representation of violence that is explained or motivated by the context in which it happens. When such a context is missing, it can be hard to "work through" the violence; unpredictable, perhaps secondary traumatic effects may be the result.

Boltanski's cinematic performances of violent, traumatic events are strong candidates for causing secondary trauma. Of course, one could argue that he is very aware of this danger, and that he is addressing it directly by showing these films. Nevertheless, there is a striking similarity between the short films and his mail art. In both cases a strong conative appeal is launched on the basis of a predominant focus on the phatic function: contact itself overwhelms the content of the communication. Boltanski forces his audience in an almost violent effort into an encounter in the actual, material present. Aesthetic distance from his works—as if they were art *objects*—is short-circuited.

In the end, how effective are the mail art and the short films in their phatic function? Only those to whom Boltanski sent the letters and who first saw the films had the chance of being overwhelmed by the violence of their appeal. Today, they fail to create an encounter in the present with us as audience. We see them now merely as art objects made by the artist Boltanski, and we do not allow ourselves to become directly engaged. We do not read a letter, but an artwork; we do not see a registered violent event, but an avant-garde art film. The films are problematic in yet another respect, for instead of addressing the danger of secondary trauma, Boltanski is in fact causing it. It's a paradoxical and ultimately hopeless endeavor to counter traumatic effects by using traumatic modes of representation, because a foregrounded effect has to be apprehended intellectually to be acted upon. In this case, the viewer is too overwhelmed to arrive at such a response.

Correspondence Regained

In 1984 Boltanski started work on a new series called *Ombres* (Shadows), which he followed in 1986 with a variation titled *Bougies* (Candles). These share important aspects with his mail art and short films

(though not at first sight). At the same time, they differ from the films in the fact that Boltanski did not employ traumatic modes of representation in them. Let me first describe the works.

In the early 1980's Boltanski made a series of works that are called, individually, *Grotesque Composition* (1981), *Classic Composition* (1981), *Theatrical Composition* (1981; Fig. 33), *Heroic Composition* (1981), *Enchanted Composition* (1982), *Mythological Composition* (1982), and *Hieratic Composition* (1983). For these works he used small puppetlike figures fashioned from cork, cardboard, paper, tin, and copper. He then photographed them and enlarged the results to monumental proportions; these he showed in galleries and museums. His series *Shadows* (Fig. 34) and *Candles* (Fig. 35) used the same type of fabricated, puppetlike figures (the real thing, not photographs). When he showed *Shadows* at the Galerie 't Venster in Rotterdam in 1984, he suspended the figures from a makeshift metal frame; three slide projectors were then directed at them, throwing their shadows onto the surrounding walls. At the Institute of Contemporary Art in Nagoya, Japan, in contrast, not slide projectors but spotlights were used. In one corner of the space a fan set the marionette-like cast of puppets in motion. Spectators were not allowed into the gallery space; they viewed the dancing shadows from the doorway, and in later variations of the installation through peepholes in specially constructed rooms. The room-sized installation transformed the gallery space into a magical theater, with the scale and definition of the quivering shadows dependent on the distance of their source figures from the projectors or spotlights. Those closest to the light cast darker, sharper forms; those farther away had fainter, blurrier shapes. Gumpert describes the effect of *Shadows* as follows:

At first, unsuspecting viewers were enchanted with the spectacle of moving images that covered the walls, unconcerned with the jumble of equipment on the floor. Gradually, however, the shadows' more sinister qualities came into focus. The figures themselves, literally suspended in air, underwent an iconographic metamorphosis as viewers realized that what they were looking at was an army of hanged men, interleaved with menacing skeletons and supernatural beings. Among the group and constructed out of wire, the hunched figure of the grim reaper, scythe in hand, reinforced the bleaker aspects of this macabre dance of death.[34]

Gumpert remarks that in other installations of the work, the shadows suggested the presence of multiple souls or ghostly ancestors. Death is evoked in one way or another. Given the rest of Boltanski's oeuvre, this overwhelming death-effect must, in fact, be a Holocaust-effect.

Figure 33.
Christian
Boltanski, *The-*
atrical Composi-
tion, 1981; color
photograph,
243 × 127 cm

Figure 34. Christian Boltanski, *Shadows*, 1984; installation view, Temporary Contemporary, New York (1988)

When we compare *Shadows* with Boltanski's mail art and his short films, we notice striking similarities as well as differences. Whereas in his earlier work Boltanski used aggressive and brutal strategies to compel the audience into an encounter, this time he uses naive, childlike motifs that lure the viewer into an engagement with his work. Deliberately avoiding the strategies of conventional art, he wants to keep at bay the aestheticizing approach to art. By creating a kind of magical theater, he conjures up a child's world in which the transcendent and distant world of aesthetics does not exist. Thus the viewer is able to engage spontaneously and directly with the work.

Once the viewer is seduced into direct engagement with the work, however, it becomes apparent that the naive, childish strategies have in fact seduced him or her into an encounter with death. A similar encounter took place in Boltanski's letters and films—similar in the sense that the viewer was prevented, in both types of works, from experiencing the art in a self-consciously aestheticizing way. In the earlier works, however, his strategies for effecting that encounter were as brutal and aggressive as the contents of the works themselves. In his project of addressing the Holocaust differently, Boltanski seems to have switched from using traumatic modes of representation to nontraumatic modes—but

Figure 35. Christian Boltanski, *Candles*, 1987; installation view, Expo Century '87, Amsterdam

surely the difference is not that simple. He is, in fact, using polar opposites, setting extreme trauma against the playfulness, comfort, and safety of the apparent world of the child.

The "naive, childlike strategies" of *Shadows*, however, are less naive than they at first glance seem, if we consider this work's epistemological history. The medieval and Renaissance tradition of shadow plays as a form of magic was not altogether absent from the "scientific," Cartesian culture that followed in its wake. Indeed, Descartes himself, Paolo Rossi

reminds us, "amused himself (as so many sixteenth-century magi had done) with the construction of automatons and shadow theaters."[35] For Descartes, the universe itself was a divine machine, and the power of the intellect to construct machines likewise exemplified man's God-given power. To know was to act upon the world. This same tradition enables us to see Boltanski's shadow plays as practices that act upon the world.

The series of installations titled *Candles* reveals a new aspect in Boltanski's work that, though present in *Shadows*, is now more explicitly foregrounded: the correspondence between model and image. In *Candles*, Boltanski crafted tiny figures from sheets of copper or tin; these he attached to narrow metal shelves that jutted out from the wall, at the end of which was a candle (Fig. 36). "With the candlelight in front of them," writes Gumpert, "the figures cast their shadows onto the walls behind. As the flames flickered, the phantasms danced, appearing to rise magically out of the inverted triangles of darkness created by the shelves. On the guest list for this dance, once again, was death, in the form of the grim reaper, accompanied by a gallery of sinister skulls and ominous winged creatures."[36] With its childlike, nontraumatic mode of representation and attention to the overwhelming issue of death, *Candles* can be seen as a variation on *Shadows*. *Candles*, however, reminds us of the installations with portraits, especially *Monuments*; for unlike *Shadows*, *Candles* evokes the memorializing function of a monument, the narrow shelves with candle and figure forming a kind of shrine.

This feature of the *Candles* installations calls on us to compare them further with *Monuments*. Both series of installations are based on projections: *Monuments* uses photographic projections, while *Candles* incorporates shadows. Generally speaking, photographs are supposed to make the portrayed subjects present; but again and again, as we have seen, the opposite happened in Boltanski's photographically based works. Instead of the portrayed subjects being made present, they were transformed into absent objects. No correspondence exists between the portrayed subject and the dramatically enlarged object we observe. According to Boltanski, we see only cadavers in those images.

The shadows of the figures produced by the candles are also based on the principle of projection. Here, however, there is total correspondence between the projected figure and the projection. When we watch the shadows on the wall we do not relate to a dead, fixed object, but to a moving subject living in the present. The relation between model and image does not imply a transformation of subject into object, as in the pho-

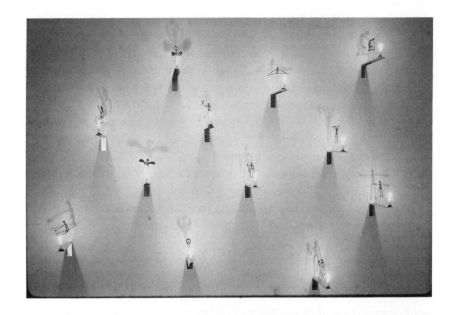

Figure 36. (above)
Christian Boltanski,
Candles, 1986; installa-
tion view, Marian Good-
man Gallery, New York:
copper figurines, tin
shelves, candles. (right)
Detail from Candles

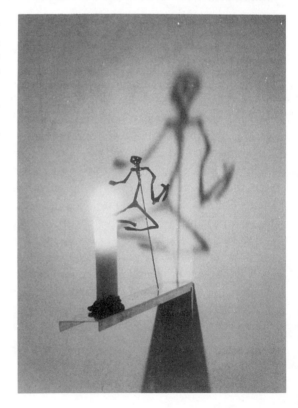

tographic projections; the relation now is between two subjects. The image responds all the time *in the present* to the figure that it faces.

This complete correspondence between subject and image strongly marks another work belonging to the *Shadows* series. The title of this work from 1986, *L'ange d'alliance* (Angel of accord; Fig. 37), emphasizes an aspect characteristic not only of this particular work, but of the *Shadows* and *Candles* series generally, and that is the harmonious "accord" between the angel of death and its projected image on the wall. This "accord" explains the angelic features that are bestowed on the figure of death. Death is no longer represented as an absence, as the dead person we lost in the past, but as a presence we can be in touch with now.

Boltanski's shadow plays gained yet another facet of meaning in the medieval church Igrexa de San Domingos de Bonaval in Santiago de Compostela, Spain. Invited by the Center for Contemporary Art in that city, he created the installation *Advento* (December 1995–March 1996), which combined the elements already known from other installations. In one chapel he installed a shadow play, this time with two projected figures: on the rotunda dome an angel of death with a sickle in his hand, and a less clearly malignant angel, moved in circles in opposite directions. They met; one expected them to clash, overlap, perhaps fight, but somehow they barely managed to pass each other without the expected deadly event arising. Death and Angel dance, not in harmony, but not fighting as Lucifer did. Although the clash does not occur, the suspenseful moment affects the viewer. The suspense, the breathless stillness in which it remains uncertain which direction the encounter will take, is itself the subject of this shadow play; the danger exists, the violence could have taken place, but, this time, does not.

In Chapter 4 I called the effects produced by the *Monument* series "Holocaust-effects." The Holocaust is not evoked in these works by direct reference, but by a reenactment of certain defining principles of that horrific event. One of those principles was the mechanical transformation of subjects into objects. Given that reading of the *Monument* series, we must conclude that the installations in the *Candles* series are the polemical opposite of the *Monuments*.[37] Here, the Holocaust is not simply reenacted by means of a systematic foregrounding of the transformation of subjects into objects; instead that principle is tested and then, in a countering move, refused. The subjects (figures) are not transformed into objects; rather, an interaction between two subjects occurs. The projection is not a dead object left behind in the past; it responds to its model

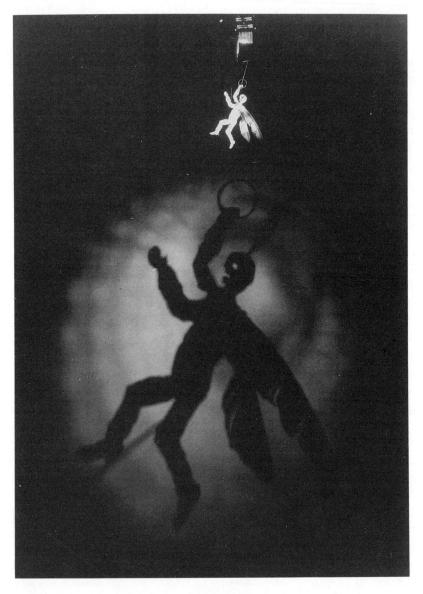

Figure 37. Christian Boltanski, *L'ange d'alliance* (Angel of accord), 1986; copper, feathers, projector, metal base

all the time within the temporal dimension in which the viewer also is: the present.

And we should not forget the identity of that model. As in the *Shadows* series, it is the dance of death with which the projections actively interact. Death—the power that organized the Holocaust—and those who were the victims of death are no longer overwhelmingly present in their confrontational absence. In *Shadows* as well as in *Candles*, the figures of death and the dead are present in their immediate correspondence with their living projections. The dead are no longer represented as absence (*Monuments*) but are brought back to life. This seems to me Boltanski's answer to the unrepresentability of the Holocaust, and the urgent need to keep its memory alive.

A Master of Amazement
Armando's Self-Chosen Exile

The words exodus and exile indicate a positive rela-
tion with exteriority, whose exigency invites us not to
be content with what is proper to us (that is, with
our power to assimilate everything, to identify every-
thing, to bring everything back to our I).
—Maurice Blanchot, "Being Jewish"

The Holocaust has short-circuited communi-
cation. As Boltanski's experiments, in which
he desperately sought contact, demonstrated,
artists and writers can no longer assume that
there is an addressee who will attend to what
they express. In the last chapter I discussed how
Boltanski's work addresses this disruption of art
as a transactive process. He makes phatic art
that thematizes and performs the urge to recon-
struct an affective community. The present chap-
ter concerns another attempt at "getting in
touch." This time, however, it is not the rap-
prochement of the addressee that is being ef-
fected, but the approach of an object of knowl-
edge. Is it possible to get in touch with what can-
not be understood?

In his book *Krijgsgewoel* (Warbustle, 1986),
Armando comments on his art practice: "Little
by little I began to understand that one should
not write or paint the things one knows. One
should write or paint that which hides itself be-
tween knowing and understanding. A little
mark, a wink is possible, a suspicion, no more,

and that is already a lot."[1] This remark can be read as the motivation for the theme that haunts all of his work: the obsession with the Second World War. While the past as such, every past, remains largely hidden, the destruction that characterizes that particular past is extremely hard to understand, especially in its most sinister practice which has become the center and symbol of that war: the Holocaust.

But Armando's preference for "that which hides itself between knowing and understanding" is more than just a thematic indication. It is also an epistemological attitude. It implies a method of getting to know things that cannot, or can hardly, be known or understood. His self-reflexive remark formulates the process he must follow in order to get in touch with what can never be identified or pinned down.

As we saw in Chapter 5, Armando's stance is willfully subjective and drawn resolutely from his past. He is permanently in the situation of being a witness of aggressive power and destruction. This position has an autobiographical background. As I mentioned, he was a young boy during the war. He grew up in the vicinity of Amersfoort Transit Camp, in the middle of Holland, not far from Utrecht. The immediate surroundings of this camp were his playground. Without being a direct victim of the war or the Holocaust, therefore, he was a witness of both. Without ever seeing the absoluteness of the destruction that went on there, somehow he felt it. He was confronted with its symptoms.

Starting from this autobiographical position of a young witness-without-understanding, I have argued how Armando surrounds or encircles the historical events of the war in such a way that practically all sense of historical and geographical location remains unclear. He uses a violent strategy of "annexation and isolation" to represent a history without narrative plot, without a beginning, ending, or development, without a clear distribution of roles.

Armando's work seeks to drive the unsurpassed uniqueness of traumatic war experiences home to us. The very fact that the war, especially the Holocaust, *is* unique, *is* so incomparable for those who were there, has specific consequences for the manner in which it can be represented. Its uniqueness implies that tropes based on similarity, like comparison and metaphor, are by definition inadequate—for claiming similarity takes away that which makes the experience unique and, as such, unspeakable, overwhelming it instead with similarity to something else. The uniqueness of war experiences, and especially of Holocaust experiences, must be indicated with other devices.

So far I have argued that Armando's language is consistently *indexical*, based on contiguity or continuity between the sign (index) and that for which it stands. We saw how Armando "circles" the unique and unspeakable of the war by representing what is juxtaposed to it, touches it. He gives shape, not to violence, death, and destruction per se, but to what was there around them. The signs that constitute Armando's work are indexical traces of those incomparable experiences. His work suggests or "touches" phenomena without ever formulating or describing them.

But his procedure for getting in touch with what cannot be known goes still further. In the end he felt compelled to exile himself from the place where he witnessed the past he wants to understand. In the 1970's he moved to Berlin, where he lives now "surrounded by the enemy," to use his own words. The question I want to address in this chapter is: What does Armando's self-chosen exile have to do with his artistic practice? Or, to reverse the question, why is the situation of exile productive for this particular practice of art; or even, why is his art only possible from a situation of exile?

Reports from Abroad

To answer these questions I will focus on three of Armando's books: *Uit Berlijn* (From Berlin, 1982), *Machthebbers* (People in power, 1983), and the 1986 *Warbustle*.[2] These books signaled a breakthrough in Armando's literary reputation. Although he was already much respected as a visual artist, until the publication of these books his standing as a writer was quite controversial. His poetry and short stories were misunderstood; his obsession with the war and with violence was regarded by his Dutch audience as irresponsible, the pose of an adolescent fascinated by war, hardly to be taken seriously. His and Hans Sleutelaar's 1967 book of interviews with Dutch members of the SS caused an outcry of indignation. The authors were even accused of being in sympathy with those they interviewed. The three new books, however, demonstrated the seriousness of his project beyond any doubt and earned him a much wider audience.

These books consist of short texts, the reports of someone living abroad; they were written in Berlin and originally published in the Dutch newspaper *NRC-Handelsblad*. In more than half of them the speaking voice is Armando's: he tells of astonishing experiences he has had in this German city where he is an alien, as well as of seemingly insignificant situations that are somehow remarkable to him. In the two later books,

some of the texts describe situations or events that occurred during short trips to Italy, Austria, and California.

These brief autobiographical texts alternate with short fragments of speech of the inhabitants of Berlin. Every so often, four or five of these fragments are cobbled together to form short chapters, always having the same heading: *flarden*, meaning "rags" or "scraps." The word *flarden* is ambiguous in a significant way. In Dutch one speaks of the "scraps" of a conversation, indicating a fragment of conversation one happens on or overhears. But the word also refers to the wisps of vapor that remain when a cloud has been dispersed by the wind. In both meanings, the word implies flimsiness, incompleteness, transience, and chance.

Armando seems to quote directly from conversations he perhaps had or overheard. He does not identify his source, or the situation of speech. He identifies the speakers only with the labels *man* or *woman*, after which their speech follows in direct discourse.

In all these speech fragments, the war can be heard. It is precisely the great variety of the ways in which they refer to the war that makes these texts so strong and disturbing. In some of the fragments it is suggested that nothing has changed in Germany, that "the Germans" learned nothing from the war they started and lost. Others make you realize that German civilians were also victims of the war. This awareness, however, never leads to a relativizing of Germany's responsibility for the war, as some revisionist historians would have it. On the contrary: if it is true that even the aggressor's own co-nationals were victimized, then the evil of this war becomes that much worse. The overall impression left by these texts is that the war is far from over. Its remains can be found in these "scraps."

The lack of specificity as to the situation in which these fragments are uttered, as it turns out, is a crucial element of Armando's discourse of exile. At first sight, the books suggest a conversation in the way it is put together. Chapters with a first-person narrator alternate with ones in which a second speaker addresses the former first person as "you" (*U*, the form of politeness). According to one possible narrative of the war, this organization of chapters alternating between the view of the war victim, an inhabitant of one of the occupied countries, and the view of the perpetrator, embodied by unidentified Germans, evokes an ideal of integrated memory.

This appearance is misleading, however. For one thing, the first-person reports are not addressed to the German speakers of the "scraps," but

to the people back home in the Netherlands. Second, although the speech situation of the "scraps" seems to suggest a dialogue between Armando the "reporter" and the speaking German who says "you," the addressee, in fact, is not identified and is not necessarily Armando. The title of the fragments, "scraps," indicates that these bits of speech are actually readymades, "found" snatches that the subject, again, sends home like a postcard.[3]

The Importance of Being Not-at-Home

The text entitled "Night" can be read as a miniature containing the entire issue, a *mise en abîme* of the exiled position from which Armando speaks in the three books.[4] In this piece he reflects on what his residence in Berlin means for his artistic calling. It begins as follows:

Sometimes I ask myself what I am doing here. Why am I not going to live in a cave or grotto, with friendly animals, who get provisions for me? But no, I am here, in the middle of the night. For the life of the artist is beautiful, but the toll is heavy; just hear this, you: the toll is heavy.

 I stroll as if I listened. Something hides, conceals itself here, do you realize that? Of course, you will never discover a trace, but the only thing that matters is the *attempt*, let's put it that way. What matters is to find a form for this attempt: the forming of the attempt, forming of the impotence. Something is going on.[5]

Armando makes it clear that there is nothing specific to be found or traced in Berlin. What matters is his mode of being in that alien city, the attempt to discover something. It is his attitude of being that is transformed by his state of exile, which is a state of perpetual search and suspicion ("something is going on").

 This transformation is caused by the special need that occurs in this state: the artist in exile is forced to relate to phenomena outside herself or himself. Armando's discourse remains on the side of knowledge, clues, answers. A little farther on he writes:

What else can I do in this city but try to think about other people's fluttering secrets? Who knows, perhaps death blows along with it. Trying to overpower disguises. But why, why then. . . . He [the artist] dwells much too often in his self-made caverns and he gives himself light with a faint candle, which is defeated by the merciless expedition. From time to time he must truly roam and that is no fun.[6]

The phrase "fluttering secrets" is related to the keyword "scraps." Secrets are not "facts" that can be found out; they just float by like a light breeze.

And yet, all the artist in the foreign city can do is think about those flying fragments. Death will blow along if he is lucky. Secrets are hidden in disguises, and although they have no substance, the disguises that are "in touch" with the secrets they hide can perhaps be overpowered. The passage is a lamentation, an elegy on the lack of substance of his quest. But that negativity is the absolute condition for his exile to become a source of creation.

It is crucial for Armando that the exiled condition not lead to a new, or second, home. That which can be gained from exile is lost when the new city or country becomes a place where one feels truly at home. The place to which Armando has exiled himself is not allowed to become a new cave in which he can hide. Caves, for all their poverty and darkness, still offer the comfort of a dwelling place, in the dark of night, in a time "before." The temptation of the cave dweller is also lamented, in a tone that stays just on this side of the lyrical outburst of elegy.[7] It is "no fun" to maintain the necessity to wander. "Night" articulates negatively all the temptations, all the borders and corners, of the exilic condition that put him in danger of feeling at home.

This taboo against establishing himself anywhere, even outside civilization, explains the writing subject's interest in the former inhabitants of houses in Berlin to which he is invited. He talks about this curiosity in *People in Power*, in a text called "Großbürgerlich." Entering a private home in Berlin, he wants to ask the following questions of the current resident: "I would like to know who has lived here and how they have lived here, how did it look in 1912 or 1926 or 1934 or 1941, what was being said here, how did it smell here, I am so eager to know all this. But I suppose you don't know it. Oh I see, it doesn't even interest you."[8] The unknowable past of these houses makes it impossible for him to feel at home in any of them. And that is exactly what he wants. For he needs to be alienated from himself. This is a precondition for getting in touch with the past he is searching for.

Armando is not even able to feel at home in the houses he lives in himself. When, full of admiration, he describes the majestic bourgeois residence of the Berlin upper middle class (the type of house one calls a *großbürgerliche Wohnung*), he confesses the following: "I had already lived in several Berlin houses, also in this kind of beauty, but I soon had to admit that they would never become my own rooms, not even if I were able to buy such a house: I am sitting in *their* room, but I don't see the dazzling shine of their interiors, I don't hear their voices, they don't reach

me, however I try. An untenable situation."[9] Armando does not regret that he does not feel at home in the houses he inhabits. On the contrary, his only regret is that while he was living in "*their*" rooms, he was still unable to trace "them" there. He is confronted with his inability to get in touch with the past he tries to understand.

As he travels and wanders, however, it becomes increasingly difficult for Armando to find places where he can feel alien. One of the effects of modernity is that the differences between places are erased. In the text titled "Heinrich," he talks about a trip he made to the German city of Kiel. Rebuilt after the war, this city is now virtually interchangeable with any other twentieth-century German city. It has lost its uniqueness, its difference. Contemporary Kiel evokes the following meditation:

> When you look at old postcards from just before the war, you see obvious *foreignness*, that is to say, you see a real German city with bony houses. Before the war when you came as a hireling to foreign countries, you didn't know what was happening to you, everything was really *strange*, everything full of secrets, and that gave you, me at least, a great feeling of satisfaction. . . . Now, everybody looks almost the same. Not that they *are* the same, but it seems so. Few national characteristics left. Or would that be conducive to peace?[10]

The past is a foreign country, indeed, but the question is whether one can reverse that saying. Armando regrets that foreign places are becoming less and less strange, as if in the process an entire past gets lost. Do foreign countries have features similar to those of the past that Armando wants to retrieve?

This passage strikes an almost nostalgic note, his disappointment seeming to arise from an unfulfilled desire for the exotic. As in the overtones of elegy in the previous example, here he appeals to the recognition of a genre with which he toys, only to reject it emphatically. The craving for estrangement suggests a form of travel literature,[11] but there is a difference. For Armando's project, travel writing is inadequate because he is not engaged in sampling "foreignness" in order to meet and "catalog" as many different places and peoples as possible. The confrontation with "strangeness" and difference is not satisfying as such; he does not want to be amazed and astonished as an end in itself. Travel is not exile; at the end of the journey is homecoming, a homecoming Armando needs to repudiate.

Another genre Armando is interdiscursively engaged in rejecting is ethnography.[12] Again, at first sight it might appear that his interest in foreign places is ethnographically motivated, for, like ethnographers, he is

acting on epistemological motivations. However, both the knowledge pursued and the mode of producing it are different. The ethnographer wants to get to know and ultimately *understand* the otherness of different cultures. The feeling of amazement and astonishment is then only a symptom of the confrontational encounter with otherness. The next step of the epistemological procedure is to follow the proper methodology to reach understanding and document that culture.

As if to "discuss" this possibility openly, Armando does incorporate within his discourse some features that support a reading of his work as ethnographic. Often he uses expressions like "a doubtful observation," "an important observation," as if he were carrying out a scientific project. He distances himself from the observed otherness so that he can reach "objective" understanding. The question is, is he really interested in the object or event that causes his astonishment, or does his astonishment serve another purpose? At second glance, in fact, he displays astonishment without any pretense of scientific or scholarly ambition. The distance implied by his scientific discourse alternates, moreover, with moments when he is fully engaged with what he sees. But this engagement is not an attempt to merge; instead, the objective is to experience the distance ever more sharply. In this sense he positions himself *against* ethnography. He does not want to set himself up for astonishment as a way toward knowledge of the object; on the contrary, the astonishment he needs to experience—and that motivates his choice of objects to approach—is presumably an end in itself.

Exile as Vocation

If Armando's interest in foreignness is neither a lamentation of homelessness, nor a fascination with the exotic, nor the epistemological drive of an ethnographer toward the understanding of otherness, the meaning of his interest in strangeness, in the difference of otherness, must lie elsewhere. The text "Being Jewish" by Maurice Blanchot will help me to formulate Armando's position in relation to what astonishes him. In this essay Blanchot tries to explain the difference that is involved in being Jewish. He wants to find an alternative to conceptions in which the Jew is no more than a product of the other's gaze. In order to rearticulate Jewishness, he decides to focus not on Jewish thought or Jewish truth but on the Jewish experience.

The experience of being Jewish, says Blanchot, exists "through exile

and through the initiative that is exodus, so that the experience of strangeness may affirm itself close at hand as an irreducible relation."[13] The "experience of strangeness" is the relevant concept for my purpose. Blanchot makes it clear that the idea of strangeness is the qualification and the consequence of a relation, not a feature of an object. Exile and exodus become a vocation as soon one begins to see strangeness as an adequate relation in which to exist. Uprooting becomes a requirement, because it is the only way of positioning oneself "in relation to," instead of as part of, origin-bound identities. For Blanchot, the Jew is someone who relates to the origin, not by dwelling there, but by distancing himself from it. Separation and uprooting are the acts in which the truth of origin can be found: "If being Jewish is being destined to dispersion—just as it is a call to a sojourn without place, just as it ruins every fixed relation of force with *one* individual, *one* group, or *one* state—it is because dispersion, faced with the exigency of the whole, also clears the way for a different exigency and finally forbids the temptation of Unity-Identity."[14]

In Blanchot's writing, the experience of being Jewish becomes ever more emblematic of an epistemological mode. For him, not only is the self-identity of a group of people itself an experience, but the identity of experience serves as the very basis of truth. According to this epistemology, the truth is not to be pursued by trying to identify and *place* it, as ethnographers traditionally do. Instead, one needs to establish a relationship, a "conversation," with what one is not part of and what one cannot understand, but *not* with the purpose of understanding it.

In Blanchot's thinking the notions "conversation" and "speech" are crucial. And again, the features he ascribes to speech in the context of conversation are emblematic for the epistemological mode he favors. Normally, speech is seen as *mediating* something that precedes it. Speech has an origin, and this origin is the subject of speech. Blanchot, however, contends that the origin of speech is constituted *while* speaking. That is, it is the event of speaking and the act by which one relates to "others" as one speaks that give speech its origin. Blanchot argues:

Speaking inaugurates an original relation in which the terms involved do not have to atone for this relation or disavow themselves in favor of a measure supposed to be common; they rather ask and are accorded reception precisely by reason of that which they do not have in common. To speak to someone is to accept not introducing him into the system of things or of beings to be known; it is to recognize him as unknown and to receive him as foreign without obliging him to break with his difference. Speech, in this sense, is the promised land where exile

fulfills itself in sojourn since it is not a matter of being at home there but of being always Outside, engaged in a movement wherein the Foreign offers itself, yet without disavowing itself.[15]

Blanchot posits the object of speech no longer inside speech, as its topic, but facing it, as its addressee and partner in conversation. One does not speak *about* that which cannot be known or pinned down; one speaks *with* it. One tries to get "in touch."

This brings me back to the issue of the last chapter, where I discussed Paul Celan's text "The Meridian" and Hartman's reading of it. Celan is apparently arguing that in the post-Holocaust era, poetic voice is betrayed into an ongoing and inconsolable monologue, because all attempts to reach the addressee seem to fail. This failure turns the topic of poetry into an insistent calling out, an endless urge to get in touch. Post-Holocaust poetry becomes by necessity conative and phatic. At first sight, Blanchot's discussion of the exilic condition of being Jewish is similar. The difference, however, is located in the object with which one wants to get in touch. Celan mourns the interlocutor, who is not self-evidently present any longer. He wants to get in touch with a listener who responds, corresponds, or resounds. The crisis he is facing is a phatic or pragmatic one. Blanchot, however, deals here with the epistemological problem of getting to know something that, by its very nature, defies understanding.

In this way of thinking, exile becomes the precondition of a pursuit of knowledge that attempts not to mediate, but actually to touch knowledge. This epistemology makes use of language not because of its referential capacities, but for language's ability to constitute subjectivity. This is in line with Benveniste's view already mentioned, that the essence of language lies not in reference but in subjectivity, defined as relational and contrastive. The key to reaching knowledge in this language is the use of deixis: terms, like the personal pronouns *I* and *you*, whose content is consubstantial with the situation of language use. Deixis requires presence; its semiotic mode is the index. Exile as a relation pursues not substance, but difference, as knowledge. The exilic condition of the Jews makes "being Jewish" into the emblem of the subject who is able to perform this epistemology.

It is of course somewhat problematic for a non-Jew to idealize the "exilic condition" of the Jew. For Jews, the exilic condition is much more than an epistemological mode for pursuing knowledge: it is a historical reality. I would venture that many Jews who live the reality of exile have little patience with Blanchot's idealization. The French philosopher Jean-

François Lyotard seems to be more self-conscious concerning the problems of idealizing the situation of Jews. In his essay "the jews," Lyotard provocatively associates the problem of what he calls "the unrepresentable and the unforgettable" with "the jews," a term that is always plural, in quotation marks, and in lower case. The expression "the jews," he claims, refers neither to a nation, nor to a political, philosophical, or religious figure or subject. It is neither a concept nor a representation of any specific people as such.

Although Lyotard clearly avoids idealization, his is nevertheless a *metaphorical* notion of Jewishness. "The jews" should therefore not be confused with real Jews. However, as David Caroll argues in his introduction to Lyotard's essay, the term "the jews" obviously cannot be completely separated from real Jews either, for it is real Jews who have always paid, through enforced conversion, expulsion, assimilation, and finally extermination, for what Lyotard calls the repeated dismissal of the appeal or ethical demand associated with the name "the jews."[16] Indeed, metaphors are motivated, and they must be held accountable for that motivation. In full awareness of that problem, I would like to "follow" Armando and endorse Blanchot's idealizing reading of exile—not as the condition that ontologically characterizes "being Jewish," however, but as an epistemological attitude. This attitude is not unrelated to Jews, because it has been imposed on many of them as an unintended side effect of the sociopolitical situation of exile that was intentionally inflicted on them. Yet this relation is obviously partial, and does not cover an ontological similarity.

Armando, who is not a Jew, is very "jewish" in the way he approaches things he does not know or understand. He exiled himself to Berlin in order to be in the epistemological situation of Outsider. He is not interested in understanding the former German enemy: he knows all too well that he can never "understand" this agent of destruction. It is also naive to think that he hopes to find the "enemy" in Germany. Armando expresses his annoyance with that notion:

An impatient shopkeeper, a grumpy postman, a stubborn clerk, a malicious woman next door, is that the enemy? Don't think so. The enemy is not that simple. The enemy lives more in secrecy. That at least is what he promised me, the enemy. He prefers to hide himself, only once in a while can you see a glimpse of him, and even then you are not sure if it was really him. I kind of like him, the enemy. Suddenly he is there, that's familiar when he is there. What would we do without the enemy. Nothing.[17]

Instead of trying to get to know the enemy, then, Armando wants to live the condition of the speaking-subject-unable-to-know. But what exactly does that condition imply? Although he is not after the enemy, it is important for his artistic project to have at least a glimpse of him now and then. Not in order to get a better understanding of him, but in order to have an experience of astonishment and amazement.

Writing about his situation as an artist in exile, Armando formulates the core of his creativity casually:

You must also realize, unless you are totally green, that you are here in a foreign country, where nobody needs you. And you must also realize that you are making a *product*, bilious hangings, which again nobody needs. On the contrary. It makes no sense to complain about that, and yet there are many who do. Again and again I am amazed about that, because I am a master only of amazement.[18]

Armando is a master of amazement. His literary as well as his visual works are representations or even enactments of that amazement. And his exiled condition is a precondition for the possibility of being astonished.

It is important to note, however, that the origin from which he has exiled himself is not "Dutchness." Indeed, he cannot stand Holland; he never went into exile from the Netherlands. He feels totally alienated from Dutch culture, in which one is constantly "waylaid by unwieldy noise." According to Armando, the Dutch rule of life is "I am loud, therefore I am."[19] Leaving the Netherlands was no exile for him, but an escape.

Rather, what he exiled himself from was the "primal scene"[20] that he witnessed in his boyhood in the vicinity of Amersfoort Transit Camp. In this primal scene—which he is unable to grasp, to know, or to understand—elements of aggression and destruction are entangled with elements of boyish adventure. He had to exile himself from the spot were the primal scene took place, where his primal watching occurred, if he was ever to approach the scene at all. Exile, thus, is the unavoidable detour back "home" to the past.

In *Warbustle*, in a section titled "Hassle," Armando describes moments in which he traces the primal scene of Amersfoort while living in Berlin:

It happens sometimes that in the middle of this rough city I suddenly smell the moor. Of course it is only imagination, yet I really smell the moor. Then memories come: crunching gravel paths and merry family members. Also the gasping enemy, who roved thereabout, exercising, he had to, he couldn't do anything else. The gunpowder smoke. The thirst. The hidden weapons, the remains of uniforms,

and the search for military boots. Loot. Plunder. The threat. And the smells of the late afternoon, the dying out. The weary sun. The boom.[21]

This retrieval of the past through literal displacement is articulated in the evocation of a kind of discourse that, in its "pastness," belongs to Armando's own past. For in this passage, in expressions like "the gasping enemy, who roved thereabout, exercising"—another allusion to a genre he subsequently rejects—Armando mixes elements of the discourse of boys' adventure books with the reality of the war he witnessed.

Of course, one could argue that this allusion to boys' adventure books is autobiographically motivated. The frame that enabled him to bestow meaning on the events of the war may have been offered by his boyhood reading, which turns his contact with the transit camp into an exciting adventure. This hybrid discourse, however, produces an effect that, though indispensable, is provisional. It seduces the reader with the promise of romanticized adventures. The camp and the war are becoming the object of an improper fascination. But since both the plot and the closure of the adventure story are missing, the reader is stuck with a glimpse of adventure that is just seductive enough. One is lured into the realm of destruction with no means of escape. Hence, this adventure, like one-way travel, leads one away with a false promise but fails to bring one back "home."

Once pulled out, one gets stuck, exiled like the writing subject. The reader is therefore forced to go along with the writer into this pointless exile. Armando must displace himself spatially in order to reach a destination that is not in space but in time, to get in touch with the past that he needs to safeguard from oblivion. This enables him to trace his primal scene—even in the middle of Berlin. His search for the past is not carried out by an attempt to retrieve the past or to capture it in involuntary memories, in the manner of Proust, but by means of "respatialization." He has to displace, to exile, himself in order to keep in touch with his primal scene.

Displacement to Germany was not the only solution. Other places would do. Armando tells of a trip to England that had the same effect. Visiting Norfolk on the east coast, the point of departure for British war planes on their way to bomb Berlin, he sees in his differential experience of space his boyhood surroundings, now irretrievably lost, as they once were: "England is a country where all kinds of things occur to you. O yes, we had that also, why has that disappeared in the Netherlands in such a sneaky, if not skulking way."[22] Again the wording recalls adven-

ture: sneaking and skulking, danger and guilt are part of the simple, banal details. He tries to get in touch with the primal scene of his past by using expressions that displace the attention from what has disappeared to *how* it disappeared. In this displacement of attention the war returns, because the expressions he uses for describing changes in time are not arbitrary: they depict the enemy. They suggest that the enemy was responsible not only for what happened in the past, but also for the fact that this past will disappear into oblivion. The enemy manifests itself in the passing of time. The past and the enemy thus have something in common—elusiveness—and that turns the past into the enemy. For that reason the passing of time can be described metaphorically as "sneaky . . . skulking."

Armando's displacement in space has yet other possibilities for retrieval of the past. Although Germany is not the only place that enables him to get in touch with the events that took place at his playing ground, the place of exile is not arbitrary. It must have certain features. In the piece titled "Prey," he talks about his admiration for Peggy Guggenheim, who, as early as 1948, knew she wanted to live in Venice. Armando ended up in Berlin, but not because he strongly prefers this city above other places. He is not able to choose among cities like Berlin, Paris, Munich, Rome, New York, or even an island like Tahiti. Although he cannot settle down anywhere permanently, he knows very well what qualities the cities have among which he is unable to choose:

I have a preference for environments with buildings that stand on high legs, I love wide stairs, high walls, high-spirited columns, proud halls, steps, even the metopes and architraves and more of those elements. I am less suited for safe smallness and pleasantness, I am not very much in favor of tiny things. Rather the monumental, rather the palaces and the underground arches.[23]

The features he ascribes to the kinds of buildings he likes are features that belonged to the enemy (or better, to the stereotype of the enemy): high legs, proud, high-spirited, broad. They lead to fascination and astonishment. In these buildings he is confronted with the strangeness of difference, which reminds him of his astonishment before the enemy. The description of the buildings as a personification of the enemy conveys the memorialized focalization of a child watching, in awe and fear, broad-shouldered men on long, booted legs. What he seeks in the built environment is to identify with the vision of the little boy he once was—as a way of erecting a monument of the past out of what surrounds him in the present. He prefers buildings endowed with the qualities of the enemy. The spaces to which he exiles himself are metaphors for the enemy and for

the destructive past this enemy set in motion. The intimidation and as-
tonishment he feels before monumental buildings reenact the astonish-
ment he once experienced as a witness of events caused by the enemy.

Armando's exile to enemylike places is a directed return to the past in
the form of a spatial encounter with it. Having been unable to understand
his primal scene at the moment he witnessed it, he looks for places where
this failure of understanding is reenacted. But the reenactment itself is not
an effort to reach understanding. Armando knows too well that the past
he has witnessed can never really be understood. His epistemological at-
titude, rather, consists in besieging the past with the awareness that the
past will never be surrendered or understood. Knowing the unknowable,
then, means being in touch with it, having an ongoing conversation, not
about it, but with it. Or to return to Blanchot, Armando does not try to
identify or place the past; instead he enters into a relation with it.

The past's elusiveness makes it threatening and renders the urge to
know it more acute. Exile is Armando's weapon against both the past as
enemy and the enemy of the past. He displaces himself in space in order
to reach his destination in time. In exile, unable to master his amazement,
he must pursue his vocation as a master *of* amazement. Going into exile
is his artifice, by means of which he produces experiences of astonish-
ment. In exile he is exposed to foreignness in all its forms: in "scraps" of
speech, where the past he has witnessed elsewhere is evoked in surprising
ways; in houses where the enemy has lived without leaving any traces but
without supplying the possibility of feeling at home; in monumental
buildings and streets. Armando does not understand the past in the mo-
ments of astonishment in exile—on the contrary; but he does keep alive
the effect the past has had on him. This reenactment of astonishment is
a way of talking back to the past, an effort at keeping in touch.

Giving Memory a Place

Sublimity in the Home
Overcoming Uncanniness

What does it mean to inhabit the (exterminated) Jewish quarter of Amsterdam (of Europe)? What does it mean to *inhabit history* as crime, as the space of the annihilation of the Other?
 —Shoshana Felman, in *Testimony: Crises of Witnessing in Literature, Psychoanalysis, and History*

This chapter will be about my own house, the house I have been living in for three years now (Fig. 38). It was built by the Jewish architect Harry Elte for himself in 1928. Elte lived in the house until 1943, when the Nazis took him and his wife away. They never came home; they died in 1944 in Theresienstadt.

My awareness of this history of the house is intense. It determines the way I feel at home in that house. A friend of mine once remarked that for him it would be impossible to live in Elte's house. Elte's not-coming-back to his own house—his own house in a double sense of the word—turned the house for my friend into a never-ending reference to the Holocaust. At the moment the Holocaust is evoked in a place, by a place, even to think of feeling at home there would be unbearable.

For me, though, that is somehow not the case. The awareness of the history of the house is not intolerable for me. I now feel "at home" in Elte's house, though it took a while. For some

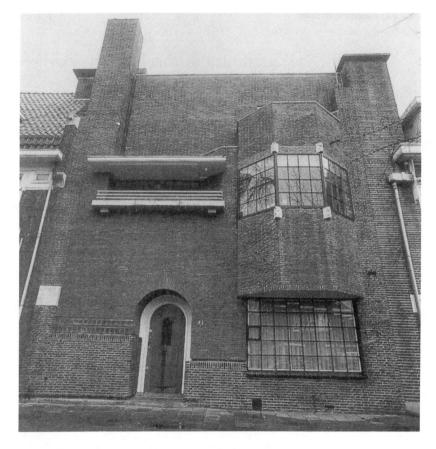

Figure 38. Harry Elte, town house, Amsterdam, built 1928

time I was hesitant. Was the house, with its evocation of the Holocaust, haunted, uncanny, because a part of a history could return there that I wanted to forget in order to feel at home? Or does the evocation of the Holocaust give additional significance to the idea of feeling "at home," which is relevant for our relationship to the past? In this chapter, I want to see whether it is possible to grasp, and speak of, such a significance.

To do that I will look again at the concept of the sublime. This time, however, I will not reflect on Kant's concept of the sublime, but rather on Edmund Burke's. Whereas Kant focuses on the sublime as an experience of the subject that results from conflicting cognitive faculties, Burke describes the sublime in terms of perceptible characteristics of the object that evoke an almost mechanically sublime terror in the viewer. Because

the starting point of this chapter is a house, its history and the feelings this house evokes in me, its inhabitant, Burke's concept of the sublime seems more relevant. I am interested in the question of whether it is the house as such or my ambivalent relation to it or to Holocaust history that makes it possibly uncanny. But I do not want to *apply* this concept for an analysis of the feelings my house evokes in me. Rather, I want to see how this case can contribute more generally to an understanding of the sublime in terms of memory and history.

In the history of literature and the arts, it is the spatial dimension that has usually been invested with the characteristics of the sublime. In the nineteenth century, for example, the sublime was experienced particularly in the openness of nature, and was expressed in terms of height, depth, and extension. Yet I will not discuss the spatial dimension of my house, the architectural features that might trigger sublimity. I am more interested here in memory as a repository of the sublime, and as a way of coping with the history of this house and with my earlier resistance to the Holocaust in terms of the events that took place here.[1]

I will start with a short text by Armando from his book *Voorvallen in de wildernis* (Occurrences in the wilderness, 1994); it is called "Oude Huizen" (Old houses).

The house I live in.

I walked through the rooms in which many generations have resided. Who has lived there, what were their conversations like, how were their rooms furnished, who was born there, who died there, and what about their servants.

I don't know. It seems important to know, but I don't know. Perhaps I could have found out some things, but that is not what I want. You can keep going then. You can conduct investigations and discover some things, but you will never know everything. Again and again new questions will arise.

It is time that I reconcile myself to the fact that I don't know some things and that I will never know them. And yes, slowly I'm coming to the point where I'm at peace with that.[2]

In this text, the house is seen not as a formal and functional entity with certain architectural characteristics, but as an embodiment of the lives that have been lived there. It is a kind of dead body in which Armando is looking for traces of the life that has passed away from it.

Armando's desire to know the past of his house and the lives lived there is a common phenomenon. I know many people who became interested in the history of the house they were renting or had bought. They

explored the city archive to find out about the house and its former inhabitants. Its antecedents were checked. Or if we continue the metaphor of the house as a dead body from which lives have passed away, we can also say that the genealogical tree, the family tree of the life of the house, was reconstructed.

I am interested in the "why" of this phenomenon and how it situates me in this present that contains the past. In what sense does knowledge of the past of a house contribute to the experience of living in that house? What desire or anxiety motivates these explorations? An obvious answer, of course, is that people want to make the house their own, take possession of it, to feel at home by creating a continuity with the past of the house. One feels at home as soon as one can add one's name to the family tree of the house. At that moment people are no longer strangers in their own house.

But a more sinister answer to this question is also tenable, one that can be phrased in terms of the uncanny. This answer would take us to the sublime's opposite. One could say that the new inhabitant is unconsciously afraid that the house is haunted, that former occupants will return. The intimacy and security of the house are constantly threatened by the potential invasion of an alien presence, of the return of dead former inhabitants whom one does not know. Knowing the past of the house, then, is a way of exorcising anxiety about the dead's uncanny return.

This explanation turns the interest in the history of one's own house into a sort of gothic tale. In the gothic stories of the romantic period, haunted houses were the virtually exclusive sites of uncanniness. Strange things occurred within the intimate space of the house when an alien force or presence intruded. The German expression for the uncanny is very much to the point for such a situation: the house becomes *unheimlich* ("unhomely").

But as Freud stressed in his essay "Das Unheimliche," the alien presence is in fact not alien at all. That which is experienced as uncanny is something that is not strange, new, or alien, but well known and familiar, though it has been repressed. According to Freud, the reason for repressing something familiar is a problematic experience in the past that blurred the demarcation of the self. The threatening, blurring experience is then projected in the present onto something alien, outside the self.

When we apply Freud's analysis of the uncanny to gothic stories, we must ask which familiar but repressed aspect of the self is returning in the haunted house? As Anthony Vidler argues in his book *The Architectural*

Uncanny (1992), Edgar Allan Poe's House of Usher is paradigmatic for all the haunted houses in the gothic stories of his romantic predecessors. In Poe's story the site is desolate. In the words of Vidler,

the walls were blank and almost literally "faceless," its windows are "eye-like," but without life: "vacant." It [the haunting] was, besides a repository of centuries of memory and tradition, embodied in its walls and objects; the walls were marked by the "discoloration of ages" and crumbling stones; the furnishings were dark, the rooms vaulted and gloomy; it was, in fact, already a museum, a collection such as that assembled by Alexandre de Sommerard in the Hotel de Cluny, here preserved in memory of a family. Finally the family itself was almost extinct, doomed by a history that lent the air of the tomb, the family vault to this once-living abode.[3]

The house is metaphorically described as a dead body. It is faceless and its eyes are vacant. But at the same time, death is being housed by the house: the house is also tomb- or cryptlike. Hence, it evokes death metonymically as well.

Freud's concept of the uncanny fits Poe's story perfectly. The house evokes the feeling of the familiar and the unfamiliar at once:

While the objects around me—while the carvings of the ceilings, the sombre tapestries of the walls, the ebon blackness of the floors, and the phantasmagoric armorial trophies which rattled as I strode, were but matters to which, or to such as which, I had been accustomed from my infancy—while I hesitated not to acknowledge how familiar was all this—I still wondered to find how unfamiliar were the fancies which ordinary images were stirring up.[4]

It is precisely this ambivalent feeling of mingled familiarity and unfamiliarity that defines the uncanny. According to Freud's reading, however, it is not in the house itself that one must look for the cause of the haunting. Although Poe's dramatization invests the house with uncanny qualities, those qualities have been repressed by the narrator and the main character, Roderick Usher, both of whom experience the House of Usher *as* uncanny. It is in fact the narrator who recognizes the tomblike quality of the house as familiar, as something that belongs to his self. The climax of the story, the horrified cry of Roderick Usher to the narrator—"*We have put her living in the tomb!*"—dramatizes such a repression.[5] Roderick's sister has been (re)pressed to the dead while still belonging to the living, to the familiar and familial. This repression of life into death is the cause of the haunting, for the sister returns from death.

Freud's analysis of the uncanny makes it impossible to locate uncan-

niness in the formal characteristics of a house or in its history. The house with its history only serves to *situate* the uncanny experience. It is the person having the uncanny experience who has agency over it, albeit unconscious. He or she, as the original agent of repression, is likewise the agent to whom the repressed feeling returns.

This does not seem to be the situation in the Armando text quoted above. In that short piece, Armando seems to express a serious interest in the lives that had been lived in the house, an interest that does not exactly signal repression. At the same time, he is aware that his interest or curiosity will remain frustrated. It is impossible to know the things he would like to know. But where does that leave agency, even in the paradoxical case of repression?

The answer becomes apparent when we realize that the relevance of the concept of the uncanny is revitalized in another way, that is, through language. Freud, namely, turns for his analysis of the psychological phenomenon of the uncanny to etymology.[6] The German word *heimlich*, he observes, means literally "belonging to the house," or more generally, something withdrawn from the eyes of strangers, something concealed or secret. The word *unheimlich*, significantly, is a synonym of its opposite, *heimlich*. Freud therefore reads the prefix *un-* as a symptom of repression, of which uncanniness is the result. To underscore the repression that is at stake in uncanniness, he quotes the German romantic philosopher Schelling: "*Unheimlich* is the name for everything that ought to have remained secret and hidden but has come to light." So far, then, the connection between familiarity and strangeness is mediated through repression.

As Vidler points out, an etymological analysis of the English words *canny* and *uncanny*—meaning in their original derivation, respectively, "possessing knowledge or skill" and "beyond ken, beyond knowledge"— opens up yet another perspective. For it is through this connection between the impossibility of knowledge and the uncanny that we enter the realm of the sublime.

In Edmund Burke's *Philosophical Enquiry into the Origin of Our Ideas of the Sublime and Beautiful* ([1757] 1990) knowing is connected, by opposition, to the sublime. The argument runs as follows: Whereas knowing is a form of setting limits, the sublime implies the impossibility of setting limits, hence, the impossibility of knowledge. How is it possible that these two concepts of the uncanny and the sublime, the one conceived in its original linguistic expression and the other in its content, can become difficult to distinguish from each other?

In fact, this is not as strange at it might at first seem. Vidler argues that the uncanny is aesthetically an outgrowth of the Burkean sublime and, further, that the spatial uncanny is essentially a domesticated version of absolute terror—the sublime experience—experienced in the comfort of the home. He sees the nineteenth-century fascination with the uncanny, embodied in the haunted house, as an expression of the anxiety of a new social class not quite at home in its own home: "The uncanny, in this sense, might be characterized as the quintessential bourgeois kind of fear: one carefully bounded by the limits of real material security and the pleasure principle afforded by a terror that was, artistically at least, kept well under control."[7]

This approximation of the two concepts makes sense, though, only if an important distinction is kept in mind. The element of terror in an uncanny experience must be distinguished from the sublime terror described by Burke. In the hierarchy of romantic genres, the uncanny was intimately bound up with, but strangely different from, the grander and more serious "sublime," the master category of aspiration and the unattainable.[8] When the narrator of "The Fall of the House of Usher" characterizes the uncanny feeling that house evokes, he does so in contrast to the sublime: "There was iciness, a sinking, a sickening of the heart—an unredeemed dreariness of thought which no goading of the imagination could torture into aught of the sublime."[9] If the sublime is the master category, then, the uncanny is a subversive subgenre of the sublime. There are more such subgenres in the romantic hierarchy: the grotesquerie, the caricature, the fairy tale, the melodrama, the ghostly romance, and the horror story. These subgenres are all subversions of the overarching premises and the transcendent ambitions of the sublime.

According to Vidler, the uncanny is the most subversive of all, not only because it is easily trivialized or caricatured (as in Jane Austen's *Northanger Abbey*), but also because it seems at times indistinguishable from the sublime, as the etymology of the English word *uncanny* demonstrates. But such considerations of generic hierarchy seem hardly satisfactory when it comes to explaining the relationship of the sublime and the uncanny, so opposed yet conflated. Indeed, an even more fundamental connection between the two concepts has been suggested by the philosopher Schelling, Freud's source of inspiration for his analysis of the uncanny. Schelling sees the uncanny as a necessary precondition for the sublime, a force to be *overcome*. The overcoming of the uncanny results in the sublime.

Schelling develops this argument in his *Philosophie der Mythologie* of 1835, in which he attempts to synthesize the history of religion with the anthropology of cults. In this context, the uncanny is seen as the first step toward poetry, religion, and philosophy, which originate in the moment that the uncanny is overcome. The Homeric songs, for Schelling the supreme examples of the sublime, are the result of such an initial repression, that is, the subjugation of mystery, myth, and the occult. Therein lies the meaning of Schelling's paradoxical statement that "Homer is not the father of mythology, mythology is the father of Homer." The following argument beautifully formulates Schelling's conviction that the Homeric sublime was founded on the repression of the uncanny:

Greece had a Homer precisely because it had mysteries, that is because it succeeded in completely subduing that principle of the past, which was still dominant and outwardly manifest in Oriental systems, and in pushing it back into the interior, that is, into secrecy, into the Mystery (out of which it had, after all, originally emerged). That clear sky which hovers above the Homeric poems, that ether which arches over Homer's world, could not have spread itself over Greece until the dark and obscure power of that uncanny principle which dominated earlier religions had been reduced to the Mysteries (all things are called uncanny which should have remained secret, hidden, latent, but which have come to light); the Homeric age could not contemplate fashioning its purely poetic mythology until the genuine religious principle had been secured in the interior, thereby granting the mind complete outward freedom.[10]

As this argument demonstrates, however, for Schelling the uncanny was not only a precondition of the sublime; it was also, and at the same time, its opposite. He opposes the uncanny to the sublime by means of dichotomies: dark interior versus the clear sky of the exterior, obscure power versus the freedom of the mind, religion versus poetry, the secrecy of the interior versus the vast openness of the exterior.

But the binary logic that structures the differences between the uncanny and the sublime is less striking than what they have in common: both are based on repression. The uncanny is based on a primal repression (in Freud, the "scientific myth" of the slaying of the father), while the sublime is in turn based on a repression of the uncanny. This similarity is not just an arbitrary analogy; rather, it turns the sublime into a repetition of a constant principle.

The point of stressing the similarity rather than the differences between the uncanny and the sublime lies in the way they are conceptualized. That is, instead of forming static realms or domains, they articulate two phases

in a single process. Those phases are based on the same principle, namely repression.

Having reformulated the uncanny and the sublime as phases in a process, it becomes relevant to look again at how they differ as repetitions of repression. The uncanny is based on the repression of something familiar, the effect of which is then projected onto something alien or exterior. This repression results in a comfortable, clearly defined self-image, but one that can be challenged again by the uncanny experience. This return puts the ego boundaries at risk. Losing those boundaries is experienced as threatening, hence, as negative.

The sublime, in contrast, involves a repression of the dark and obscure power of the uncanny into the interior, or, as in Homer's days, into the institutionalized practice of the Mysteries. Thus, the direction of the repression is reversed. Repression no longer takes the form of a projection outward, as in the uncanny; rather, it is redirected back to the interior. What is the gain of this second repression? Apparently, the opposite of the preservation of a clearly defined self-image or strong ego boundaries is at stake. After the destabilizing threat caused by the uncanny has been repressed inward, the subject's orientation can still be directed outward. There continues to be interest in that which is beyond the self, and beyond the grasp of the self. Instead of safeguarding the self, then, there is in the sublime an inclination to lose the self in the extensions of the ungraspable and unattainable, and thus to engage with it.

This discussion of Schelling's construction of the Homeric sublime makes the opposition between interior and exterior, if anything, more ambiguous. This opposition no longer refers to a simple spatial distinction. Now it also has psychological and aesthetic resonances. This implies that the concepts no longer are confined to atemporal, formal terms, but become bound up with experiences, happenings—historical events. Hence, instead of shifting from one semantic field to the other, I would like to complicate both concepts, in conjunction, by keeping both the spatial and the aesthetic-psychological resonances together, as the resonances of the other, so to speak. To do so I will, paradoxically, focus on *time*.

It is striking that in their popularized constructions, the uncanny and the sublime are generally not only located in space but also conceived in spatial terms. Indeed, that tendency seems to me most relevant. The uncanny is usually situated inside closed spaces—houses, buildings. It is associated with silence, loneliness, and confinement. Conversely, the sub-

lime is experienced in the openness of nature. One has only to think, for example, of the paintings of Caspar David Friedrich, where man is depicted as small and insignificant against the grandeur of nature. This opposition of man and nature suggests that the sublime, like the uncanny, can also conjure up feelings of loneliness. The fact that the sublime can also be experienced when one is confronted with vast structures such as cathedrals or monumental buildings with colonnades likewise indicates that feelings of isolation are often expressed metaphorically by means of spatiality. Just as mountain peaks remind us of our own insignificance, so does the monumental aspect of magnificent buildings. Loneliness, confinement, depth, and extension become inextricably linked within temporal, psychological, or aesthetic dimensions. Without losing sight of the spatial aspects of the uncanny and the sublime, then, I want finally to foreground their temporal dimensions.

As I discussed earlier, living in Elte's house at first evoked in me uncanny feelings. This was so because of its history—or, more accurately, because I live in the house of someone who died in the Holocaust and who was its architect, owner, and resident. Yet at the same time, the house is sublime: it has many formal architectural features that, in our tradition, are experienced as evoking sublimity.

In my rereading of Schelling, however, I began to see the uncanny and the sublime as articulations of two moments in a single process. I now propose this process as therapeutic and political: the experience of uncanniness can be overcome, I believe, when sublimity is allowed to happen. The possibility for sublime experience emerges through the dialectic between private and public, personal and collective.

First, the uncanny experience. The moment of uncanniness is based on the return of something that had been familiar but was repressed and projected onto something alien or exterior. The uncanny is threatening because one's ego boundaries become lost. One's self-experience is at stake and must be defended. The question I must ask, then, is: How can the return of the idea of somebody who died in the Holocaust threaten my experience of self? And why do I need to repress this person (familiar as he is in the sense that I know his history), or memory or awareness of his dying in the Holocaust, in order to feel at home?

Gaston Bachelard wrote in *The Poetics of Space* ([1958] 1969) that people invest spaces, both public and private, with memory. His discussion, though, is limited to the private domain: he discusses the function

of the home as providing shelter not only for those who live there, but also for their memories and their past. As Bachelard expresses it, that is the ultimate relevance of his reflection on space in the home; the home allows the memory of the past to live. But Bachelard is interested in the home only as a condensation of the memory of one's *own* past. The house consolidates one's sense of self because it offers space to invest with memories.

This personal investment is in tension with the distinction between self and other: my own life, Elte's past. And Elte's past is, crucially, both private, personal, and collective because others shared the same fate. Even more threatening than this crossover of identities, my home becomes the conveyor of a collective memory, the memory of those who died in the Holocaust and never came home. The memory of the Holocaust is bearable, and even then hardly, only in an institutionalized form: in the form of official memorials, in the form of Holocaust museums, in the form of an annual day of commemoration. The memorial and the museum are public places that convey memory—a collective memory, that is. Collective spaces can be the bearers of such memories because they don't affect me, my life, privately. The issue of these collective spaces, then, is the maintenance of privacy itself.

The relevance of Bachelard's view is limited to the personal, individualistic appropriation of the home. Yet there is also a practical connection between memory and space. In her seminal study *The Art of Memory* (1966), Frances Yates describes how classical orators used the house to fix the structure of their arguments and commit speeches to memory. According to the Roman rhetorician Quintilian, the house, with its distinct floor plan and organization, offered an excellent method for learning speeches: the orator was simply to visualize himself walking through the house and attaching a part of his speech to each successive area or piece of furniture. An imaginary walk through the house would then recall the various sections of the speech in the correct order.

The difference between Bachelard and Quintilian in their description of how space becomes invested with memory is, I find, revealing of the former's utter individualism. The price to pay for this individualism is uncanniness. Bachelard's vision of the home makes his home into a suitable candidate for becoming haunted or uncanny. He defines the individual subject as a being who depends on his or her memories for an experience of wholeness.

Quintilian's vision of the home, in contrast, is ultimately practical. It

does not invest the home, or the memories it can carry, with qualities like self versus other, or individual personality versus collective anonymity. Although in the classical tradition there is a temporal dimension to space—that is, space can convey memory—the identity of the memory is completely open. In Bachelard's case, space always carries a personal memory, and the boundaries of the home are at the same time the boundaries of one's individuality. This identification between home and individuality is for that matter revealingly present in Poe's story, where the expression "the House of Usher" signifies both the building and the family.

Bachelard's vision explains why the memory of the Holocaust in Elte's house is unbearable and has to be repressed. I contend that Bachelard has given voice to our contemporary notion of the home as being tied to the constitution of individual subjectivity. And that connection between home and subjectivity is, precisely, what is threatened. When Elte's house embodies an ongoing reference to the Holocaust, it implies that my home is intruded upon, not only by someone other than me, but by a collective memory. It is not anecdotal knowledge of somebody's life and death that is evoked—I know almost nothing specific about Elte; rather, it is a collective memory of what happened to a group of people who were treated as utterly anonymous. That collective memory now occupies the space of the house that was waiting to be invested with my own personal memories.

But—and this is why I had to address this problem through the very personal case of living in Elte's house—the sublime can offer a solution to this rivalry between *their* memory (which is both plural and other) and my own memory. In order to overcome the uncanny, to overcome our inclination to strengthen ego boundaries or the self by means of the boundaries of the private home, the second phase in the process can reverse that individualistic repression. By turning the tables on individualism, we can use sublime experience to break out of individualism. The subject's orientation is now directed outward. Whereas within the realm of the uncanny the memory of the Holocaust is life- (or subject-)threatening, within the realm of the sublime it gives a perspective outside the self. Precisely because the content of the Holocaust, its meaning, is ungraspable, its sublime ungraspability can become the significance of the moment in which our individualism crumbles away.

This is the way I can live with the memory of the Holocaust in Elte's house. His house, my house, has also become, then, a memorial. Its

boundaries expand—literally—as I walk out of it into a neighborhood where so many Jews settled in the early twentieth century, from where they were deported in the mid-twentieth century, and where I now shop and stroll and live in the post-Holocaust era. My house does not delimit only my own boundaries anymore; it is invested not only with the memories of *my* past, but also with the memories of his past. My house is in continuity with the memory of Elte and his death in Theresienstadt. It is thanks to its features, which enable sublime experience, that my/his house can touch the ungraspable, the unattainable, of the Holocaust.

Reference Matter

Notes

INTRODUCTION

1. A fourth work commissioned by the museum is *Loss and Regeneration* by Joel Shapiro. This work is overtly symbolic rather than formalistic abstract. Its symbolism, suggesting a house and a tree, is so nonspecific for the Holocaust that again there is no suggestion of the representational strategies of documentary realism. For a discussion of the works of art commissioned by the Holocaust Museum in Washington, see Johnson 1993.

2. Schama 1995, 75–134.

3. Huyssen 1989, 27 4. Huyssen 1992, 92.

5. Huyssen 1989, 45. 6. Camus 1958, 11.

CHAPTER 1

1. This oppositional distinction informs, for instance, the writings of Lawrence Langer about Holocaust literature. He expresses his suspicion of Holocaust literature thus: "When the Holocaust is the theme, history imposes limitations on the supposed flexibility of artistic license. We are confronted by the perplexing challenge of the reversal of normal creative procedure: instead of Holocaust fictions liberating the facts and expanding the range of their implications, Holocaust facts enclose the fictions, drawing the reader into an ever narrower area of association, where history and art stand guard over their respective territories, wary of abuses that either may commit upon the other" (1990, 117–18).

2. See White 1978.

3. See, for instance, the catalog *After Auschwitz: Responses to the Holocaust in Contemporary Art* (Bohm-Duchen 1995). Moreover, Bohm-Duchen's own contribution about contemporary art and the Holocaust, "Fifty Years On" (103–45), fails to introduce new issues or perspectives beyond the condemnation of aesthetic pleasure.

4. Adorno 1992, 87–88. 5. Ibid., 88.

6. See, for instance, Kenrick 1982. 7. Young 1990, 60.

8. Hirsch 1992–93, 12. 9. Young 1990, 57.

10. Hirsch 1992–93, 27. 11. Scholes 1975, 7.

12. Young 1990, 17.

13. I do not, of course, mean to say that the events are not "true." Let me state up front that the arguments put forward in this study cannot be aligned with skepticism, relativism, or revisionism of the kind that questions the historical reality of the Holocaust. My aim, rather, is to rethink the notion of "truth" in representation as no longer automatically coinciding with the notion of "real." The truthfulness of an event, in other words, does not guarantee the possibility of a uniquely realistic account of it.

14. Young 1990, 27.
15. Ibid., 28.
16. Ibid., 36.
17. Lang 1990, 134.
18. Ibid., 146.
19. Culler 1981, 202.
20. Ibid.
21. Lang 1990, 154, 145.
22. Ibid., 145.

23. See White 1973, 1978; Ankersmit 1983, 1990; Kellner 1989; Bann 1984; LaCapra 1987.

24. Kellner 1989, 24, 1.

25. Swift 1983, 139-40.

26. In particular, Saul Friedlander has fought the German historiographic impulse through analysis of its strategies very convincingly. See his chapters "A Conflict of Memories? The New German Debates About the 'Final Solution'" and "Martin Broszat and the Historicization of National Socialism" in his *Memory, History, and the Extermination of the Jews of Europe* (1993b). See also LaCapra's *Representing the Holocaust: History, Theory, Trauma* (1994).

27. Friedlander [1982] 1993a, 91, 92.

28. Friedlander 1992, 17.

29. This has been argued convincingly and insightfully by Cathy Caruth (1990, 1991, 1995) and Geoffrey Hartman (1995b, 1996). See also the pathbreaking book *Trauma and Recovery* (1992) by psychiatrist Judith Herman; and van der Kolk and van der Hart 1995.

CHAPTER 2

1. In "the jews" (1990), Lyotard discusses the silence as an ethical question. I will not engage that position in this chapter.

2. Dresden 1992, 8 (my translation).

3. Ringelheim 1990, 142.

4. Langer's *Holocaust Testimonies* (1991) is a valuable book because of the careful attention he pays to the testimonies discussed. I do not agree, however, with the unmediated status he applies to testimony as a genre. Although experience and testimony are for him authentic because unmediated, he meets literary representations of the Holocaust with suspicion because of their dependence on mediated conventions. I fully agree with LaCapra's critique of Langer: "Langer's view obscures the role of rhetorical conventions in oral discourse and the inter-

action between 'literary' writing and speech" (1994, 194). Another insightful critique of Langer can be found in Ezrahi 1996.

In what follows, page references in the text are to Langer 1991.

5. Basing his argument on the work of Berel Lang (1990), White calls for a rhetorical mode that offers a subject position that is neither active nor passive. He refers to classical Greek as an example of a language with not only active and passive modes but also a so-called middle voice. These three voices imply different actantial relations (of the agent) to the action or event. Whereas the modern Indo-European languages only offer the possibility of the active and the passive mode, classical Greek offers with this "middle voice" a different subject position in relation to the event.

6. J. Ringelheim, quoted in Goldenberg 1990, 153.

7. Delbo 1995, 267. 8. Culler 1988, xiv.

9. Ibid., xv. 10. Ibid., xiv.

11. White 1992a, 47.

12. Armando and Sleutelaar 1990, 63; subsequent page references in the text are to this work, and all translations are my own.

13. The volume edited by Friedlander, *Probing the Limits of Representation* (1992), to which many of the aforementioned historians have contributed, is very valuable because it contains diverse positions, critical of one another, but all within the same "questioning" mode of critical historiography. Friedlander's books *Reflections of Nazism* ([1982] 1993a) and *Memory, History, and the Extermination of the Jews of Europe* (1993b) provide detailed discussions of the repercussions of several ways in which the Holocaust and Nazism have been framed. Young's book on Holocaust memorials, *The Texture of Memory* (1993), also provides an analysis that derives its strength and value from the insight that the memory of the Holocaust is constructed in the act of framing it.

14. "Liberal view" applies here to the European context, in which *liberal* does not mean left-wing, as it does in the United States, but conservative.

15. Friedlander 1993b, 25; subsequent page references in the text are to this book.

16. Quoted in ibid., 34.

17. Young 1993, 15.

18. Ibid., 2.

CHAPTER 3

1. In this chapter I use the last name Salomon to refer to the artist and the first name Charlotte to refer to the character in the autobiographical work *Life or Theater?* In a third role, Salomon appears as a narrator who is not at the same time a character within the fictional universe being depicted (see Bal 1985); this function is indicated by the term *narrator* or *external narrator*. In this guise the

narrator marks her exteriority by speaking of Charlotte in the third person and by demonstrating access to others' thoughts. These are two signs that mark the text generically as a fiction, a genre that stands in tension with both historiography and autobiography.

2. In her important study *To Paint Her Life: Charlotte Salomon in the Nazi Era* (1994), Mary Lowenthal Felstiner has convincingly shown that the suicides in Salomon's family are not anomalous but reflect a widespread pattern for German Jews in the Nazi era. The suicide rates of Prussians between 1923 and 1927 lead Felstiner to make the following statement: "Fränze Salomon's suicide took place in a nation with one of the highest rates in the world, in a province and capital with the highest rate in the nation, in a city with the highest ratio of female suicides, in a class with the highest rate among classes, in a faith with the highest proportion among faiths" (14).

3. All the sheets of *Life or Theater?*, as well as the unnumbered sheets not included in the finished work (nor reproduced in the book of *Life or Theater?*), are in the collection of the Jewish Historical Museum in Amsterdam and can be viewed on request. In references below to the unnumbered sheets, I use the codes assigned by the museum.

4. In what follows, page references in the text are to this essay.

5. These peculiar conceptions of Daberlohn become slightly more understandable against the background of the experiences of the real person represented: Alfred Wolfsohn. At the outbreak of World War I Wolfsohn was eighteen years of age, and he served in that conflict as an army stretcher bearer. He incurred a serious shock when he remained buried for several days under dead and dying soldiers. After the war, while attempting to restore his psychic balance, he developed a theory of the human voice. The sounds he heard from the dying soldiers had been far from normal in range and volume. Afterward he experimented with his own voice and took singing lessons, but he failed to find the vocal heights and depths to equal the extreme emotions that he had experienced and that he had perceived in the dying soldiers. He concluded that the voice and the soul are inseparably bound and that the limitations of the voice reflect those of the soul. Development of the voice, he further believed, can help to cure the soul.

Page references in the text are to Salomon 1981; the statement quoted here is from p. 435.

6. Klaus Theweleit analyzes this tradition of "Orphic creation" in *Buch der Könige* (1988); see also his "Politics of Orpheus, Between Women, Hades, Political Power, and the Media" (1985). Theweleit sees Orphic creation as a masculine process facilitated by the encounter with the beautiful dead woman who may not come out or sing her own song. Orphic creation is thus an artificial "birth" produced by men, by male couples who can bypass the generativity of women. Charlotte Salomon has not only arrived at the same analysis of Orphic creation as Theweleit; she is also able to resist and transgress it.

7. The notion of the "homosocial" is developed by Eve Sedgwick in her book *Between Men: English Literature and Male Homosocial Desire* (1985). With that term Sedgwick indicates a social bond between men, not directly sexual in nature, that also delimits and determines the relationship between men and women. Although homosociality is not the same as homosexuality, the intensity of the social competition between men can easily brim over into sexual desire for other men. See also van Alphen 1996a.

8. "Doch glaub ich auch für mich an die Erlösung durch die Frau" (Unnumbered sheet C 34876, JHM 4948).

9. Felman 1993, 36.

10. "Und wenn ich ihr ganz tief in ihre Augen schau dann seh ich nur mein eigenes Gesicht + sich spiegeln ist mir + dies nicht ein Symbol dafür daß wir wenn den anderen zu lieben glauben nur immer selbst Objekt und Subjekt sind" (Unnumbered sheet C 34872, JHM 4963).

11. "Künste Frau B klar zu machen, daß dieser Orpheus, den sie darstellen soll, nichts anderes ist als sie selber, die diesen Seelenverlust erlitten hat und nun in ihr eigenes Inneres herabsteigen muß um sich selbst wieder zu finden. Du wirst vielleicht gemerkt haben, wieviel Bluff hinter ihrem ganzen Getue ist, mit dem sie schon eine Reihe von Jahren sehr viele Menschen betört. Und das Interessante ist nämlich, daß darunter eine ganz phantastische Frau steckt, eine Frau zu der man aussehen konnte, . . . und sollt ich nicht mit sehnsüchtiger Gewalt in's Leben ziehn, die einzigste Gestalt. Eine Maria, eine Helena, eine Mona Lisa. Mein Gott hör auf. . . . Hinter deinem ganzen philosofischen Getue steckt nichts weiter, als daß du bis über beide Ohren in sie verliebt bist" (Unnumbered sheet C 34406v, JHM 5045).

12. Salomon 1981, 525–37.

13. As I will argue shortly, this text is not simply an accompaniment but more precisely a literal overwriting of the traditional image—as well as of what it reveals.

14. See unnumbered sheets C 34870, JHM 5000–5003.

15. "Charlotte bleibt unbeweglich. Das ist ihm in seiner langjährigen Praxis noch nicht vorgekommen. Er hat das Gefühl von etwas kaltem Totenähnlichem und ist erstaunt interessiert. Er setzt 'seine Experimente' die ihn wie immers sehr interessieren fort" (Unnumbered sheet C 34381, JHM 4998).

16. Felstiner (1990) has argued that Salomon's autobiography in art shows a strong identification with the female family members, and that the discovery of the female suicides in her family helped to determine its form. To explain this gender specificity of Salomon's work, Felstiner notes that "identification between women is a major theme of female self-representation" (185). I argue that Salomon's gender awareness is motivated by the genderedness (that is, maleness) of the poetics and concepts of art that have shaped her thinking about art.

17. This cousin is depicted in the final version of *Life or Theater?* only once.

Just after her daughter Franziska has committed suicide, Charlotte's grandmother lists all the family members who have killed themselves and those who are still alive. The six dead family members are represented in the upper part of the image, divided by a line from those still living: Charlotte, the male cousin, and the grandmother herself. Salomon depicts him, however, only alive; his suicide goes unremarked.

18. In an unpublished paper (housed at the Jewish Historical Museum, Amsterdam), Reichenfeld (1987) provides a detailed analysis of the ways in which the musical citations function in *Life or Theater?* The following draws upon that analysis.

19. For the term *suture*, see Silverman 1983.

20. "Mein Grossvater war für mich das Symbol für die Menschen gegen die ich kämpfen sollte" (Unnumbered sheet JHM 4928, N4).

CHAPTER 4

1. An exception to this general tendency is Sidra DeKoven Ezrahi's valuable book *By Words Alone: The Holocaust in Literature* (1980), which discusses all kinds of Holocaust literature: works that keep close to the documentary as well as those of mythical proportions. She sees what she calls the "survival novel" as "the first breach in the tyranny of fact over imagination, employing memory, fantasy, and metaphor as a manner of escape from and denial of reality within the private soul of the victim" (14). For her, Holocaust literature is not submitted exclusively to the function of providing historical knowledge.

2. Des Pres 1988, 217.

3. Hirsch and Spitzer 1994, 16.

4. Lanzmann's refusal of the fictional mode of realism in favor of the archival mode of collecting memories should not be understood as an effort to reach more "objective" knowledge of the Holocaust. As Bartov (1996) and Hirsch and Spitzer (1994) point out, Lanzmann's choice of witnesses for his documentary was highly partial.

5. When we compare these filmmakers with historians, Lanzmann has the position of those who criticized Simon Schama (Spielberg) for adopting the narrativist mode too liberally and eagerly in his *Death Certainties*.

6. Boltanski 1987, n.p.

7. Nochlin 1974, 29.

8. Brilliant 1990, 7.

9. For the use of the photographic portrait in medical and legal institutions, see Tagg 1988 and Sekula 1989. Sekula argues that the photographic portrait extends and degrades a traditional function of artistic portraiture, that is, to provide the ceremonial presentation of the bourgeois self: "Photography came to establish and delimit the terrain of the *other*, to define both the *generalized look*—the typology—and the *contingent instance* of deviance and social pathology" (345).

10. Gadamer [1960] 1975, 131.

11. For a discussion of the equivalence of mimesis and make-believe, see Walton 1993.

12. In the words of Brilliant (1990, 13), "Portraits concentrate memory images into a single, transcendent entity; they consolidate many possible, even legitimate, representations into one, a constant image that captures the consistency of the person, portrayed over time but in one time, the present, and potentially, forever." I contend that his "transcendent entity," the result of the concentration of several images into one, is based on the same representational logic as Gadamer's "increase of being."

13. In his essay "Betraying Faces: Lucian Freud's Self-Portraits" (1991, 61–74), Benjamin discusses the semantic economy of mimetic representation from a philosophical perspective. I follow here the main points of his argument.

14. Ibid., 62.

15. This example is mentioned in Alpers 1988. For a study of Rembrandt's self-portraits, see Chapman 1990. A semiotic perspective, related to psychoanalysis, is proposed in Bal 1991.

16. Boltanski 1973; quoted in Gumpert 1994, 38.

17. Marsh 1989, 36; quoted in Gumpert 1994, 128.

18. Démosthènes Davvetas, Interview with Christian Boltanski, New Art, no. 1 (Oct. 1986): 20; quoted in Gumpert 1994, 84.

19. Gumpert 1994, 143.

20. Ibid.

21. Boltanski, quoted in René van Praag, "Century '87, een expositie van 'ideetjes,'" Het Vrije Volk, Aug. 28, 1987.

22. Renard 1984, 27; quoted in Gumpert 1994, 176.

23. See Marianne Hirsch's analysis of the family portrait, "Masking the Subject" (1994). She uses Lacanian concepts for what Boltanski calls "a set of cultural codes." The subjectivities of portrayed persons in family portraits are "masked," writes Hirsch, because, "existing in the familial, the subject is subjected to the familial gaze and constructed through a series of familial looks" (114).

24. Renard 1984, 27; also in Gumpert 1994, 177.

25. Eco 1976, 10.

26. For a seminal discussion of the important role of the index in contemporary art, see Krauss 1985.

27. See note 12 to this chapter.

28. Renard 1984, 71; quoted in Gumpert 1994, 32.

29. In his site-specific work Missing House (1990) in Berlin, Boltanski turned himself into the archivist of a vacant lot in a former Jewish neighborhood. The "missing house" was demarcated by name plates attached to the fire walls of houses adjacent to the empty lot created by the destruction of a house in the Sec-

ond World War. The plates included the name, dates of residence, and professions of the last inhabitants of the missing house. For an excellent reading of this work, see Czaplicka 1995.

30. Friedlander [1982] 1993a, 91.

31. Ibid., 92.

32. Karen Holtzman, in her article "The Presence of the Holocaust in Contemporary American Art" (1994), points to the danger of artists using techniques analogous to those of the Nazis. This is indeed a serious risk, but the fact that Boltanski explores the archival mode of the (Nazi) historian in an utterly self-reflexive and critical way keeps him from falling into that trap.

33. Marsh 1990, 10.

34. Gjessing 1994, 42–43.

35. White 1987, 66, referring to Valesio 1980.

36. Ibid., 72.

37. Ibid., 75.

38. Quoted in Gjessing 1994, 43.

CHAPTER 5

1. Fokkema 1985, 64.

2. Blotkamp 1989, n.p.

3. The concept of experience needs some qualification here. Experience is a challenge to representation because it is utterly subjective, whereas representation is an attempt to make experience intersubjectively accessible. See De Lauretis 1983.

4. Thus, as I will demonstrate, he provides a solution to the dilemma of representing death in a manner complementary to that proposed by Rembrandt's paintings, as Mieke Bal (1991) argues.

5. Lotman 1977.

6. Peirce 1984, 9–10.

7. Krauss 1985, 198.

8. Ibid., 217.

9. "Ze groeien en zwijgen. Wat erook gebeurt. Er is nogal wat gebeurd bij de bomen. Men besloop en beschoot, men ranselde en vernederde. Je zou dus kunnen zeggen dat de bomen medeplichtig zijn, zich schuldig gemaakt hebben. Maar nee: het zijn maar bomen. Die treft geen blaam. Een bosrand bijvoorbeeld. De voorste bomen moeten het een en ander gezien hebben. Die daarachter staan kun je nauwelijks iets kwalijk nemen, die hebben nooit iets kunnen zien. Maar de bosrand, de woudzoom, die heeft het gezien. Er zijn heel wat bosranden, her en der, van wie ik het een en ander weet" (*NRC-Handelsblad*, May 3, 1985). In what follows, all translations are my own.

10. "Kijk naar de afbeeldingen waarop de vijand doende is: daar staan ze op de achtergrond te lachen. En niet alleen de denne- en sparrebomen, de andere bomen ook.

"Moet daar niet es iets van gezegd worden?

"Ik dacht van wel, want ze staan er soms nog, de bomen, de bosrand en het geboomte, op dezelfde plek waar ze destijds ook stonden, je moet er niet aan denken dat ze verderop zijn gaan staan, ze staan er nog steeds als onverschillige getuigen" (1988, 245–46).

11. "Eindelijk kwam de tijd dat de bomen konden vertellen over vroeger. Hoe bewonderenswaardig. Hoe edelmoedig. Maar ze verbloemden veel, zo niet alles" (1988, 118–19).

12."16 augustus / Dit landschap heeft kwaad gedaan. Ik kan de legers vermoeden. Het is hier vredig, maar opgepast. Stilte komt soms na lawaai: hier was pijn, hier ranselde de medemens. De tijd heeft schuld, alles groeit weer, maar denken wordt vergeten. Verraad! Dit slagveld blijft mijn eigendom, al leef ik nog zo erg"; "2 september / De Natuur heeft het wel verbruid. Eerst was Zij laf, toen liet Zij mij aanhoudend in de steek. En laten de bomen zich niet eeuwig duwen door de wind, zonder noemenswaard verzet? . . . En de Bodem. De Bodem leent zich voor de val der helden. Plekken dulden eerst, begroeien later. O, de plek zal wel begroeid zijn. Ja, plekken zijn altijd begroeid" (1973, n.p.).

13. Barthes 1981.

14. "Het zijn Duitse kaarten, Voorwerpen waar de geschiedenis overheen is gegaan. Resten. Zeer tastbare resten van het verleden, met sporen van mensen erop. Ik heb thuis een kaart van een soldaat in uniform uit de eerste wereldoorlog, waar sporen van potlood opzitten. Ik heb er nog steeds niets mee gedaan. . . . De tekeningen met ansichtkaarten, die zijn voor mij de totale melancholie. . . . De mensen die zo'n kaart in handen hebben gehad en hebben beschreven zijn dood" (quoted in Sanders 1985, 12).

15. The Dutch "Nul beweging" is related to the international movements of *Nouveau Réalisme* and Zero. Its main artists were Armando, Jan Hendrikse, Henk Peeters, and Jan Schoonhoven. Conceiving of daily reality itself as art, they used the materials and products of mass production as their media and source of inspiration. Seriality and the readymade were their main devices in making art that was defined by its "cool impersonality." Armando called the literary manifestation of this movement "total poetry"; its practitioners were the poets who published in the journals *Gard Sivik* and *Barbarber*.

16. "Niet de Realiteit be-moraliseren of interpreteren (ver-kunsten), maar intensiveren. Uitgangspunt: een konsekwent aanvaarden van de Realiteit. Interesse voor een meer autonoom optreden van de Realiteit, al op te merken in de journalistiek, tv-reportages en film. Werkmethode: isoleren, annexeren. Dus: authenticiteit. Niet van de maker, maar van de informatie. De kunstenaar, die geen kunstenaar meer is: een koel zakelijk oog" (1992b, 19).

17. "Ik heb de oorlog zo gehaat dat ik me er mee ben gaan identificeren. Ik ben de oorlog zelf geworden" (quoted in van Garrel, "Een dagje met Armando," Apr. 17, 1971, n.p.).

18. "Hij had bloed gespuwd en twee tanden verloren, / wel een bewijs / dat zijn kolfslag niet bepaald een liefkozing geweest was" (1964, n.p.).

19. On story lines, see Brooks 1984.

20. "[5] de machine is uitgerust met 4 hakborden / de machine heeft 3 lucht-bandwielen / de machine werkt ook met 3 groepen van 2 borden // de machine vraagt weinig onderhoud / de machine werkt zeer schoon"; "[13] met stalen tanden / de wortels van het gezaaide gewas worden niet beschadigd. / het onkruid wordt in de kiem gedood. / met stalen tanden // het effect 'schoon land' moet verbluffend zijn" (1992a).

21. "Het zgn. 'nekschot.' Dat je daar nooit van gehoord hebt. Nekschot: het woord zegt het al. Heb je daar echt nooit van gehoord? Geeft niet, hoor. Gek wo-ord evengoed, hè: *nekschot.* Jaja" (1981, 25).

22. "Laten we het vooral 'boekstaven.' Hij zei: 'boekstaven.' Alweer zo'n woord, pas toch op" (1981, 70).

23. "*22 juni* / O, het geroep van een vogel! Ik luister naar de vogel. Hij praat nu eens dit, dan weer dat. Korte gezegdes. Stilte tussen de gezegdes is steeds van lengte gelijk. . . . Het dier is sterk en wilskrachtig, zo moet ook ik een eigen lied zingen. Goed voorbeeld, de vogel" (1973, n.p.).

24. Krauss 1985, 206.

25. De Nijs 1990, 8.

26. "*29 juli* / De tijd heeft weer geduwd. Hoe kom ik ooit tot staan?"; "*8 au-gustus* / Heden een akelig besef: overlevenden worden ouder. Het is steeds langer geleden. Wel eeuwen. En de medemens weet slechts van talmen en vergeten" (1973, n.p.).

27. "Kijk, de samenhang ontbreekt, begrijp je? En dat moet ook: er bestaat namelijk geen samenhang" (1980, 128).

28. "Je hebt het verleden, je hebt het heden en dan is er ook nog de toekomst.
"Dat zijn er drie.
"Maar er is nog een vierde: het verleden van de herinnering, van de verbeeld-ing. En dat is een ander verleden. Het is met de wijsvinger ingekleurd, het is gekneed en verbogen, het is verschoven en gekrompen, het is verfomfaaid, hier dik en daar dun geworden en men denkt dat het zo hoort.
"Hier is sprake van een onwrikbaar verlangen naar *de idylle*" (1988, 238; em-phasis in the original).

29. On reading for the ending, see Brooks 1984.

30. For an analysis of the paradoxical narrativity of Bacon's paintings, see van Alphen 1992.

31. Sylvester [1975] 1985, 22, 63.

32. "Ik kan er niet omheen: dit soort tekeningen is uit haat ontstaan. . . . Het was het voortzetten van een proces. Ik heb ooit eens tegen iemand gezegd: 'zo'n tekening, daar werd een mens in vermoord.' Ik heb op die manier heel wat mensen te pakken gehad. En dat is dan kunst. Het heeft wel degelijk ook met een

soort hysterie te maken. Je moet jezelf ontzettend opladen om zo'n tekening te kunnen maken. Dat kun je niet elk uur van de dag. Het is geen ontspannen tekenen, het is heel verkrampt en met heel veel kracht gedaan, maar niet snel" (quoted in Sanders 1985, 9).

33. This crucial dialectic of trauma is brilliantly analyzed in Felman and Laub 1992.

34. The relevance of the romantic concept of the sublime for Armando's work has been argued by, for example, Gribling 1985 and de Nijs 1990.

35. The romantic sublime has been discussed exclusively by men and in sometimes strikingly masculinist terms. My use of male-gendered language in this section is therefore deliberate.

36. See Koerner 1990 for a seminal study of Friedrich's work.

37. De Nijs 1990, 19.

38. "Der Gegenstand wird als erhaben mit einer Lust angenommen, die nur vermittelst einer Unlust möglich ist" (Kant [1790] 1983, 348; English translation 1964, 102).

39. "Das Gefühl des Erhabenen ist also ein Gefühl der Unlust, aus der Unangemessenheit der Einbildungskraft in der ästhetischen Größenschätzung, zu der Schätzung durch die Vernunft, und eine dabei zugleich erweckte Lust, aus der Abereinstimmung eben dieses Urteils der Unangemessenheit des größten sinnlichen Vermögens mit Vernunftideen, sofern die Bestrebung zu denselben doch für uns Gesetz ist" (Kant [1790] 1983, 344–45; English translation 1964, 106).

CHAPTER 6

1. Bernstein 1994, 47.

2. Appelfeld 1994, 14.

3. Hartman 1996, 155.

4. Appelfeld 1994, 14.

5. Ibid., xiv.

6. Hartman 1996, 155; see also Hartman 1995a.

7. Laub 1992b, 78.

8. Laub writes extensively about this crucial function of testimony's addressee in "Bearing Witness, or the Vicissitudes of Listening" and "An Event Without a Witness" (1992a,b).

9. Laub 1992b, 81; emphasis in the original.

10. Ibid., 82.

11. Ibid., 85.

12. Laub 1992a, 71.

13. Irene Kacandes (1994) comes to similar conclusions by means of a detailed analysis of some testimonies. She shows how the shape and meaning of the testimony is constructed by the person testifying in cooperation with the interviewer.

14. See Benveniste 1966, or the English translation of 1971.

15. The work of scholars like Geoffrey Hartman, Dori Laub, Shoshana Felman, James Young, and Dominick LaCapra differs fundamentally from the dom-

inant tradition. These authors are especially interested in the performative quali-
ties of Holocaust representations. My own work is very much informed by the
perspectives they have introduced into Holocaust studies.

16. Translation in Gumpert 1994, 9; for a facsimile, see *Christian Boltanski—
Reconstitution*, exhibition catalog (London, Eindhoven, Grenoble, 1990). The
original text is as follows: "Il faut que vous m'aidiez, vous avez sans doute en-
tendu parler des difficultés que j'ai eu récemment et de la crise très grave que je
traverse. Je veux d'abord que vous sachiez que tout ce que vous avez pu entendre
contre moi est faux. J'ai toujours essayé de mener une vie droite, je pense,
d'ailleurs que vous connaissez mes traveaux; vous savez sans doute que je m'y
consacre entièrement, mais la situation a maintenant atteint un degré intolérable
et je ne pense pas pouvoir le supporter bien longtemps, c'est pour cela que je vous
demande, que je vous prie, de me répondre *le plus vite que possible*. Je me'excuse
de vous déranger, mais il faut absolument que je m'en sorte."

17. Gumpert 1994, 10.

18. Boltanski 1975, 147–48; English translation in Gumpert 1994, 171.

19. Susan Sontag's "Against Interpretation" is the programmatic text for this
critical attitude toward art. For a discussion of the art that was proposed in place
of the old, see Rosalind Krauss's *Passages in Modern Sculpture* (1977), especially
"Mechanical Ballets" and "The Double Negative."

20. Boltanski explicitly expresses his affinity with the art of the 1970's in an
interview with Alain Fleisher and Didier Semin from 1988: "If today's art inter-
ests me much less than the art of the 1970's, this is in part a question of genera-
tion, but it's mainly because there are far fewer political struggles today—those
real-life struggles that we saw in the United States, even more than in France,
which meant that artists were producing works that were more courageous, more
interesting" (6–7).

21. Celan 1986a, 17.

22. Celan 1986b, 49.

23. Ibid.

24. See Blanchot's postface to *Vicious Circles* (1985), 68.

25. Quoted in Hartman 1996, 162.

26. Ibid., 164.

27. Boltanski 1975; English translation in Gumpert 1994, 171–72.

28. Lascault 1971. 29. Gumpert 1994, 16.

30. Hartman 1994, 24, 26. 31. Lifton 1991.

32. Hartman 1996, 152. 33. Hartman 1994, 8.

34. Gumpert 1994, 80. 35. Rossi 1995, 268.

36. Gumpert 1994, 94.

37. Andrew Benjamin, too, sees the *Candles* and *Shadows* series as a domain
of artistic activity different from, but obviously related to, the work of Boltanski
that I discussed in Chapter 4. He says about *Candles* and *Shadows* that "actuality
is central" (1994, 61). See also Newman 1992.

CHAPTER 7

1. "Langzamerhand ben ik gaan begrijpen dat je niet moet schrijven of schilderen wat je weet. Je zou datgene moeten schrijven of schilderen wat zich tussen het weten en begrijpen verbergt. Een kleine aanduiding, een wenk is mogelijk, een vermoeden, meer niet, en dat is heel wat" (1986, 161).

2. The English translation of a selection of these three books is available under the title *From Berlin* (1996).

3. In his visual work of the 1970's Armando often made use of postcards. He is, however, less interested in the visual images on the postcards than in the past world from which they stem. He uses postcards as leftovers, as indexes, of an irretrievable past. See Chapter 5.

4. For an explanation of the term *mise en abîme*, see Bal 1985.

5. "Soms vraag ik me af wat doe ik hier. Waarom ga ik niet in een hol of grot wonen, met vriendelijke dieren, die proviand voor mij halen. Maar nee, ik ben hier, midden in de nacht. Want schoon is het kunstenaarsleven, maar de tol is hoog, laat dat je gezegd wezen, de tol is hoog.

"Ik wandel alsof ik luister. Wat zich hier verstopt, verbergt, besef je dat? Natuurlijk, je zult geen enkel spoor ontdekken, maar het gaat om de poging, zullen we maar zeggen. Waar het om gaat is een vorm te vinden voor deze poging: vormgeving van de poging, van de onmacht. Er is iets aan de hand" (1982, 164).

6. "Maar wat kan ik in deze stad anders doen dan nadenken over andermans waaiende geheimen. Wie weet waait de dood wel mee. Je meester proberen te maken van vermommingen. Maar waarom, waarom toch. . . . Hij [de kunstenaar] vertoeft veel te vaak in z'n zelfgeschapen spelonken en hij licht zichzelf bij met een zwak kaarsje, dat het tegen de onbarmhartige tocht moet afleggen. Hij moet zo nu en dan waarlijk dolen en dat is geen pretje" (1982, 165).

7. For a theory of elegy as an interdiscursive genre with a long tradition, see Ramazani 1994.

8. "Ik zou zo graag willen weten wie hier woonden en hoe ze woonden, hoe zag het eruit in 1912 of 1926 of 1934 of 1941, wat werd hier gezegd, hoe rook het hier, dat zou ik zo graag willen weten. Maar ik neem aan, dat u dat niet weet. Ik merk het al, het interesseert u niet eens" (1983, 15).

9. "Ik heb al in menig Berlijns huis gewoond, ook in deze huizenpracht, maar ik heb snel moeten toegeven, dat het nooit je eigen kamers worden, al zou je zo'n huis kunnen kopen: je zit in *hun* kamer. Maar de loense gloed van hun interieurs zie ik niet, hun stemmen hoor ik niet, ze dringen nauwelijks tot me door, hoe ik me ook inspan. Een onhoudbare toestand" (1983, 15–16).

10. "Bekijk je oude ansichtkaarten van even voor de oorlog, dan zie je duidelijk *buitenland*, namelijk een echte Duitse stad met schonkige huizen. Als je voor de oorlog als huurling in vreemde landen kwam, wist je niet wat je overkwam, alles was inderdaad *vreemd*, alles vol geheimen, en dat gaf, mij althans, een groot gevoel van tevredenheid. . . . Nu ziet iedereen er bijna gelijk uit. Niet

dat ze gelijk *zijn*, maar het lijkt zo. Weinig nationale kenmerken nog. Of zou dat bevordelijk voor de vrede zijn?" (1982, 160–61).

11. On travel literature, see Pratt 1992 and Obeyesekere 1992.

12. A good overview of the problems inherent to ethnography can be found in Fabian 1983, Clifford 1988, and Sperber 1982.

13. Blanchot 1993, 125.

14. Ibid., 125–26.

15. Ibid., 128.

16. Lyotard 1990, xii.

17. "Een ongeduldige winkelier, een norse postbode, een halsstarrige ambtenaar, een kwaadaardige buurvrouw, is dat de vijand? Dacht van niet. Zo eenvoudig zit de vijand niet in elkaar. De vijand leeft toch meer in het verborgene. Dat heeft ie me tenminste beloofd, de vijand. Hij verstopt zich liever, af en toe mag je een glimps van 'm zien, en dan weet je niet eens zeker of ie het wel is. Ik mag 'm wel de vijand. Ineens is ie er, dat doet vertrouwd aan als ie er is. Wat zouden we zonder de vijand moeten beginnen. Niets" (1983, 50).

18. "Maar je moet ook weten, als je niet geheel onnozel bent, dat je hier in een ander land bent, waar niemand op je zit te wachten. En je moet ook weten, dat je een *produkt* maakt, zwartgallige hangsels, waar eveneens niemand op zit te wachten. Integendeel. Het heeft weinig zin om je daarover te beklagen en toch zijn er die dat doen, ik verbaas me daar iedere keer weer over, want slechts in het verbazen ben ik een meester" (1983, 51).

19. Armando 1982, 110.

20. I do not use the term "primal scene" in the strict psychoanalytic sense, to indicate a scene in which the child observes the parents having sexual intercourse, or infers such activity on the basis of certain indications or fantasies (Laplanche and Pontalis 1980, 335). Rather, I call the transit camp scenes witnessed by Armando "primal" because they function as the basis for all his later observations and experiences.

21. "Het gebeurt wel eens dat ik midden in deze hardhandige stad plotseling de hei ruik. Dat is natuurlijk maar verbeelding, toch ruik ik duidelijk de hei. Dan komen de herinneringen: knarsende grintpaden en vrolijke familieleden. De hijgende vijand ook, die daar ronddoolde om te oefenen, hij moest, hij kon niet anders. De kruiddamp. De dorst. De verborgen wapens, de resten van uniformen en de speurtocht naar soldatenlaarzen. Buit. Roof. De dreiging. En de geuren van de namiddag, het versterven. De vermoeide zon. De galm" (1986, 91).

22. "Engeland is een land waar je van alles te binnen schiet. Oja, dat was bij ons ook, waarom is dat in Nederland op geniepige, zo niet sluiperige wijze verdwenen" (1982, 173).

23. "Mijn voorkeur gaat uit naar een omgeving met bouwwerken die op hoge benen staan, ik hou van de brede trappen, de hoge wanden, de fiere zuilen, de trotse zalen, de bordessen, zelfs van de metopen en architraven en meer van die

onderdelen. Ik ben minder geschikt voor het veilige kleine en genoeglijke, ik ben niet zo erg voor het kleingoed. Liever het monumentale, liever de paleizen en de onderaardse gewelven" (1986, 201).

CHAPTER 8

1. For a fascinating analysis of the importance of sacred places for the commemoration of exceptional and supernatural events in Christianity, see Halbwachs 1941, and the English translation of 1992.

2. "Het huis dat ik bewoon.

"Ik liep door de kamers waar vele geslachten gewoond hebben. Wie hebben er gewoond, hoe waren hun gesprekken, hoe waren hun kamers ingericht, wie zijn er geboren, wie zijn er gestorven, en hoe zat het met het personeel.

"Ik weet het niet. Het zou belangrijk zijn om het te weten, maar ik weet het niet. Misschien had ik sommige dingen te weten kunnen komen, maar dat wil ik ook weer niet. Dan kun je wel aan de gang blijven. Je kunt nasporingen doen en iets te weten komen, maar je komt nooit alles te weten. Steeds steken nieuwe vragen de kop op.

"Ik moet er maar es vrede mee hebben dat ik het een en ander niet weet en nooit te weten zal komen. En ja, langzaam ben ik zover dat ik er vrede mee heb" (1994, 23).

3. Vidler 1992, 18.

4. Poe 1899, 106–7.

5. Ibid., 197.

6. Freud 1974.

7. Vidler 1992, 4.

8. Ibid., 20.

9. Poe 1899, 179.

10. Schelling, quoted in Vidler 1992, 26–27.

Works Cited

Abish, Walter. 1979. *How German Is It*. New York: New Directions.

Adorno, Theodor W. 1992. "Engagement" (1962). In *Notes to Literature*, edited by Rolf Tiedeman, translated by Sherry Weber Nicholsen, 2:76–94. New York: Columbia University Press.

Alpers, Svetlana. 1988. *Rembrandt's Enterprise: The Studio and the Market*. Chicago: University of Chicago Press.

Alphen, Ernst van. 1987. *Bang voor schennis? Inleiding in de ideologiekritiek*. Utrecht: Hes.

———. 1988a. *Bij wijze van lezen. Verleiding en verzet van Willem Brakmans lezer*. Muiderberg: Coutinho.

———. 1988b. "Literal Metaphors: On Reading Postmodernism." *Style* 21 (2): 208–18.

———. 1989a. "The Complicity of the Reader." *V/S Versus* 52 (3): 121–32.

———. 1989b. "The Heterotopian Space of the Discussions on Postmodernism." *Poetics Today* 10 (4): 819–38.

———. 1990. "The Narrative of Perception and the Perception of Narrative." *Poetics Today* 11 (3): 483–510.

———. 1992. *Francis Bacon and the Loss of Self*. London: Reaktion Books/Cambridge, Mass.: Harvard University Press.

———. 1996a. "The Homosocial Gaze: According to Ian McEwan's *The Comfort of Strangers*." In *Vision in Context*, edited by Theresa Brennan and Martin Jay, 169–86. London: Routledge.

———. 1996b. "The Portrait's Dispersal: Concepts of Representation and Subjectivity in Twentieth-Century Portraiture." In *Portraiture: The Visual Construction of Identity*, edited by Joanna Woodall, 239–56. Manchester, Eng.: Manchester University Press.

Ankersmit, Frank. 1983. *Narrative Logic: A Semantic Analysis of the Historian's Language*. The Hague: Mouton.

———. 1990. *De navel van de geschiedenis. Over interpretatie, representatie en historische realiteit*. Groningen: Historische Uitgeverij.

———. 1994. *History and Tropology: The Rise and Fall of Metaphor*. Berkeley: University of California Press.

Appelfeld, Aharon. 1988. "After the Holocaust." In *Writing and the Holocaust*, edited by Berel Lang, 83–92. New York: Holmes & Meier.

————. 1994. *Beyond Despair: Three Lectures and a Conversation with Philip Roth.* New York: Fromm International.

Armando. 1964. "Karl May–Cyclus." *Gard Sivik* 33 (Jan.–Feb.).

————. 1973. *Dagboek van een dader.* Leiden: Tango.

————. 1978. *De ruwe heren.* Amsterdam: De Bezige Bij.

————. 1980. *Aantekeningen over de vijand.* Amsterdam: De Bezige Bij.

————. 1982. *Uit Berlijn.* Amsterdam: De Bezige Bij.

————. 1983. *Machthebbers. Verslagen uit Berlijn en Toscane.* Amsterdam: De Bezige Bij.

————. 1986. *Krijgsgewoel.* Amsterdam: De Bezige Bij.

————. 1988. *De straat en het struikgewas.* Amsterdam: De Bezige Bij.

————. 1992a. "De agrarische cyclus" (1965). In *De nieuwe stijl. Werk van de internationale avantgarde.* Amsterdam: Literaire Reuzenpocket. Reprinted in *De nieuwe stijl, 1959–1966*, 33–36. Amsterdam: De Bezige Bij.

————. 1992b. "Een internationale primeur" (1964). *Gard Sivik* 33 (Jan.–Feb.). Reprinted in *De nieuwe stijl, 1959–1966*, 18–20. Amsterdam: De Bezige Bij.

————. 1994. *Voorvallen in de wildernis.* Amsterdam: De Bezige Bij.

————. 1996. *From Berlin.* Translated by Susan Massotty. London: Reaktion Books.

Armando and Hans Sleutelaar. [1967] 1990. *De SS-ers. Nederlandse vrijwilligers in de tweede wereldoorlog.* Amsterdam: De Bezige Bij.

Bachelard, Gaston. [1958] 1969. *The Poetics of Space.* Translated by Maria Jolas. Boston: Beacon Press.

Bal, Mieke. 1985. *Narratology: Introduction to the Theory of Narrative.* Translated by Christine van Boheemen. Toronto: University of Toronto Press.

————. 1991. *Reading "Rembrandt": Beyond the Word-Image Opposition.* New York: Cambridge University Press.

Bann, Stephen. 1984. *The Clothing of Clio: A Study of the Representation of History in Nineteenth-Century Britain and France.* Cambridge: Cambridge University Press.

Barthes, Roland. 1981. *Camera Lucida: Reflections on Photography.* Translated by Richard Howard. New York: Hill & Wang.

Bartov, Omer. 1996. *Murder in Our Midst: The Holocaust, Industrial Killing, and Representation.* New York: Oxford University Press.

Benjamin, Andrew. 1991. *Art, Mimesis, and the Avant-Garde.* London: Routledge.

————. 1994. "Installed Memory: Christian Boltanski." In *Object. Painting*, 54–69. London: Academy Editions.

Benveniste, Emile. 1966. *Problèmes de linguistique générale.* Paris: Gallimard. English translation: *Problems in General Linguistics.* Translated by Mary Elizabeth Meek. Coral Gables, Fla.: University of Miami Press, 1971.

————. 1970. "L'appareil formelle de l'énonciation." *Langage* 17: 12–18.

Bernstein, Michael André. 1994. *Foregone Conclusions: Against Apocalyptic History*. Berkeley: University of California Press.

Bersani, Leo. 1990. *The Culture of Redemption*. Cambridge, Mass.: Harvard University Press.

Blanchot, Maurice. 1985. *Vicious Circles. Two Fictions and "After the Fact."* Barrytown, N.Y.: Stationhill Press.

———. 1993. "Being Jewish" (1969). In *The Infinite Conversation*, translated by and foreword by Susan Hanson, 123–30. Minneapolis: University of Minnesota Press.

Blotkamp, Carel. 1989. "Past Imperfect: Armando's Theme." In *Armando, Damnable Beauty, or Resonance of the Past* (exhibition catalog). Edinburgh: Fruitmarket Gallery.

Bohm-Duchen, Monica, ed. 1995. *After Auschwitz: Responses to the Holocaust in Contemporary Art*. Sunderland, Eng.: Northern Centre for Contemporary Art.

Boltanski, Christian. 1973. *Monumente. Eine fast zufällige Ausstellung von Denkmäler in der zeitgenössischen Kunst* (exhibition catalog). Düsseldorf: Städtische Kunsthalle.

———. 1975. "Monument à une personne inconnu: Six questions à Christian Boltanski." In *Art Actuel Skira Annuel*, 147–48. Geneva. English translation of part of this text in *Christian Boltanski*, by Lynn Gumpert, 171–72. Paris: Flammarion, 1994.

———. 1984. *Boltanski* (exhibition catalog). Paris: Musée National d'Art Moderne, Centre Georges Pompidou.

———. 1987. *Classe Terminale du Lycée Chases, 1931: Castelgasse-Vienne* (exhibition catalog). Düsseldorf: Kunstverein für die Rheinlande und Westfalen.

———. 1988. *Lessons of Darkness*. Chicago: Museum of Contemporary Art.

Brilliant, Richard. 1990. "Portraits: A Recurrent Genre in World Art." In *Likeness and Beyond: Portraits from Africa and the World*, by Jean M. Borgatti and Richard Brilliant, 11–27. New York: Center for African Art.

———. 1991. *Portraiture*. London: Reaktion Books/Cambridge, Mass.: Harvard University Press.

Brooks, Peter. 1984. *Reading for the Plot: Design and Intention in Narrative*. New York: Alfred A. Knopf.

Browning, Christopher R. 1992. *Ordinary Men: Reserve Battalion 101 and the Final Solution in Poland*. New York: HarperCollins.

Buchloh, Benjamin H. D. 1994. "Residual Resemblance: Three Notes on the Ends of Portraiture." In *Face-Off: The Portrait in Recent Art*, edited by Melissa E. Feldman, 53–69. Philadelphia: Institute of Contemporary Art.

Burke, Edmund. [1757] 1990. *A Philosophical Enquiry into the Origin of Our Ideas of the Sublime and Beautiful*. Oxford, Eng.: Oxford University Press.

Camus, Albert. 1958. *The Fall*. Translated by Justin O'Brien. New York: Alfred Knopf.

Caruth, Cathy. 1990. Introduction to *Psychoanalysis, Culture, and Trauma*, pt. 1. Special issue of *American Imago* 48 (1): 1–12.

———. 1991. Introduction to *Psychoanalysis, Culture, and Trauma*, pt. 2. Special issue of *American Imago* 48 (4): 417–24.

———. 1995. *Trauma: Explorations in Memory*. Baltimore: Johns Hopkins University Press.

Celan, Paul. 1986a. "Conversation in the Mountains" (1958). In *Collected Prose*, translated by Rosmarie Waldrop, 17–22. Riverdale-on-Hudson, N.Y.: Sheep Meadow Press.

———. 1986b. "The Meridian" (1960). In *Collected Prose*, translated by Rosmarie Waldrop, 37–56. Riverdale-on-Hudson, N.Y.: Sheep Meadow Press.

Chapman, H. Perry. 1990. *Rembrandt's Self-Portraits*. Princeton: Princeton University Press.

Clifford, James. 1988. *The Predicament of Culture: Twentieth-Century Ethnography, Literature, and Art*. Cambridge, Mass.: Harvard University Press.

Culler, Jonathan. 1981. "The Turns of Metaphor." In *The Pursuit of Signs: Semiotics, Literature, Deconstruction*, 188–209. Ithaca: Cornell University Press.

———. 1988. *Framing the Sign: Criticism and Its Institutions*. Norman: University of Oklahoma Press.

Czaplicka, John. 1995. "History, Aesthetics, and Contemporary Commemorative Practice in Berlin." *New German Critique*, no. 65: 155–87.

De Lauretis, Teresa. 1983. "Semiotics and Experience." In *Alice Doesn't: Feminism, Semiotics, Cinema*. London: Macmillan.

Delbo, Charlotte. 1995. *Auschwitz and After*. Translated by Rosette C. Lamont. New Haven: Yale University Press.

Delden, Maarten van. 1990. "Walter Abish's *How German Is It*: Postmodernism and the Past." *Salmagundi* 85–86: 172–94.

De Quincey, Thomas. [1821] 1979. *Confessions of an English Opium Eater*. Harmondsworth, Eng.: Penguin Books.

Des Pres, Terrence. 1976. *The Survivor: An Anatomy of Life in the Death Camps*. Oxford: Oxford University Press.

———. 1988. "Holocaust Laughter." In *Writing and the Holocaust*, edited by Berel Lang, 216–33. New York: Holmes & Meier.

Dresden, S. 1991. *Vervolging, vernietiging, literatuur*. Amsterdam: Meulenhoff.

———. 1992. "Souvenir inoubliable" (1963). *Raster* 57: 7–12.

Eco, Umberto. 1976. *A Theory of Semiotics*. Bloomington: Indiana University Press.

Ezrahi, Sidra DeKoven. 1980. *By Words Alone: The Holocaust in Literature*. Chicago: University of Chicago Press.

———. 1996. "Representing Auschwitz." *History and Memory* 7 (2): 121–54.

Fabian, Johannes. 1983. *Time and the Other: How Anthropology Makes Its Object*. New York: Columbia University Press.

Felman, Shoshana. 1993. "*What Does a Woman Want?* The Question of Autobiography and the Bond of Reading." In *What Does a Woman Want? Reading and Sexual Difference*, 1–19. Baltimore: Johns Hopkins University Press.

Felman, Shoshana, and Dori Laub. 1992. *Testimony: Crises of Witnessing in Literature, Psychoanalysis, and History*. New York: Routledge.

Felstiner, Mary. 1990. "Engendering an Autobiography in Art." In *Revealing Lives: Autobiography, Biography, and Gender*, edited by Susan Groag Bell and Marilyn Yalom, 183–92. Albany: State University of New York Press.

———. 1994. *To Paint Her Life: Charlotte Salomon in the Nazi Era*. New York: HarperCollins.

Fleisher, Alain, and Didier Semin. 1988. "Christian Boltanski: La revanche de maladresse." *Art Press* 128 (Sept.): 4–9.

Fokkema, R. L. K. 1985. "De dichter als nuchter romanticus." In *Armando, schilder-schrijver*, 63–67. Weesp: de Haan.

Freud, Sigmund. 1974. "The Uncanny" (1919). In *The Standard Edition*, edited by James Strachey, 17: 217–52. London: Hogarth Press.

Friedlander, Saul, ed. 1992. *Probing the Limits of Representation: Nazism and the "Final Solution."* Cambridge, Mass.: Harvard University Press.

———. [1982] 1993a. *Reflections of Nazism: An Essay on Kitsch and Death*. Translated by Thomas Weyr. Bloomington: Indiana University Press.

———. 1993b. *Memory, History, and the Extermination of the Jews of Europe*. Bloomington: Indiana University Press.

Gadamer, Hans-Georg. [1960] 1975. *Truth and Method*. New York: Continuum Press.

Gjessing, Steinar. 1994. "Christian Boltanski—An Interview, November 1993." In *Treskel/Threshold*, no. 11: 41–50.

Goldenberg, Myrna. 1990. "Different Horrors, Same Hell: Women Remembering the Holocaust." In *Thinking the Unthinkable: Meanings of the Holocaust*, edited by Roger S. Gottlieb, 150–66. New York: Paulist Press.

Gribling, Frank. 1985. "Armando en de romantische traditie." In *Armando, schrijver-schilder*, 49–61. Weesp: de Haan.

Gumpert, Lynn. 1994. *Christian Boltanski*. Paris: Flammarion.

Halbwachs, Maurice. 1941. *La topograhie légendaire des évangiles en terre sainte. Etude de mémoire collective*. Paris: Presses Universitaires de France. English translation: *On Collective Memory*. Edited, translated, and with an introduction by Lewis A. Coser. Chicago: University of Chicago Press, 1992.

Hartman, Geoffrey H. 1994. "Public Memory and Its Discontents." *Raritan* 13 (4): 24–40.

———. 1995a. "Learning from Survivors: The Yale Testimony Project." *Holocaust and Genocide Studies* 9 (2): 192–207.

230 ■ WORKS CITED

———. 1995b. "On Traumatic Knowledge and Literary Studies." *New Literary History* 26: 537–63.

———. 1996. "Holocaust Testimony, Art, and Trauma." In *The Longest Shadow: In the Aftermath of the Holocaust*, 151–72. Bloomington: Indiana University Press.

Herman, Judith Lewis. 1992. *Trauma and Recovery*. New York: Basic Books.

Hirsch, Marianne. 1992–93. "Family Pictures: *Maus*, Mourning, and Post-Memory." *Discourse* 15 (2): 3–29.

———. 1994. "Masking the Subject: Practicing Theory." In *The Point of Theory: Practicing Cultural Analysis*, edited by Mieke Bal and Inge E. Boer, 109–24. Amsterdam: Amsterdam University Press.

Hirsch, Marianne, and Leo Spitzer. 1994. "Gendered Translations: Claude Lanzmann's *Shoah*." In *Gendering War Talk*, edited by Miriam Cooke and Angela Wollacott, 4–19. Princeton: Princeton University Press.

Holtzman, Karen. 1994. "The Presence of the Holocaust in Contemporary Art." In *Burnt Whole: Contemporary Artists Reflect on the Holocaust*, 22–26. Washington, D.C.: Washington Project for the Arts.

Huyssen, Andreas. 1989. "Anselm Kiefer: The Terror of History, the Temptation of Myth." *October*, no. 48: 25–46.

———. 1992. "Kiefer in Berlin." *October*, no. 62: 85–101.

Jakobson, Roman. 1960. "Linguistics and Poetics" (fragment). In *Style in Language*, edited by T. A. Sebeok, 350–58. Cambridge, Mass.: MIT Press.

Johnson, Ken. 1993. "Art and Memory." *Art in America*, Nov.: 90–99.

Kacandes, Irene. 1994. "You Who Live Safe in Your Warm Houses: Your Role in the Production of Holocaust Testimony." In *Insiders and Outsiders: Jewish and Gentile Culture in Germany and Austria*, edited by Dagmar Lorenz and Gabriela Weinberger, 189–213. Detroit: Wayne State University Press.

Kant, Immanuel. [1790] 1983. *Kritik der Urteilskraft*. Vol. 5 of *Werke*. Darmstadt: Wissenschaftliche Buchgesellschaft. English translation: *Critique of Judgment*. Oxford: Oxford University Press, 1964.

Kellner, Hans. 1989. *Language and Historical Representation: Getting the Story Crooked*. Madison: University of Wisconsin Press.

Kenrick, D. A. 1982. "The White Hotel." In *Times Literary Supplement* 26 (March).

Koerner, Jospeh Leo. 1990. *Caspar David Friedrich and the Subject of Landscape*. London: Reaktion Books.

Kolk, Bessel A. van der, and Onno van der Hart. 1995. "The Intrusive Past: The Flexibility of Memory and the Engraving of Trauma." In *Trauma: Explorations in Memory*, edited by Cathy Caruth, 158–82. Baltimore: Johns Hopkins University Press.

Krauss, Rosalind. 1977. *Passages in Modern Sculpture*. Cambridge, Mass.: MIT Press.

———. 1985. "Notes on the Index," pts. 1 and 2. In *The Originality of the*

Avant-Garde and Other Modernist Myths, 196–209 and 210–20. Cambridge, Mass.: MIT Press.

LaCapra, Dominick. 1987. *History, Politics, and the Novel*. Ithaca: Cornell University Press.

———. 1994. *Representing the Holocaust: History, Theory, Trauma*. Ithaca: Cornell University Press.

Lang, Berel. 1990. *Act and Idea in the Nazi Genocide*. Chicago: University of Chicago Press.

Langer, Lawrence L. 1990. "Fictional Facts and Factual Fictions: History in Holocaust Literature." In *Reflections of the Holocaust in Art and Literature*, edited by Randolph L. Braham, 117–30. New York: Institute for Holocaust Studies.

———. 1991. *Holocaust Testimonies: The Ruins of Memory*. New Haven: Yale University Press.

Laplanche, J., and J. B. Pontalis. 1973. *The Language of Psychoanalysis*. Translated by Donald Nicholson-Smith. New York: W. W. Norton.

Lascault, Gilbert. 1971. "Boltanski au Musée Municipal d'Art Moderne." *XXe Siècle* 33 (7): 143.

Laub, Dori. 1992a. "Bearing Witness, or the Vicissitudes of Listening." In *Testimony: Crises of Witnessing in Literature, Psychoanalysis, and History*, edited by Shoshana Felman and Dori Laub, 57–74. New York: Routledge.

———. 1992b. "An Event Without a Witness: Truth, Testimony, and Survival." In *Testimony: Crises of Witnessing in Literature, Psychoanalysis, and History*, edited by Shoshana Felman and Dori Laub, 75–92. New York: Routledge.

Lifton, Robert Jay. 1991. *Death in Life: Survivors of Hiroshima*. Chapel Hill: University of North Carolina Press.

Lotman, Jurij M. 1977. *The Structure of the Artistic Text*. Translated by Gail Lenkoff and Ronald Varson. Ann Arbor: University of Michigan Press.

Lyotard, Jean-François. 1990. "the jews." In *Heidegger and "the jews."* Translated by Andreas Michel and Mark Roberts, introduction by David Caroll. Minneapolis: University of Minnesota Press.

Marsh, Georgia. 1989. "The White and the Black." *Parkett* 22: 36–40.

———. 1990. "Christian, Carrion, Clown, and Jew; Christian Boltanski Interviewed by Georgia Marsh, Revised by Christian Boltanski." In *Reconstruction* (exhibition catalog). London: Whitechapel Gallery.

Newman, Michael. 1992. "Suffering from Reminiscences." In *Postmodernism and the Re-Reading of Modernity*, edited by F. Baker, P. Hulme, and M. Iversen, 84–114. Manchester, Eng.: Manchester University Press.

Nijs, Pieter de. 1990. "Ik heb iets vreselijks gezien. De stoere gevoeligheid van Armando." *Bzzlletin* 173: 8–20.

Nochlin, Linda. 1974. "Some Women Realists." *Arts Magazine*, May: 29–32.

Obeyesekere, Gananath. 1992. *The Apotheosis of Captain Cook: European Mythmaking in the Pacific*. Princeton: Princeton University Press.

Peirce, Charles Sanders. 1984. "Logic as Semiotic." In *Semiotics: An Introductory Anthology*, edited by Robert E. Innis, 3–11. Bloomington: Indiana University Press.

Poe, Edgar Allan. 1899. "The Fall of the House of Usher." In *The Works of Edgar Allan Poe*, edited by John H. Ingram, 1: 179–99. London: A. & C. Black.

Pratt, Mary Louise. 1992. *Imperial Eyes: Travel Writing and Transculturation*. London: Routledge.

Ramazani, Jahan. 1994. *The Poetry of Mourning: The Modern Elegy from Hardy to Heaney*. Chicago: University of Chicago Press.

Renard, Delphine. 1984. "Interview with Christian Boltanski." In *Boltanski* (exhibition catalog). Paris: Musée National d'Art Moderne, Centre Georges Pompidou.

Ringelheim, Joan. 1990. "Thoughts About Women and the Holocaust." In *Thinking the Unthinkable: Meanings of the Holocaust*, edited by Roger S. Gotlieb, 141–49. New York: Paulist Press.

Rossi, Paolo. 1995. "The Scientist." In *Baroque Personae*, edited by Rosario Villari, 263–89. Chicago: University of Chicago Press.

Salomon, Charlotte. 1981. *Charlotte: Life or Theater?* With an introduction by Judith Herzberg. New York: Viking Press.

Sanders, Martijn. 1985. "De galm van het verleden. Martijn Sanders in gesprek met Armando." In *Armando. 100 tekingen, 1952–1984* (exhibition catalog). Rotterdam: Museum Boymans van Beuningen.

Schama, Simon. 1995. *Landscape and Memory*. London: HarperCollins.

Schelling, Friedrich Wilhelm Joseph. [1835] 1966. *Philosophie der Mythologie*. Darmstadt: Wissenschaftliche Buchgesellschaft.

Scholes, Robert. 1975. *Structural Fabulation*. Notre Dame: University of Notre Dame Press.

Scott, Joan W. 1992. "Experience." In *Feminists Theorizing the Political*, edited by Judith Butler and Joan W. Scott, 22–56. New York: Routledge.

Sedgwick, Eve Kosofsky. 1985. *Between Men: English Literature and Male Homosocial Desire*. New York: Columbia University Press.

Sekula, Alan. 1989. "The Body and the Archive." In *The Contest of Meaning: Critical Histories of Photography*, edited by Richard Bolton, 343–88. Cambridge, Mass.: MIT Press.

Silverman, Kaja. 1983. *The Subject of Semiotics*. New York: Oxford University Press.

Sontag, Susan. [1966] 1979. *Against Interpretation*. New York: Dell.

Sperber, Dan. 1982. "Ethnographie interprétative et anthropologie théorique." In *Le savoir des anthropologues*, 13–48. Paris: Hermann.

Spiegelman, Art. 1991. *Maus: A Survivor's Tale*. New York: Pantheon Books.

Swift, Graham. 1983. *Waterland*. New York: Vintage.

Sylvester, David. [1975] 1985. *Interviews with Francis Bacon*. London: Thames & Hudson.

Tagg, John. 1988. *The Burden of Representation: Essays on Photography and Histories*. Amherst: University of Massachusetts Press.

Theweleit, Klaus. 1985. "The Politics of Orpheus, Between Women, Hades, Political Power, and the Media: Some Thoughts on the Configuration of the European Artist, Starting with the Figure of Gottfried Benn. Or: What Happens to Euridice?" *New German Critique* 36: 133–56.

———. [1977] 1987. *Male Fantasies*. Translated by Stephen Conway in collaboration with Erica Carter and Chris Turner. Minneapolis: University of Minnesota Press.

———. 1988. *Buch der Könige*. Basel: Stroemfeld Roterstern.

Thomas, D. M. 1981. *The White Hotel*. New York: Viking Press.

Valesio, Paolo. 1980. *Novantiqua: Rhetorics as a Contemporary Theory*. Bloomington: Indiana University Press.

Vidler, Anthony. 1992. *The Architectural Uncanny: Essays in the Modern Unhomely*. Cambridge, Mass.: MIT Press.

Walton, Kendall L. 1993. *Mimesis as Make-Believe*. Cambridge, Mass.: Harvard University Press.

White, Hayden. 1973. *Metahistory: The Historical Imagination in Nineteenth-Century Europe*. Baltimore: Johns Hopkins University Press.

———. 1978. "The Forms of Wildness: Archeology of an Idea." In *Tropics of Discourse*, 150–82. Baltimore: Johns Hopkins University Press.

———. 1987. "The Politics of Historical Interpretation: Discipline and De-Sublimation." In *The Content of the Form: Narrative Discourse and Historical Representation*, 58–82. Baltimore: Johns Hopkins University Press.

———. 1992a. "Historical Emplotment and the Problem of Truth." In *Probing the Limits of Representation: Nazism and the "Final Solution,"* edited by Saul Friedlander, 37–53. Cambridge, Mass.: Harvard University Press.

———. 1992b. "Writing in the Middle Voice." *Stanford Literature Review* 9: 179–87.

Yates, Frances. 1966. *The Art of Memory*. Oxford: Oxford University Press.

Young, James. 1990. *Writing and Rewriting the Holocaust: Narrative and the Consequences of Interpretation*. Bloomington: Indiana University Press.

———. 1993. *The Texture of Memory: Holocaust Memorials and Meaning*. New Haven: Yale University Press.

Žižek, Slavoj. 1989. *The Sublime Object of Ideology*. London: Verso.

Library of Congress Cataloging-in-Publication Data

Alphen, Ernst van.
 Caught by history : Holocaust effects in contemporary art,
 literature, and theory / Ernst van Alphen.
 p. cm.
 Includes bibliographical references.
 ISBN 0-8047-2915-8 (cloth).—ISBN 0-8047-2916-6 (pbk.)
 1. Holocaust, Jewish (1939–1945), in art. 2. Arts,
 Modern—20th century. I. Title
 NX650.H57A45 1997
 700'.458—DC21 97-20754
 CIP

⊚ This book is printed on acid-free, recycled paper.

Original prining 1997
Last figure below indicates year of this printing:

06 05 04 03 02 01 00 99 98 97